2023

JANUARY
S	M	T	W	T	F	S
1	2	3	4	5	6	7
8	9	10	11	12	13	14
15	16	17	18	19	20	21
22	23	24	25	26	27	28
29	30	31				

FEBRUARY
S	M	T	W	T	F	S
			1	2	3	4
5	6	7	8	9	10	11
12	13	14	15	16	17	18
19	20	21	22	23	24	25
26	27	28				

MARCH
S	M	T	W	T	F	S
			1	2	3	4
5	6	7	8	9	10	11
12	13	14	15	16	17	18
19	20	21	22	23	24	25
26	27	28	29	30	31	

APRIL
S	M	T	W	T	F	S
						1
2	3	4	5	6	7	8
9	10	11	12	13	14	15
16	17	18	19	20	21	22
$^{23}/_{30}$	24	25	26	27	28	29

MAY
S	M	T	W	T	F	S
	1	2	3	4	5	6
7	8	9	10	11	12	13
14	15	16	17	18	19	20
21	22	23	24	25	26	27
28	29	30	31			

JUNE
S	M	T	W	T	F	S
				1	2	3
4	5	6	7	8	9	10
11	12	13	14	15	16	17
18	19	20	21	22	23	24
25	26	27	28	29	30	

JULY
S	M	T	W	T	F	S
						1
2	3	4	5	6	7	8
9	10	11	12	13	14	15
16	17	18	19	20	21	22
$^{23}/_{30}$	$^{24}/_{31}$	25	26	27	28	29

AUGUST
S	M	T	W	T	F	S
		1	2	3	4	5
6	7	8	9	10	11	12
13	14	15	16	17	18	19
20	21	22	23	24	25	26
27	28	29	30	31		

SEPTEMBER
S	M	T	W	T	F	S
					1	2
3	4	5	6	7	8	9
10	11	12	13	14	15	16
17	18	19	20	21	22	23
24	25	26	27	28	29	30

OCTOBER
S	M	T	W	T	F	S
1	2	3	4	5	6	7
8	9	10	11	12	13	14
15	16	17	18	19	20	21
22	23	24	25	26	27	28
29	30	31				

NOVEMBER
S	M	T	W	T	F	S
			1	2	3	4
5	6	7	8	9	10	11
12	13	14	15	16	17	18
19	20	21	22	23	24	25
26	27	28	29	30		

DECEMBER
S	M	T	W	T	F	S
					1	2
3	4	5	6	7	8	9
10	11	12	13	14	15	16
17	18	19	20	21	22	23
$^{24}/_{31}$	25	26	27	28	29	30

Attention, Pet Parents!

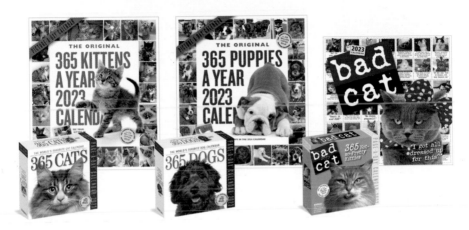

Do you have an adorable cat or dog that wants to be a star?
Submit photos of your pet for a chance to be featured
in one of our beloved and bestselling pet calendars.

For instructions on how to submit photos, learn about
prizes, and for complete contest rules, go to:

pageaday.com/contests

WORKMAN, PAGE-A-DAY, and the PAGE-A-DAY design/logo are
registered trademarks of Workman Publishing Co., Inc.

Written by Wayne Harry Kirn
Compiled by Analucia Zepeda
Photo research by John Blum
Cover photo: Cobberdog
Cover photo credit: Nynke van Holten/Shutterstock

ISBN 978-1-5235-1579-0

Printed in Thailand on responsibly sourced paper.

Workman Publishing Co., Inc.
225 Varick Street
New York, NY 10014-4381

pageaday.com

workman

ACKNOWLEDGMENT

Text vetted by
Kristin Kutscher, V.M.D.

BUSTER (DACHSHUND MIX)— CAROLYN SAMPRON, MORRISON, CO

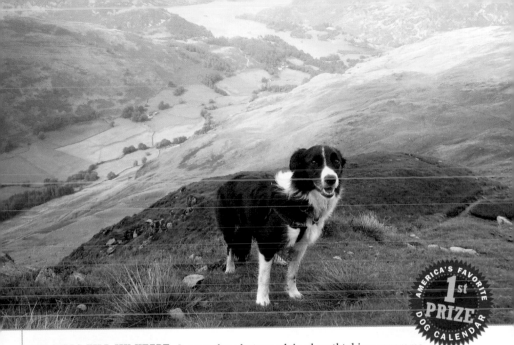

THE HILLS FILL MY HEART Our top dog photograph is a breathtaking panorama featuring a Border Collie on a visit to her breed's ancestral home in the Lake District of northern England. Carol Cook of Hull, England, re-homed "her beautiful girl" TESS after the lovely Collie had spent her first years in a situation in which she was rarely played with or walked. Tess's life is very different today, and especially so when it's time to spend a holiday with her new family exploring the magnificent English countryside.

1·Sunday·January 2023

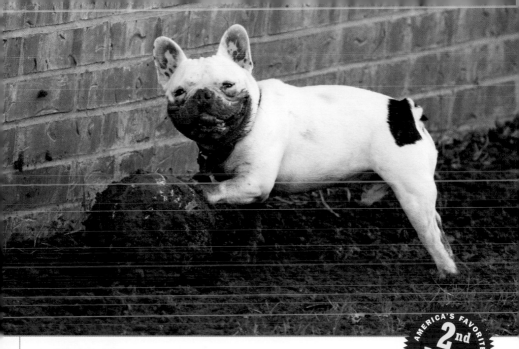

HIS GAME IS MUD As dog lover Winston Churchill once said, "Never, never, never give up." That sentiment might be the motivation for the dogged determination of our second-place winner, French Bulldog HANK. Hank's owner, Andrew Benich, of Flower Mound, TX, says that Hank loves to push his ball around, no matter what the conditions and what the consequences.

2·**Monday**·**January** *2023*

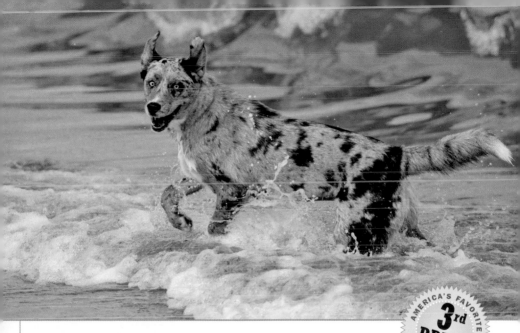

GOOD GOLLY MISS MOLLY An action shot dominated by a dog's strikingly patterned coat against cool blue surf is our third-place winner. MISS MOLLY is a Husky/Australian Shepherd mix who was born in a desert area of California but later moved with Michele Friszell and her family to the San Diego coast. These days, Molly gets to go swimming, which is her passion, all the time, and we can't help but wish we could jump into the surf right alongside her.

3·Tuesday·January *2023*

3 Tuesday, January

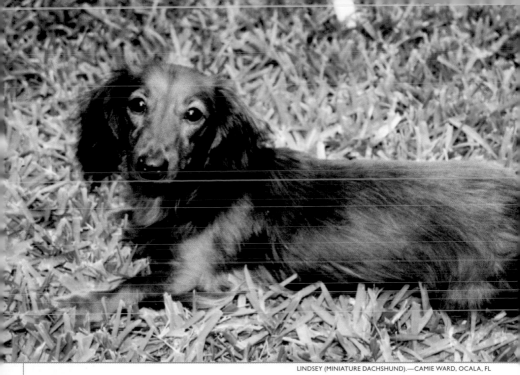

LINDSEY (MINIATURE DACHSHUND).—CAMIE WARD, OCALA, FL

"**I**f you don't want a dog who follows you everywhere you go and is almost always underfoot, the Dachshund is probably not for you."

—ANN GORDON, Dachshund breeder

4·Wednesday·January *2023*

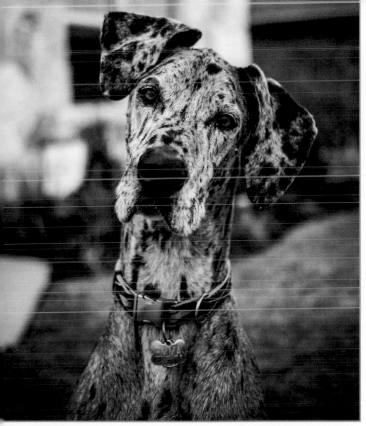

DON'T LOSE YOUR MARBLES

The term *merle* refers to a distinctive pattern of marbling on a dog's coat caused by dark patches of color set against a lighter background of the same hue. Shetland Sheepdogs, Collies, Great Danes, and Australian Shepherds may all have merle coats.

5·Thursday·January *2023*

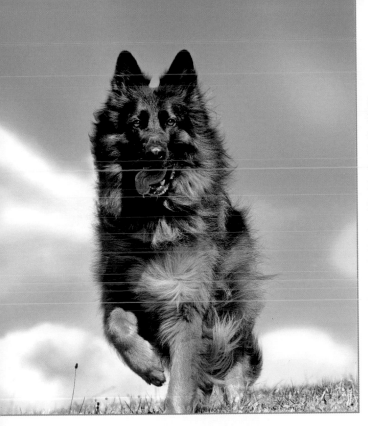

SKY KING

KAISER lives down under in Australia, but his confident expression and proud gait as he gallops beneath a big blue sky suggest that he's a dog who feels on top of the world. The German Shepherd is actually a movie star and a part-time model, and his nickname is "Mr. Clooney." His coach and biggest fan is Merran Hamilton of Kew, Victoria, Australia.

6·Friday·January *2023*

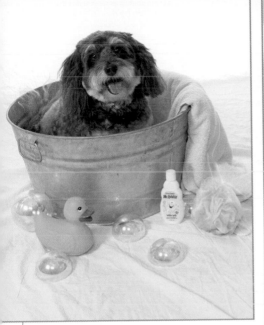

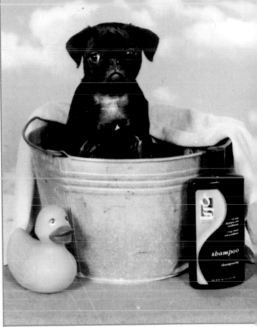

RUB-A-DUB-DUB . . .
JASMINE (Havanese).—
C. J. Jackson, Gilbert, AZ

7·Saturday
January *2023*

. . . A PUG IN A TUB
SAMSON (Pug).—
Tom & Susy Nash, Tustin, CA

8·Sunday
January *2023*

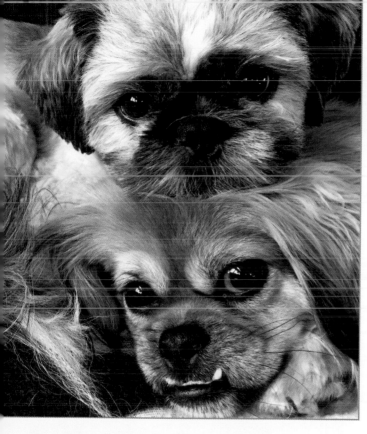

TAKE A PEKE
WALDO (on top) is a Pekingese/ Shih Tzu mix, and his younger half-brother, NIXON, is a Pekingese/ Poodle. They live in Midland Park, NJ, with Richard Minuski, who insists that, despite the urge to get one up on each other once in a while, the brothers love each other very much.

9 · Monday · January 2023

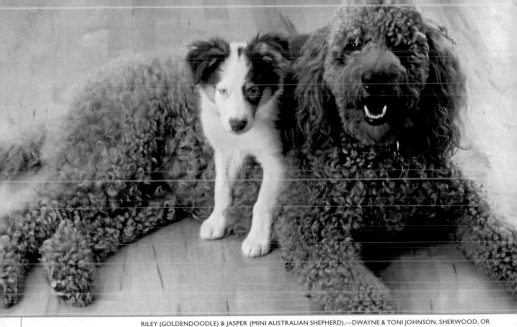

RILEY (GOLDENDOODLE) & JASPER (MINI AUSTRALIAN SHEPHERD).—DWAYNE & TONI JOHNSON, SHERWOOD, OR

SIZE MATTERS Some dog parks are divided into two sections—one for smaller dogs and the other for larger dogs. This protective measure seems to make sense because, obviously, an aggressive large dog could do serious damage to a small dog, and some small dogs are comfortable only around other small dogs. At the same time, it's interesting to note that statistics show that dog-to-dog aggression more often occurs between dogs that are relatively equal in size and age, and often the same sex.

10 · Tuesday · January 2023

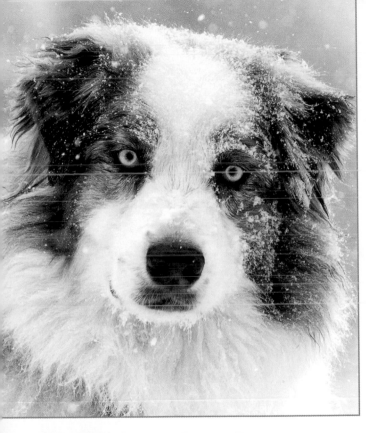

SNOW QUEEN
We instantly warmed to this frosty portrait of DELLA, a beautiful Australian Shepherd from Halesite, NY. Della's owner, Jane Cumming, explains that because of her enormous coat, Della is never cold, and winter is her favorite season.

11·Wednesday·January₂₀₂₃

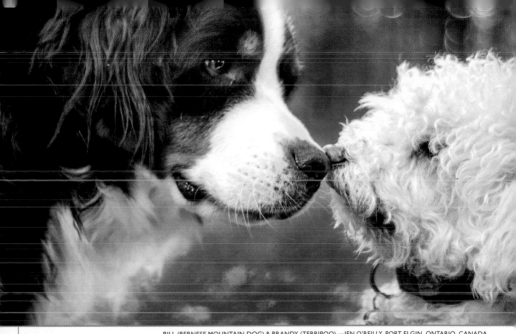

BILL (BERNESE MOUNTAIN DOG) & BRANDY (TERRIPOO).—JEN O'REILLY, PORT ELGIN, ONTARIO, CANADA

A CLOSE SHAVE Unlike the annoying whiskers that human males shave off their faces every morning (or don't), the whiskers of a dog, either male or female, serve an important function. At the bottom of each stiff whisker is a high concentration of touch-sensitive neurons, which at the slightest pressure send signals to the dog's brain. Whiskers alert a dog that he is approaching something or that something is *approaching him.* Dogs whose whiskers have been removed may be more hesitant than those with whiskers when navigating in dim light.

12·Thursday·January 2023

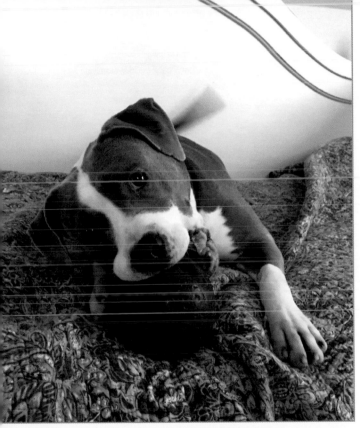

MUTT OF THE MONTH

Pretty Pit Bull mix PRINCESS was rescued from New York City Animal Care and Control just before she was to be euthanized. Her adoptive owners, Nicole and Jeremy Buturla of Norwalk, CT, report that she's sweet and somewhat shy, and she loves the other dogs in her new family. We can tell by the tooth marks on it that Princess really loves her red ball, too.

13·Friday·January 2023

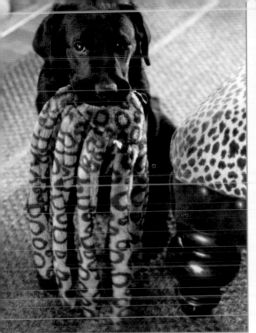

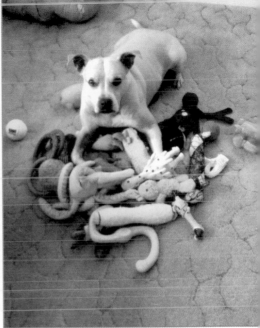

PLUSH PAL
ZOE (Labrador Retriever).—Eugene &
Susan Massamillo, Whitesboro, NY

14 · Saturday
January *2023*

TOYS "R" US
MAX (Pit Bull).—
Caroline Bohn, Perkasie, PA

15 · Sunday
January *2023* *MARTIN LUTHER KING JR.'S BIRTHDAY*

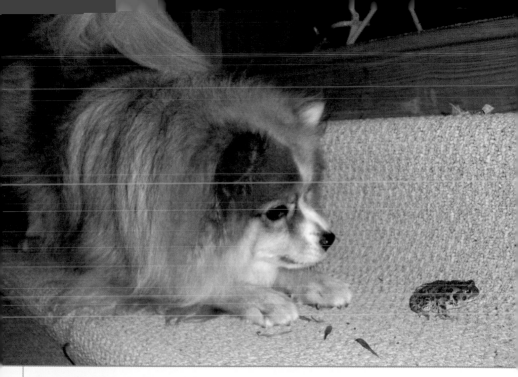

BEST FRIENDS As OLIVER always says, where there's a frog there's a friend. Oliver's caretaker J. A. LeBlanc of Swanton, UT, reports that the playful Pomeranian never fails to find something—or someone—to play with.

16·Monday·January 2023

MARTIN LUTHER KING JR. DAY

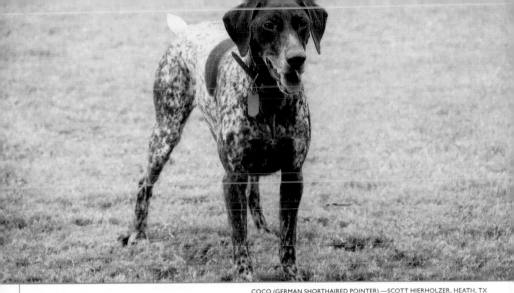

GERMAN SHORTHAIRED POINTER • *Origin:* A relatively modern breed developed around the turn of the 20th century. His forebears include the Old Spanish Pointer, the English Foxhound, and a number of German tracking hounds, including the German Bird Dog.

• *Profile:* Hunting, tracking, pointing . . . this amazingly versatile breed does it all. Intelligent, fun-loving, undeniably handsome, and a quintessential field dog, the German Shorthaired Pointer was bred to combine the finest qualities of several older European breeds. Weighing in at between 55 and 70 pounds, his frame is muscular but lean. His short, sleek coat may be colored solid liver or, more commonly, a combination of liver and white with patches. Although he was born to hunt, the GSP excels as a companion for an active and outdoorsy family.

17·Tuesday·January 2023

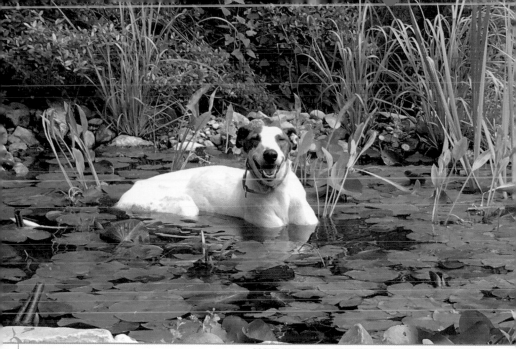

ROCKET (GREYHOUND).—KIRK & LESLIE WINEMILLER, COLLEGE STATION, TX

" **A** nybody who doesn't know what soap tastes like has
never washed a dog."

—FRANKLIN P. JONES

18·Wednesday·January 2023

TRAILS (CHIHUAHUA).—KATHY YOUNGREN, HUNTSVILLE, AL

TRAINING TIP "Say again?" While repeating a training exercise many times is a good thing, repeating a verbal command within one exercise is not. Your dog's sense of hearing is a lot better than yours, and chances are he heard you the first time. Utter his name and the command (for instance "Max, lie down!") loudly, clearly, and only once. If he doesn't respond, withhold the treat and move on to something else.

19·Thursday·January 2023

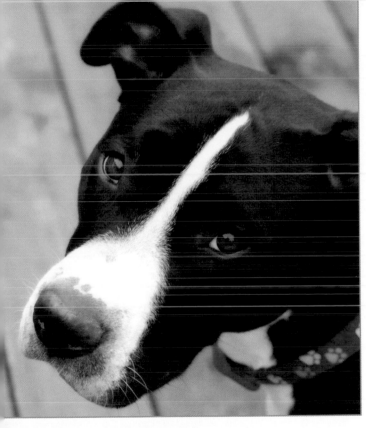

HOME RUN

When Jenni Foust first brought her rescued dog, DHARMA, to the baseball field in Reading, MI, she noticed that, as much as the gentle rescue wagged her tail in anticipation of making friends, people kept their distance because Dharma's a Pit Bull. Finally, a friend's child came up and started petting Dharma—then another child, and another. By the end of the season, Dharma's smiling face had become familiar to everyone at the park, and she became the unofficial mascot of the team.

20·Friday·January 2023

BIG CHILL
DYNA (Lhasa Apso).—Gary, Cindy &
Adam Zabretsky, West Nanticoke, PA

21·Saturday
January *2023* *SPRING FESTIVAL EVE*

BIG FOOT
CHASE (Chihuahua/Pomeranian mix).—
Jessica Horn, Brooklyn Park, MN

22·Sunday
January *2023* *LUNAR NEW YEAR*

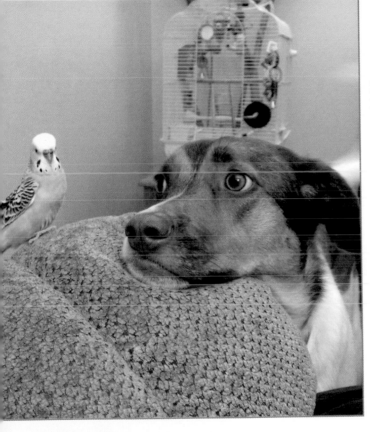

EVERYBODY'S BEST FRIEND

"A little bird told me!" RILEY, a Springer Spaniel/Pointer mix from Corunna, MI, is always glad to hear what his feathered friend, Mango, has to say. After all, you never know when the parakeet will fly home with some new gossip. The friends' caretaker, LaNeda Elrod, admits that just before this photo was snapped they had been chasing each other around the house nonstop.

23·Monday·January 2023

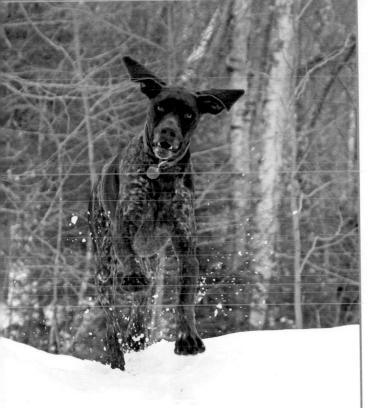

IKE LIKES HIKES

If you're trudging along the northeastern end of the Appalachian Trail and suddenly hear panting behind you, don't be surprised to find IKE gaining ground. If you stop to catch your breath, he'll probably beat you to the next lean-to shelter. Scott and Rita Schrecongost of Islip, NY, rescued Ike through Eastern German Shorthair Pointer Rescue. Known for their vigor and hunting skills, GSPs have a zest for the outdoors that's hard to contain. Since his rescue, Ike no longer needs to hunt for security. Instead, he can focus on the trail ahead.

24·Tuesday·January 2023

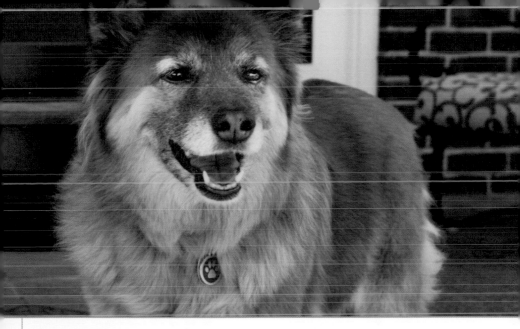

HAPPY ENDINGS HOPE, an appropriately named German Shepherd mix, had a rough start in life when her mother and two of her siblings were shot on a roadside. Rescued by Kristi Schmidt of Surprise, AZ, Hope takes a daily morning walk and enjoys being included in every activity going on around her. At a Meet & Greet event sponsored by the Arizona Humane Society, Hope even got to pick out her own future sister, whom Kristi has named Pepsi.

25·Wednesday·January *2023*

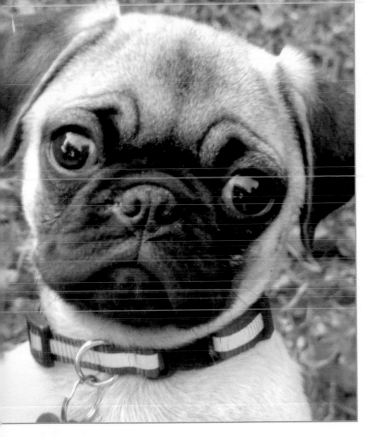

JOVI (PUG).—TANYA THIFFAULT, DARTMOUTH, NOVA SCOTIA, CANADA

NAME GAME

Can you name the breeds that have earned the following canine nicknames?

A. The American Gentleman

B. The Silver Ghost

C. The Barge Dog

D. The Monkey Face Dog

E. The Chrysanthemum Dog

ANSWERS:
A. Boston Terrier
B. Weimaraner
C. Schipperke
D. Affenpinscher
E. Shih Tzu

26·**Thursday**·**January**₂₀₂₃

AUSTRALIA DAY (AUSTRALIA)

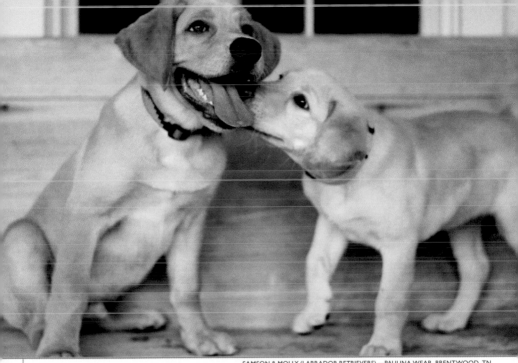

SAMSON & MOLLY (LABRADOR RETRIEVERS).—PAULINA WEAR, BRENTWOOD, TN

TOUCHY FEELY The most primitive sense a dog has is his sense of touch. Touch is functional at a pup's birth, and it remains important to him throughout his life. A dog has touch receptors in the skin all over his body, and the most sensitive ones are in his paw pads. Besides that, a dog has touch-sensitive long hairs called vibrissae on his snout and chin, and above his eyes.

27·Friday·January 2023

I'VE GOT YOUR BACK
BEETLE (Labrador Retriever).—
Nakita Simons, Prattsburgh, NY

28·Saturday
January *2023*

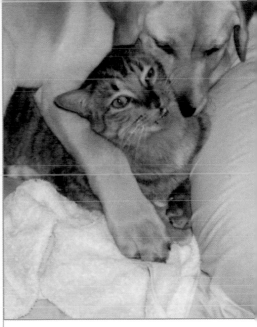

BEAR HUG
MILO (Labrador Retriever).—
Arlene Jorgensen, Missoula, MT

29·Sunday
January *2023*

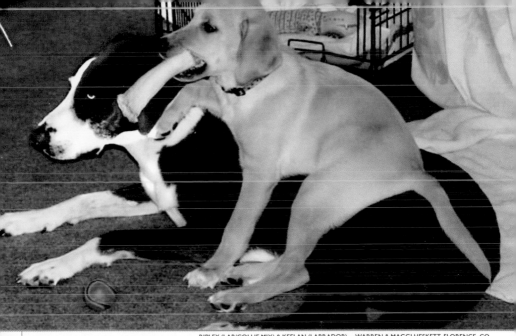

RIPLEY (LAB/COLLIE MIX) & KEELAN (LABRADOR).—WARREN & MAGGI HESKETT, FLORENCE, CO

COLD WEATHER CUDDLING Does your dog like to remain outside on even the coldest days, while you worry that he may be exposing himself to hypothermia or frostbite? Eve Adamson, columnist for the AKC's *Family Dog* magazine, suggests this compromise: "Bring him inside, snuggle up, and enjoy your own personal dog-shaped heating pad. It's his favorite job in any season."

30 · Monday · January 2023

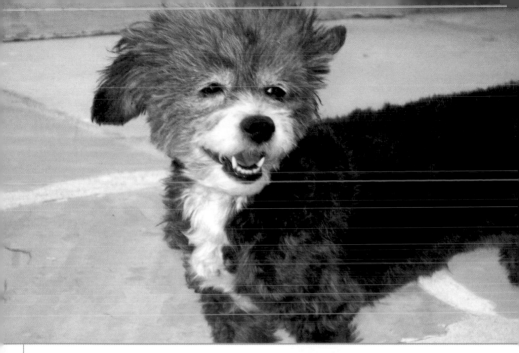

HAPPY ENDINGS In Spanish, buena suerte means "good luck," and it sounds like this sweet mutt has had at least a fair share of it. MADISON was rescued from the streets of Guadalajara, Mexico. Her companion, Linda Gilbert of Phoenix, AZ, says that the mixed breed still understands both Spanish and English. She loves to go for long walks and will do amazing tricks for a piece of chicken—or should we say pollo?

31·Tuesday·January 2023

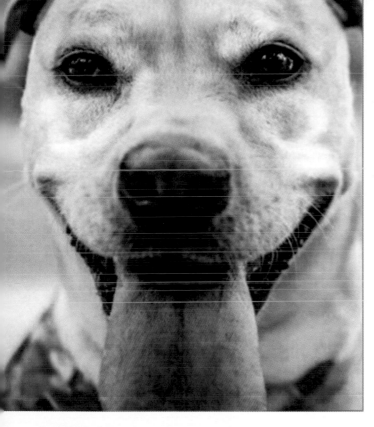

MUTT OF THE MONTH
Julie A. Grimm of
Hagerstown, MD,
explains that BELLA
came into the life of
her family soon after
Julie's oldest son was
diagnosed with brain
cancer. She attests
that since then the
Lab mix has been the
family's strength when
they were weak, their
comfort when they
were sad, and the most
constant and loving
companion imaginable.
In ways that were at
the same time simple
yet profound, Julie
explains, their lives
were forever changed
by this wonderful mutt.

1·Wednesday·February *2023*

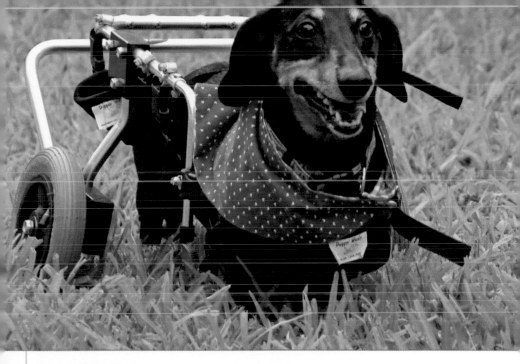

HAPPY ENDINGS If ever there was a Doxie with moxie, it's SNICKERS. The spunky black-and-tan Dachshund injured three discs in his back and had to undergo surgery. He's just as playful as ever, and his companion, Kevin McNamara of Tampa, FL, says that when Snickers is scooting around the yard in his rolling cart "he really flies!"

2·Thursday·February*2023*

PUT A LID ON IT!

Dogs are very susceptible to food poisoning. Kevin Fitzgerald, DVM, a writer for AKC's *Family Dog* magazine, believes that many stomach upsets attributed to a virus or some other factor are actually caused by food poisoning. Foods commonly associated with bacterial infections include milk and dairy products, sausages, gravy, pastry crusts, raw fish, and undercooked meat. There are two clear and simple methods of prevention: Clean out the refrigerator and make sure old food is put into dog-proof receptacles. Although any dog might raid the garbage, the most common canine culprits are puppies, big dogs, and dogs who are accustomed to human food in their diet.

3·Friday·February 2023

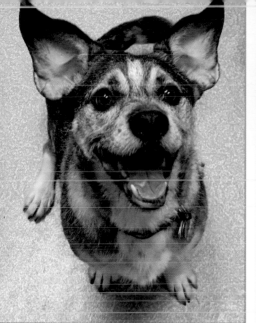

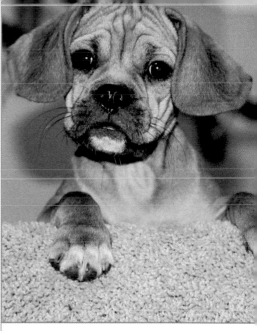

KEEP AN EAR OPEN . . .
FRED (Mixed breed).—
David & Angela Gardner, Renton, WA

4 · Saturday
February *2023*

. . . AND AN EAR TO THE GROUND
MARLEY MANGO (Puggle).—
Sandra Hendrix, Austin, TX

5 · Sunday
February *2023*

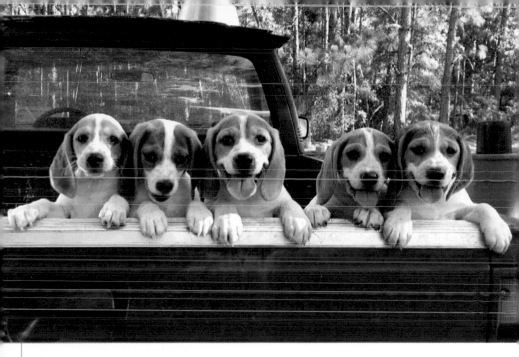

BEAGLES ON BOARD Which way to the doggie drive-up window? These Beagle puppies are members of two litters born within a week of each other. Their breeder, Sharon Stillwell of Windsor, SC, says the hungry pups love to picnic in the pickup.

6 · Monday · February 2023

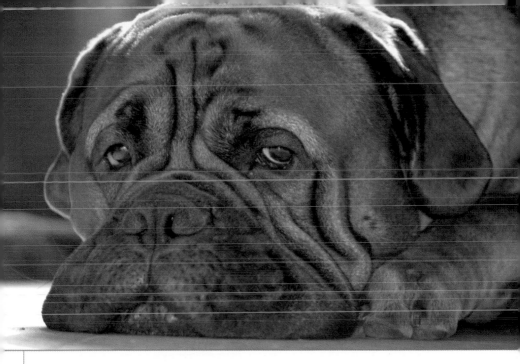

HIGH-PRIORITY POOCH Meet a mellow mastiff who's got his priorities straight: ZEUS loves food and naps, in that order. The 125-pound Bullmastiff is from Mason, OH, where he lives with Brett Ball and enjoys visits from his friends Mini the Pug and Lucy the chocolate Lab.

7·Tuesday·February *2023*

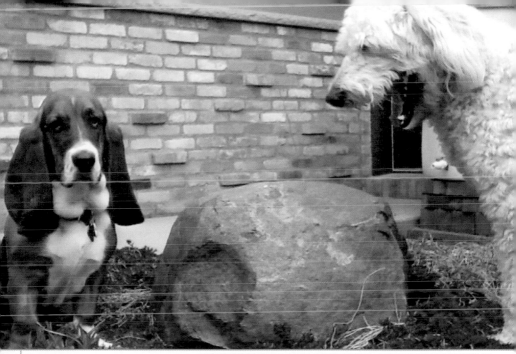

LINCOLN (BASSET HOUND) & BELLA (GOLDENDOODLE).—ROB & LISA CONVERY, OSHKOSH, WI

"**D**ogs do speak, but only to those who know how to listen."

—ORHAN PAMUK

8·**Wednesday**·**February** *2023*

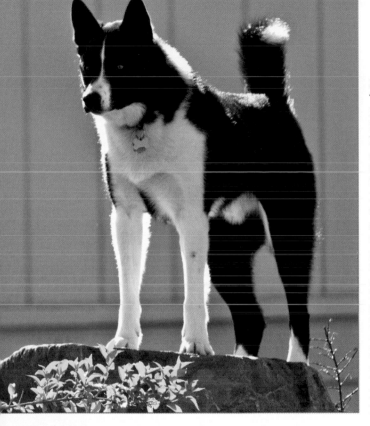

RARE OCCASIONS

The Karelian Bear Dog was developed in Finland and Russia to hunt elk, bear, lynx, and wolf. In the United States, the breed has been recruited by the National Park Service to help keep human and bear encounters to a minimum, thus preventing many bears from having to be put down. MAXX's family, Rod Catalano and Nancy Simat of Moccasin, CA, learned of the breed on a visit to Yosemite National Park, and these days their "KBD" keeps bears and mountain lions away from the livestock on their ranch.

9·Thursday·February 2023

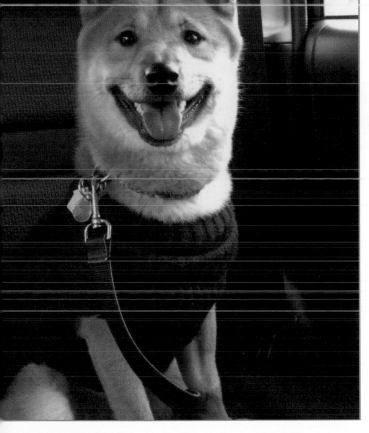

DOG LOVER'S CHALLENGE

There are dogs all over the globe. Name the country of origin of these breeds:

1. Keeshond
2. Golden Retriever
3. Dachshund
4. Shiba Inu
5. Havanese

A. Japan
B. Scotland
C. Holland
D. Cuba
E. Germany

ANSWERS: 1C, 2B, 3E, 4A, 5D

10·Friday·February 2023

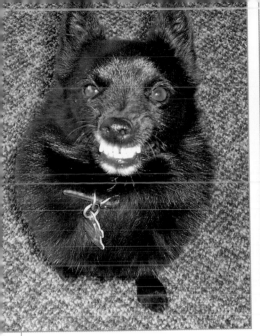

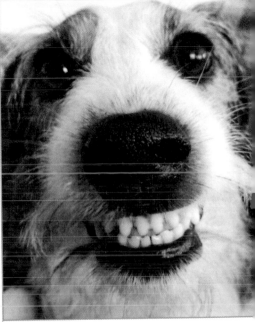

WHO BRUSHES HER TEETH REGULARLY?
Sedona (Schipperke).—
John & Barbara Titus, Apache Junction, AZ

11·Saturday
February 2023

WHO HAS NO CAVITIES?
Buddy (Jack Russell mix).—
J. Marvin Moldowan, Bristow, VA

12·Sunday
February 2023

LINCOLN'S BIRTHDAY

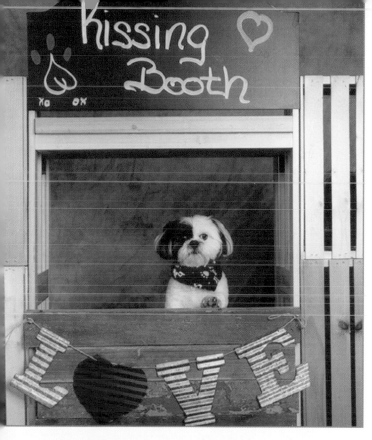

BUSINESS IS BOOMING

MASON was found in a hospital parking lot during a snowstorm in 2011. He was brought to a local humane society and efforts were made to locate his owner, but no one came looking for him. Finally, Jean Burke happened to notice him in the shelter and decided to take him back to her home in Crown Point, IN. Jean writes that the little Shih Tzu is smart, funny, and, above all, loving. She feels that Mason came into her life just when she really needed a lift, and the two live by the motto "Who rescued whom?"

13·Monday·February 2023

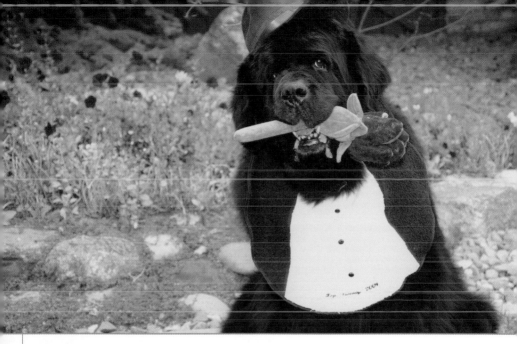

NEWFOUND ROMANCE OLIVER's fallen head over paws in love. Going all out for this romantic holiday, the Newf hopes to impress his valentine with his handsome tux and fedora, and he's even brought her a red rose chew toy. Happy Valentine's Day, Oliver, we're rooting for you! The lovesick Newf lives in Greenwood Village, CO, with Ron and Scarlett Horn.

14·Tuesday·February₂₀₂₃

VALENTINE'S DAY

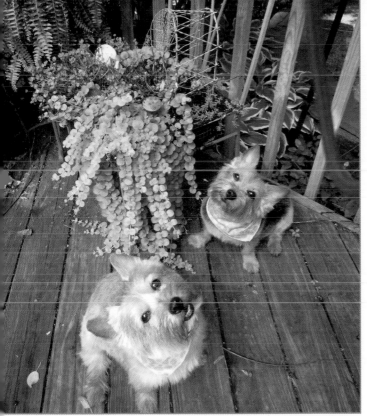

NORWICH TERRIER

• *Origin:* Norwich is a city in East Anglia, a region in England. One of the smallest of all terriers, the Norwich was created as a barnyard ratter; however, he also proved himself robust enough to flush foxes out of their dens during the hunt.

• *Profile:* Prick ears distinguish the Norwich from his close relation the Norfolk Terrier, who has drop ears. His hard, wiry coat comes in various shades of red, wheaten, black and tan, or grizzle. An extremely adaptable companion dog, the Norwich thrives in both town and country environments.

15·Wednesday·February 2023

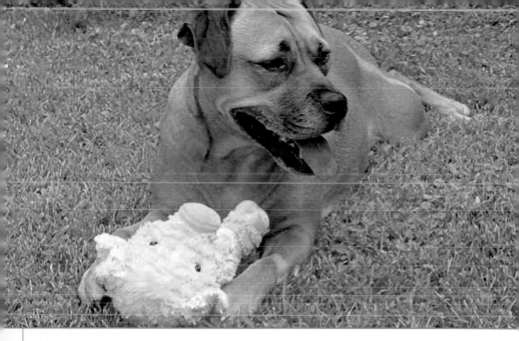

HAPPY ENDINGS A very ill puppy confined to a pound that didn't have the resources to pay for her health care, Boxer/Pit Bull mix Roxy was saved by Michelle Worrell of Virginia Beach, VA.

Michelle remembers that when she first brought Roxy home, the neglected puppy didn't even know what a toy was! These days she has so many toys they can hardly be counted. In fact, she's nicknamed her "Roxy Wiggles" because she greets every visitor at the door, wiggling her entire body and holding a toy in her mouth, ready to play.

16·Thursday·February 2023

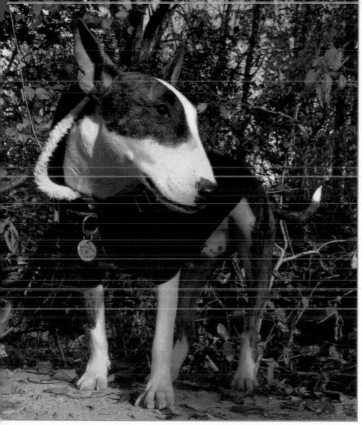

LETTING THE CAT OUT OF THE BAG

Although they themselves might hesitate to fess up to it, several breeds, including the Doberman Pinscher, Airedale Terrier, Old English Sheepdog, Keeshond, and Bull Terrier, have what are called "cat feet." That means that their paws have a shorter third digital bone, resulting in a rounder, more compact foot than other dogs have. It's thought that this design allows dogs to use less energy to lift their feet, thereby increasing their endurance.

17·Friday·February 2023

*LAILAT AL-MIRAJ
BEGINS AT SUNDOWN*

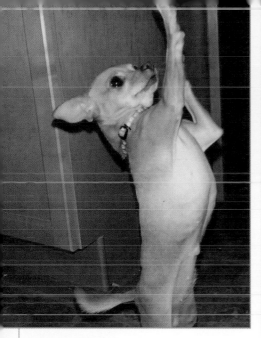

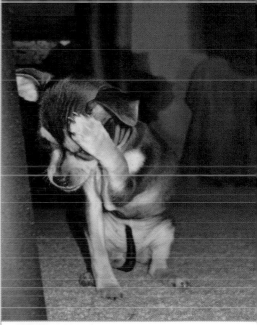

SOOOOOOO BIG
Jolie (Chihuahua).—
Laurel Osorn, Nazareth, PA

18·Saturday
February*2023*

TELL ME IT ISN'T SO!
Carly (Chihuahua).—
Liz Lerie, Levittown, PA

19·Sunday
February*2023*

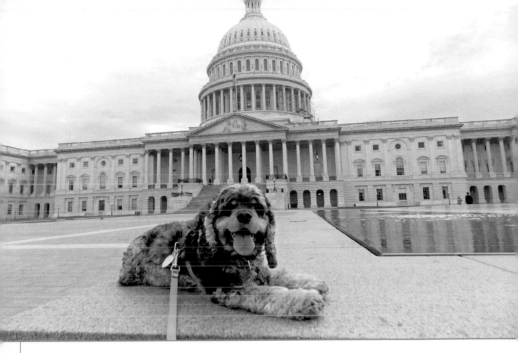

CAPITOL IDEA JENSEN lives in Washington, DC, where he has friends on both sides of the aisle. He and his companion, Mariah Stover, get to take walks around the capital's famous landmarks on a regular basis. The Hill is one of his favorites.

20·Monday·February 2023

PRESIDENTS DAY
FAMILY DAY (CANADA)

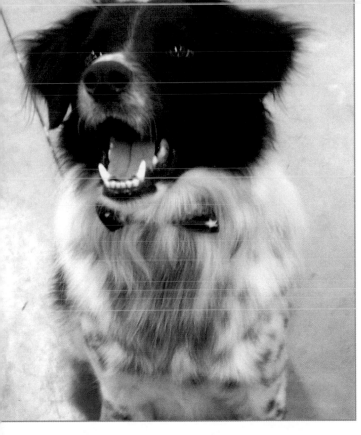

TWO-WAY STREET

Here's a great story about one of the many ways in which dogs and their human friends have been good for each other. BUDDY's life was saved when he was rescued from a shelter by Susan and Gene Allen of Tyler, TX. Late one night some time after he had settled into his new home, the rescued Border Collie mix woke his adoptive family to alert them to the presence of a burglar on their property. The burglar was arrested—and Buddy was a hero!

21·Tuesday·February *2023*

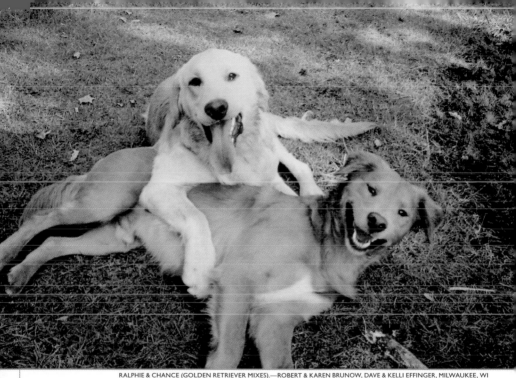

RALPHIE & CHANCE (GOLDEN RETRIEVER MIXES).—ROBERT & KAREN BRUNOW, DAVE & KELLI EFFINGER, MILWAUKEE, WI

"**W**hen we are with our dogs there is no loneliness of spirit. We are connected."

—BAFFIN ISLAND INUIT SAYING

22 · Wednesday · February 2023

WASHINGTON'S
BIRTHDAY
ASH WEDNESDAY

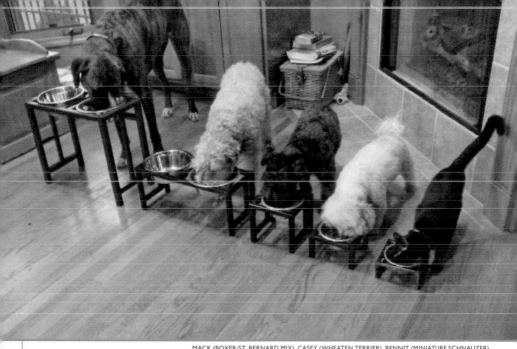

MACK (BOXER/ST. BERNARD MIX), CASEY (WHEATEN TERRIER), BENNIT (MINIATURE SCHNAUZER), CLARA (BICHON FRISE), MORTIMER (BLACK CAT).—MICHELE, JASON, ERIK & RACHEL REIBEL, MCHENRY, IL

MEALTIME WARMUP Sometimes even the pickiest pooches eat more if their food is warmed. Adding warm water to dry dog food softens it and creates an appetizing gravy. Canned food can be put in a bowl and warmed slightly in the microwave. Make sure the food is warm, but not hot, and thoroughly mix it before you serve it.

23·Thursday·February 2023

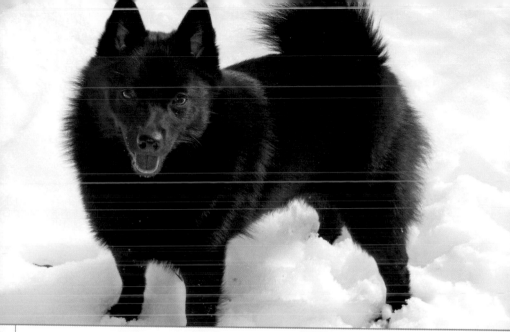

MAISIE (SCHIPPERKE).—GLADYS UNGER, HAGERSTOWN, MD

WHATEVER FLOATS YOUR BARGE Also known as the "barge dog," the Schipperke is a Belgian breed originally created to work on commercial boats that navigated canals. The breed name is Flemish for "little captain." Small (no taller than 13 inches at the withers), quick, and sturdy, with a quiet, almost catlike hunting style, the Schipperke is an ideal vermin-catching machine. A dog show held just for the breed and sponsored by guild workmen of the Grand Palace of Brussels in 1690 is thought to be the very first specialty dog show in history.

24·Friday·February₂₀₂₃

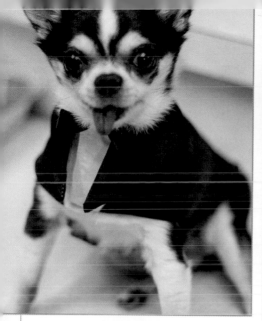

**"CROSS A DOG AND A PLANE AND
YOU GET A JET-SETTER!"**
SQUEAKER (Chihuahua).—
Lisa Budd, Pine Bluff, AR

25·Saturday
February 2023

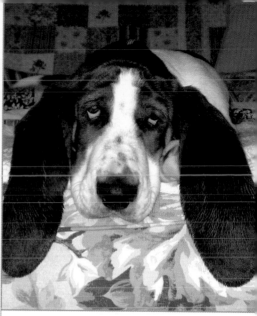

**"NOW I'VE HEARD
EVERYTHING!"**
NEUMANN (Basset Hound).—
Wendy Schneider, Wyandotte, MI

26·Sunday
February 2023

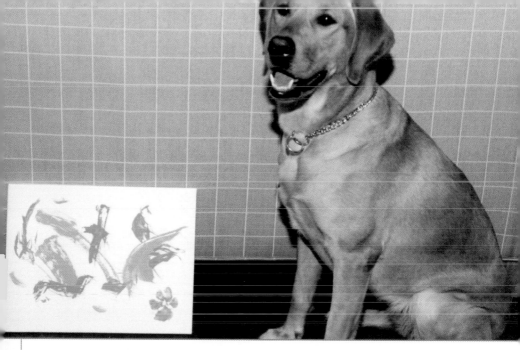

DOUBLE TAKE Artistic ANNA is what's sometimes called a "Goldador," a hybrid mix of Golden and Labrador Retrievers. Her human mom is a teacher who works in a school that encourages the faculty to contribute items for the school's annual fundraising auction. So Anna made this contemporary painting using the classic canine technique of paw-and-tail painting. We think it's a masterpiece! Anna and Jan Williams live in Tampa, FL.

27·Monday·February 2023

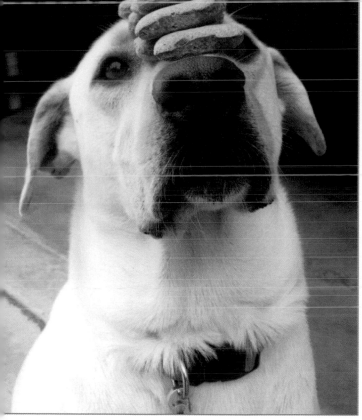

TRAINING TIPS

It's important to make your dog understand that training sessions and play times are different events. Play should be scheduled after rather than before any training sessions. In fact, the best time to hold training sessions is when your dog is both hungry and bored because he'll be more attentive to you and to food rewards. If you choose not to use food for training, use a special toy that appears only during training sessions, not during play.

28·Tuesday·February 2023

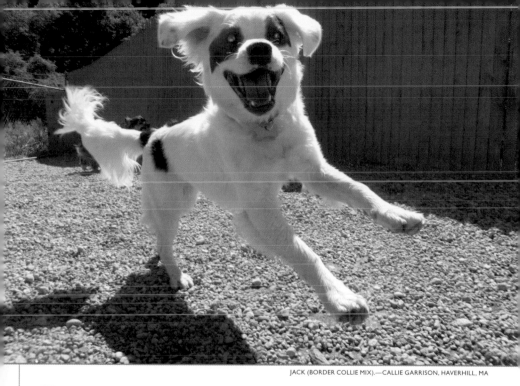

JACK (BORDER COLLIE MIX).—CALLIE GARRISON, HAVERHILL, MA

"**I**f you can't decide between a Shepherd, a Setter, or a Poodle, get them all . . . adopt a mutt!"

—ASPCA Slogan

1·Wednesday·March *2023*

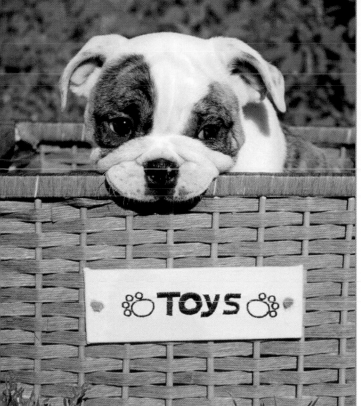

TOYS

IS "ROVER" OVER?

Americans continue to show a preference for giving their dogs names that are traditionally assigned to people rather than pets. The most popular female names today are Bella, Lucy, Daisy, Lola, and Luna. The most popular male names are Max, Charlie, Buddy, Cooper, and Jack.

2·Thursday·March 2023

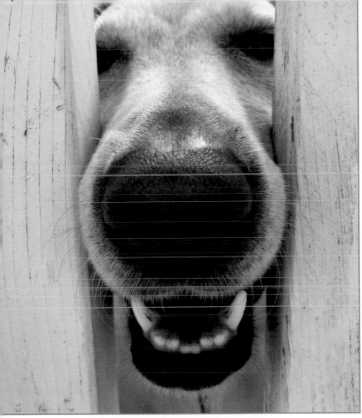

GETTING TO NOSE YOU

One of the reasons we feel so close to our dogs may be that their incredibly acute sense of scent enables them to *smell* our feelings! Dogs' noses are sensitive to the subtlest changes in their humans' body chemistry. They can smell nervousness or anxiety, and they can detect certain illnesses, such as skin melanomas. It's thought that their noses can even inform them that a household member is expecting a baby.

3·Friday·March *2023*

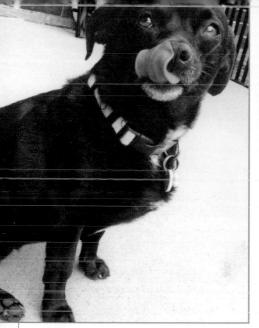

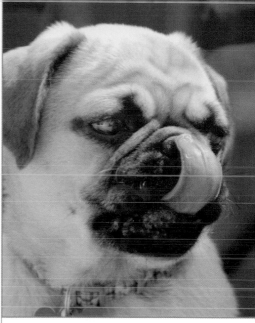

LICKITY SPLIT
GRACIE (Chihuahua mix).—
Stephanie Baxter, Grand Prairie, TX

4·Saturday
March *2023*

GOOD 'TIL THE LAST LICK
TIMBIT (Pug).—Evan Ward,
Tecumseh, Ontario, Canada

5·Sunday
March *2023*

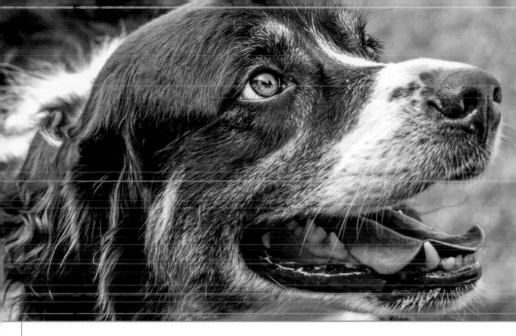

MUTT OF THE MONTH Never one to mince words, Bernese Mountain Dog mix JAX wrote his entry for the Dog Calendar Contest himself. Jax recounted the day when, as a young pup, he was abandoned on the side of the road. Luckily, he was smart enough to locate and adopt a great new owner, Terri Carr of Del City, OK, and these days he's doing just fine. Jax describes himself as loyal, loving, and basically a big teddy bear, and Terri, who helped Jax send in his submission, adds that he gets along well with everyone, dogs and people alike.

6 · Monday · March *2023*

LABOUR DAY (WA AUSTRALIA)

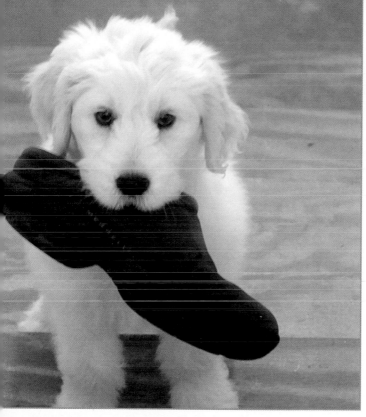

FREAKY FOOTWORK

According to English folklore, when a dog howls you must take the shoe off your left foot, spit on the sole, and place it bottom-up on the ground. Then, you must put your foot down on the spot where you spat. It's believed that this will drive away evil and also make the dog stop howling. Of course, it may be that the dog will stop howling because he's so freaked out by your weird behavior!

7·Tuesday·March 2023

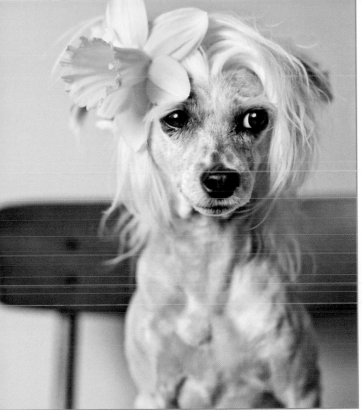

LET ME ENTERTAIN YOU!

Although the breed is still not very well known by the general American public, the Chinese Crested has been steadily building a fan base in the United States since the early 1900s. During the 1950s, the unorthodox, but very popular, entertainer Gypsy Rose Lee became an active devotee and brought much publicity to the toy breed. The Chinese Crested was first registered with the AKC in 1991.

8·Wednesday·March 2023

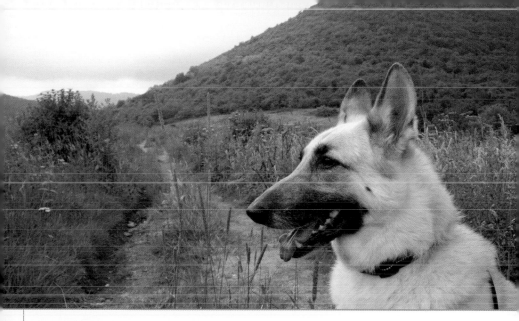

TO THE RESCUE Deemed unadoptable because of her shy and anxious temperament, in 2007, Lady was facing euthanasia at a shelter in eastern North Carolina. Luckily, a volunteer photographer at the shelter saw a great deal of spirit under all her stress and contacted members of German Shepherd Rescue & Adoptions in Raleigh, who agreed to bring Lady into their network. Turns out all Lady really needed was training and TLC: Soon she found both with foster mom Brenda deLaet of Black Mountain, NC. Now Lady lives in a forever home, and Brenda says that the Shepherd's sweet spirit still continues to shine.

9·Thursday·March 2023

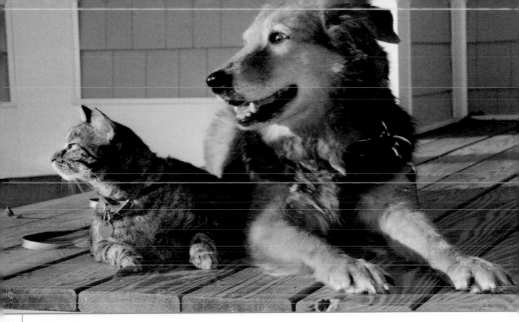

EVERYBODY'S BEST FRIEND In human years, mixed-breed PRINCESS would be well into her eighties. Yet somehow she still acts like a much younger dog, taking brisk morning walks, chasing squirrels, and hanging out with her best friends, like Slugger the cat. Owners Jann and Mike Steele attribute Princess's youthful spirit to healthy food, vitamins, and periodic acupuncture treatments to ward off arthritis. Princess and the Steeles are from Richmond, VA.

10·Friday·March*2023*

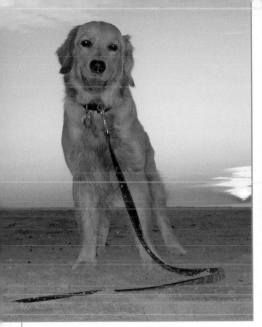

SPRING AHEAD
Joy (Golden Retriever).—
John Cooke, Cape May, NJ

11·Saturday
March <small>2023</small>

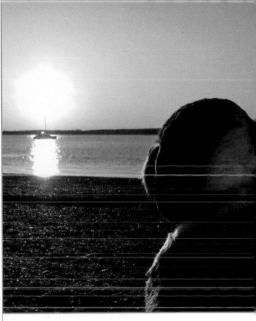

FALL BEHIND
Buddy (English Cocker Spaniel).—
Lara Merceer, Middletown, RI

12·Sunday
March <small>2023</small>

DAYLIGHT SAVING TIME
BEGINS AT 2:00 A.M.
(US & CANADA)

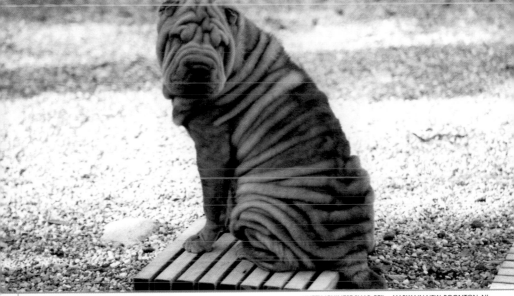

CHINESE SHAR-PEI • *Origin:* The Shar-Pei has been bred in China since the Han dynasty, in approximately 200 BCE. Ancient manuscripts attest to the fact that even his original owners, who trained this powerful dog for guard duty and for hunting large animals such as bears, referred to him, as we do today, as "the wrinkled dog."

• *Profile:* A number of unusual characteristics make the breed unique: his blue-black tongue, his jowly "hippopotamus" foreface, and, more than any other feature, the abundant folds of his grit-textured coat. At home, the Chinese Shar-Pei bestows fierce loyalty on his human family while remaining cautious about other people and animals.

13 · Monday · March 2023

LABOUR DAY (VIC AUSTRALIA)

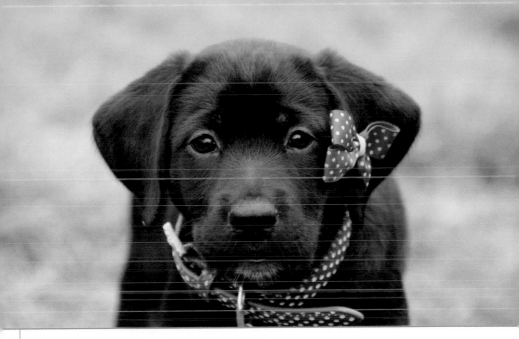

POLKA DOTS AND PUP TENTS As fun-loving and outdoorsy as any Labrador Retriever, CHARLIE likes camping trips, hiking, and horsing around with her older brother, Cedar. But sometimes she likes to get in touch with her feminine side, too. Doesn't she look pretty in her pink polka-dot accoutrements? Charlie's from Victoria, British Columbia, Canada, where she explores the great outdoors with Erin Sawatzki.

14·Tuesday·March₂₀₂₃

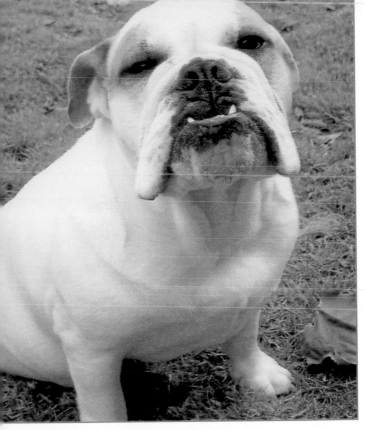

FUNNY BONES

"I want a dog of which I can be proud," said Mrs. Newlyrich. "Does that one have a good pedigree?"

"Oh, yes," declared the kennel owner, "if he could talk, he wouldn't speak to either of us."

—JACOB MORTON BRAUDE

15·Wednesday·March 2023

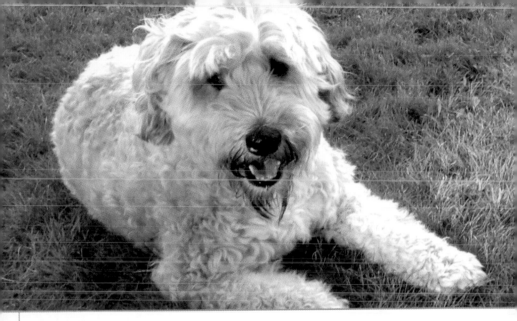

HAPPY ENDINGS Wheaten Terrier STRYKER has Addison's disease (also known as hypoadrenocorticism), a condition in which too little corticosteroid is produced by the adrenal gland. Sometimes difficult to diagnose, Addison's can cause lethargy, anorexia, vomiting, muscle weakness, and, in rare cases, shock and collapse due to the imbalance of electrolytes and metabolism. Luckily, once Addison's disease is properly diagnosed, it can be reliably treated with meds. His family, Sheila and Michelle Knight of Berwick, ME, report that, with his illness well in check, Stryker is the happiest dog they know.

16·Thursday·March *2023*

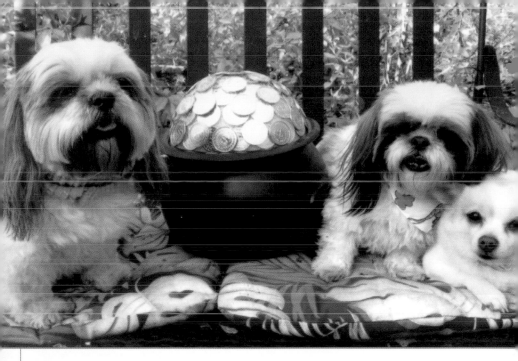

THREE'S THE CHARM A trio of lapdog leprechauns have amassed quite an impressive pot of gold. How many dog biscuits would it buy, they wonder? TESSIE and GINGER are Shih Tzus, and TWINKLE is a Chihuahua. They live with Becky and Myra Herber in Round Rock, TX.

17·Friday·March*2023*

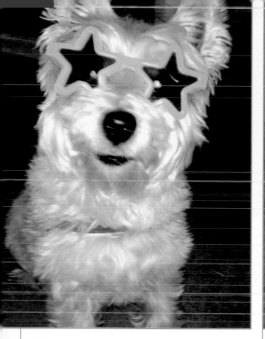

STARGAZING
SKEETER (West Highland White Terrier).—
The Bart Family, Novi, MI

18 · Saturday
March *2023*

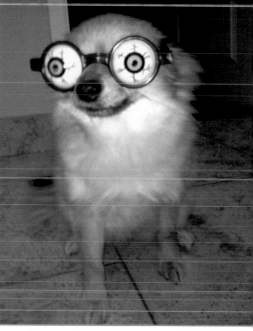

GOOGLE GLASS
MIMI (Pomeranian).—
Sofia-Marie Pinelli, St. Leonard, Quebec, Canada

19 · Sunday
March *2023*

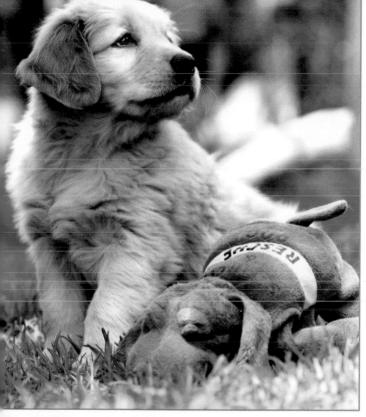

INTO THE WOODS

The AKC's new SAR-W (Search and Rescue in the Wilderness) title acknowledges the work of dogs who use their natural abilities to locate missing people in remote settings. Dogs specialize in tracking, trailing, air scent, water, or avalanche work. To be eligible for SAR-W, a dog must be deployed on at least five missions and be certified by an AKC-recognized club.

20·Monday·March 2023

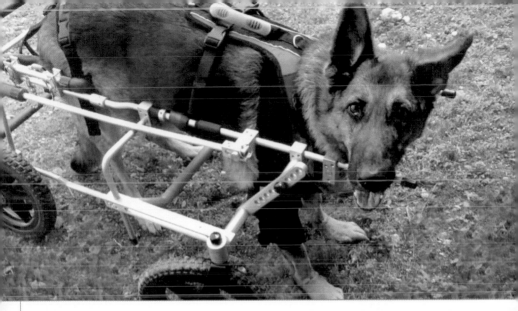

COURAGE TO SPARE After years of abuse at a breeding farm, GABBY was dumped in a high-kill shelter in Florida. Because she had spent the entire first five years of her life locked in a small cage, her legs never developed properly, and she'll spend the rest of it in a wheelchair. Just in time, Gabby came to the attention of Sindi and Don Blanchette, who manage a rescue and rehab center that shelters more than 60 dogs with special needs—dogs who are sick, old, blind, or otherwise disabled. In Gabby's case, the Blanchettes decided to make her their own forever dog right away. Today, the courageous shepherd serves as ambassador for their rescue efforts. She also serves as an example to other dogs that no matter what cruelties have been dealt to them in the past, there's still a chance for happiness in the future.

21·Tuesday·March *2023*

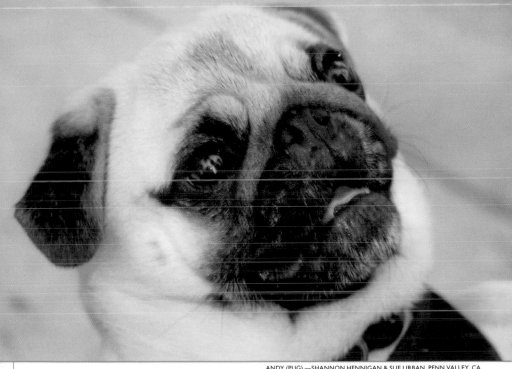

ANDY (PUG).—SHANNON HENNIGAN & SUE URBAN, PENN VALLEY, CA

FUNNY BONES

Q: Why did the dog cross the road?

A: To get to the barking lot.

22·Wednesday·March 2023

RAMADAN
BEGINS AT SUNDOWN

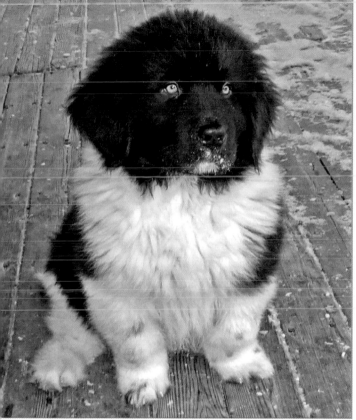

THE NEW NAME GAME

A survey conducted by Rover.com highlights some interesting trends in the way Americans have been naming their dogs. Names based on coffee—such as Kona, Espresso, and Mocha—are on the decline (except in Seattle, the home base of Starbucks), while names based on alcohol products—like Brandy, Whisky, and Guinness—are on the rise. Names based on health foods—like Peaches, Mango, and Tofu—are decreasing, while names inspired by powerful women—such as Coco Chanel, Beyoncé, or Eleanor Roosevelt—are on the rise. Many of us are naming our dogs with the names of other animals, and the most popular ones are Bear, Moose, and Tiger.

23·Thursday·March *2023*

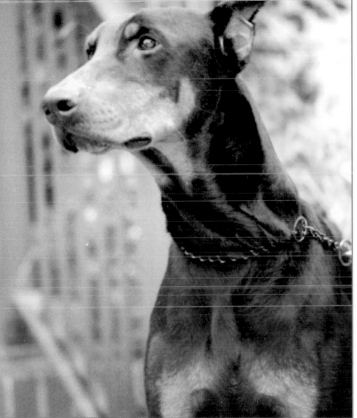

CASH-AND-CARRY

The Doberman Pinscher was first bred during the late 19th century by Louis Doberman, a German tax collector who wanted to develop a dog smart and tough enough to accompany him when he collected cash in dangerous neighborhoods. The breed was an instant success in Europe and soon in North America, too. During the 20th century, the Dobie became America's favorite "macho" dog, resulting in unscrupulous breeding and overly aggressive dogs. Fortunately, the fad for the breed has died down, and these days Dobies from reputable breeders make peaceful and wonderful family companions.

24·Friday·March *2023*

WHEN ALL AT ONCE I SAW A CROWD
STELLA (Flat-Coated Retriever/Black and Tan Coonhound mix).—Gary & Dana Cestone, Pompton Plains, NJ

25·Saturday
March *2023*

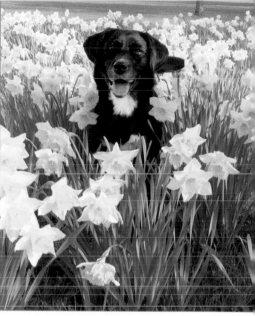

A HOST, OF GOLDEN DAFFODILS
MOLLIE (Labrador/Collie mix).— Giles Austin, Bracknell, Berkshire, United Kingdom

26·Sunday
March *2023*

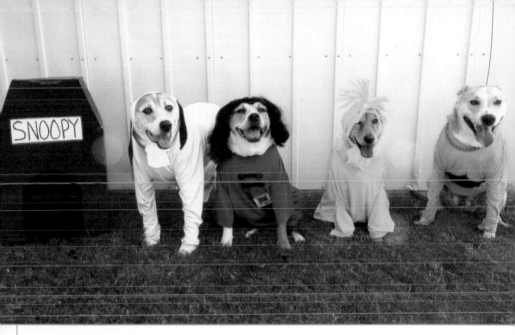

HAPPINESS IS A WARM RESCUE DOG Smile if you love *Peanuts*! BANDIT (Snoopy), BAILEY (Lucy), WILLOW (Woodstock), and SCOUT (Charlie Brown) are all mixed breeds rescued by Annette Kost of El Paso, TX. Annette tells us the whole gang dresses up each year for holiday fun. We think these costumes are especially great.

27·Monday·March 2023

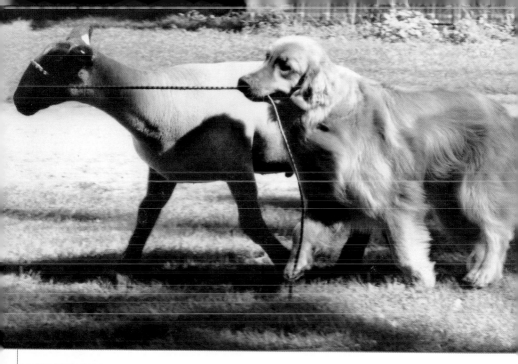

BEST FRIENDS Who's walking ewe? Golden Retriever Roscoe graduated at the top of his basic training class, so he knows how to walk without pulling. He helps some of his friends work on their leash-walking skills, too. Roscoe and his woolly pal are from Montello, WI, where they live with the Coddington family.

28·Tuesday·March*2023*

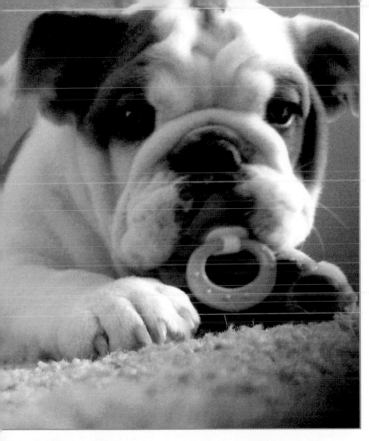

"**T**he best way to get a puppy is to beg for a baby brother—and they'll settle for a puppy every time."

—WINSTON PENDLETON

29·Wednesday·March 2023

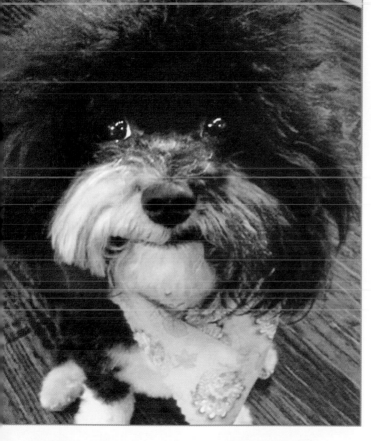

THE DOG WHO SWALLOWED THE CANARY

Lyle and Toni Wilson of Sunnyvale, TX, admit that LUCY has a mischievous side. Come to think of it, it does look as if the tight-lipped Havanese might know something that we don't. In any case, we think that yellow bandanna looks great on this impish little bandita.

30·Thursday·March₂₀₂₃

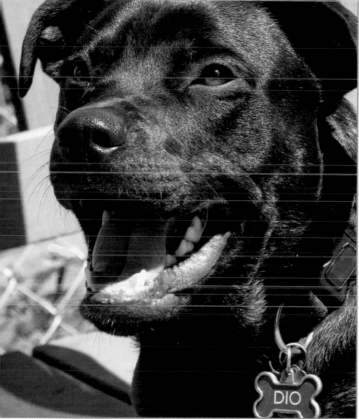

THE PIT PARADE

In addition to a spot on the A-list, each of these high-profile dog lovers shares one thing—they all live with or have lived with a Pit Bull: Jennifer Aniston, Katherine Heigl, Alicia Silverstone, Marc Jacobs, Rachael Ray, Josh Hutcherson, Adrian Grenier, Norman Reedus, Betty White, Liam Hemsworth, and Cesar Millan.

31·Friday·March *2023*

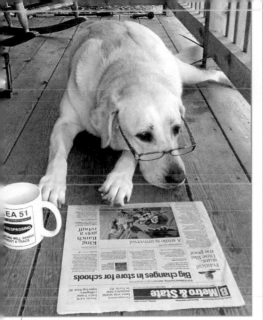

NOSE FOR NEWS
RUBY (Labrador Retriever).—
Sarah Brown & Mike Arduini,
Austin, TX

1·Saturday
April2023

WHAT'S A THREE-LETTER WORD FOR UNCONDITIONAL LOVE?
CASEY (Golden Retriever).—
Vardry Landrum, Ridgeland, MS

2·Sunday
April2023

PALM SUNDAY

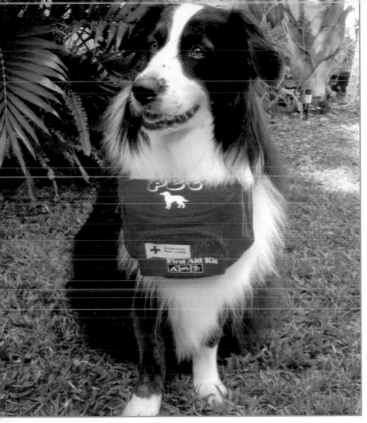

READY AND ABLE
With her pet first-aid kit at the ready, HOLLY reminds us that April is Pet First Aid Awareness Month for the American Red Cross. Kathy May of Jupiter, FL, writes that the Australian Shepherd loves anything that takes place outdoors—boating, hanging out at the beach, playing with neighborhood friends, and, of course, helping out whenever she can.

3·Monday·April 2023

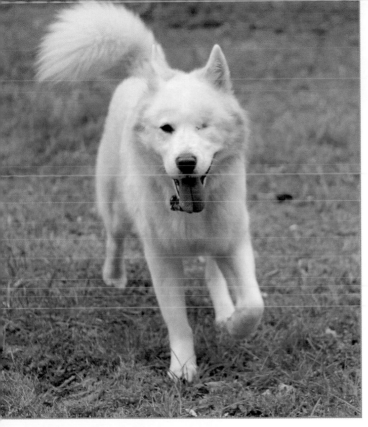

MUTT OF THE MONTH

When rescuers found ASPYNN in North Carolina, her left eye was severely injured. Even though doctors had to remove the eye, Lyncee Kowalcik of Knoxville, TN, says the Siberian Husky mix hasn't let her disability slow her down one bit. Lyncee says Aspynn loves to run, snuggle, and eat cheese, but not necessarily in that order.

4·Tuesday·April 2023

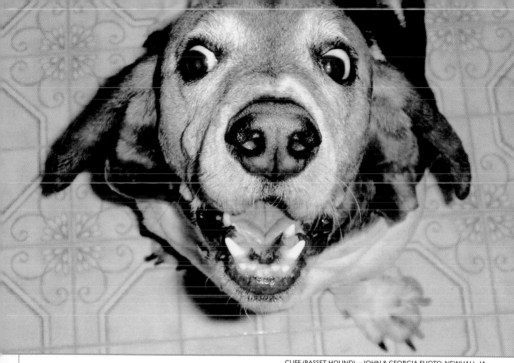

CLIFF (BASSET HOUND).—JOHN & GEORGIA FUOTO, NEWHALL, IA

"**T**he usual dog about the Town
Is much inclined to play the clown."

—T. S. Eliot, *Old Possum's Book of Practical Cats*

5·Wednesday·April 2023

PASSOVER BEGINS AT SUNDOWN

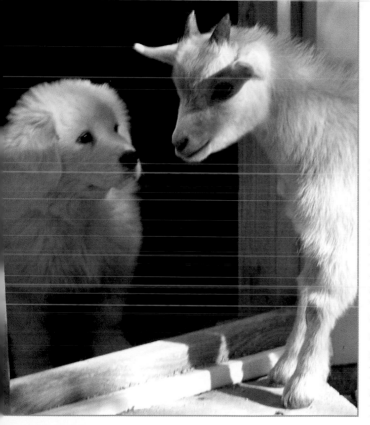

BEST FRIENDS
Have you *herd*? A Great Pyrenees pup named STELLA, who hopes to grow up to be a reliable herding dog, gets a few tips from a new pal. Stella and the billy goat live with Danny and Amy Price in Parsons, TN.

6·Thursday·April₂₀₂₃

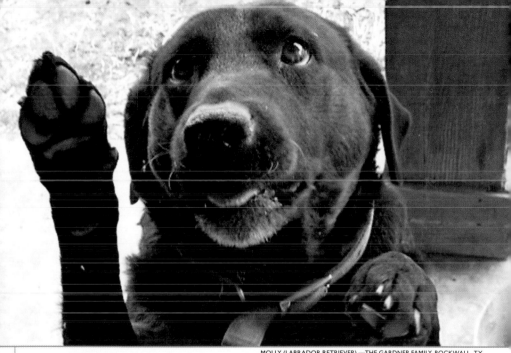

MOLLY (LABRADOR RETRIEVER).—THE GARDNER FAMILY, ROCKWALL, TX

NAILED IT! Instead of waiting for your dog's nails to grow long, trim them often, every two to four weeks or so depending on their growth. Clip off a small amount and keep them short. As nails grow longer, the blood supply grows out as well, making them more difficult to trim.

7·Friday·April 2023

GOOD FRIDAY

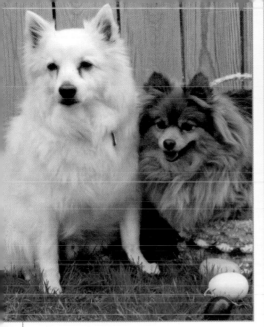

PUTTING ALL THEIR EGGS . . .
KASPER (American Eskimo Dog) &
KOKO (Pomeranian).—
Dan and Rita Vetsch, Monticello, MN

8·Saturday
April*2023*

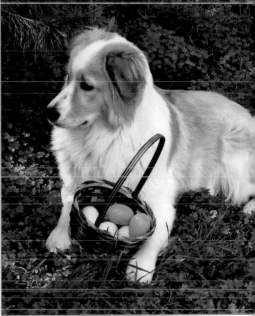

. . . IN ONE BASKET
MOLLY LOU (Mixed breed).—
Hank and Gerri Johnson,
Escondido, CA

9·Sunday
April*2023*

EASTER

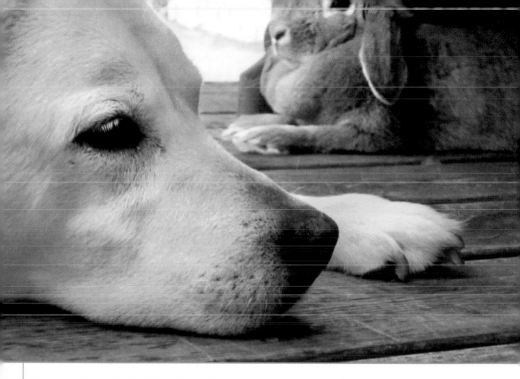

EVERYBODY'S BEST FRIEND Too pooped to hop! Yellow Labrador Darma and her lop-eared pal Tilly chill out after a playdate on the bunny trail. They're from Bolton, Ontario, Canada, and their caretaker is Jill Esposito.

10·Monday·April ₂₀₂₃

*EASTER MONDAY BANK HOLIDAY
(ENG., WALES, N. IRE., AUSTRAL., NZ)*

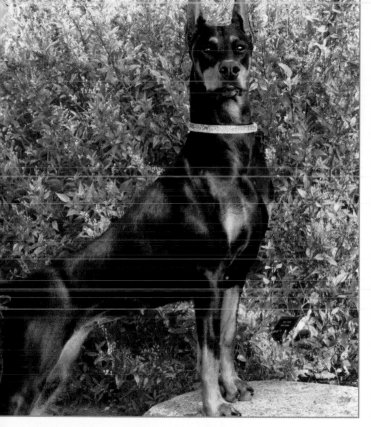

OVERACHIEVER
We get tired just thinking about following this active Doberman Pinscher around for a day. BINDI stays busy with agility, lure coursing, barn hunt, and conformation competition; she's also a certified therapy dog and fits in frequent visits to schools and nursing homes. Bindi's companion, Jan Knode of Wooster, OH, tries to keep up with her as best she can.

11·Tuesday·April *2023*

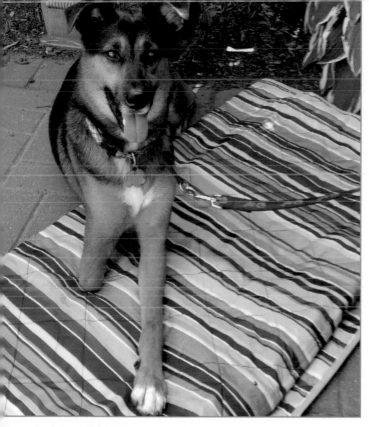

HAPPY ENDINGS

Good-looking TONTO was rescued by Dean and Kim Urban of Ronkonkoma, NY. The Urbans write that the Shepherd mix loves to play and enjoys life to the max. They add that even though Tonto's got only three and a half legs, he runs as though he has five.

12·Wednesday·April *2023*

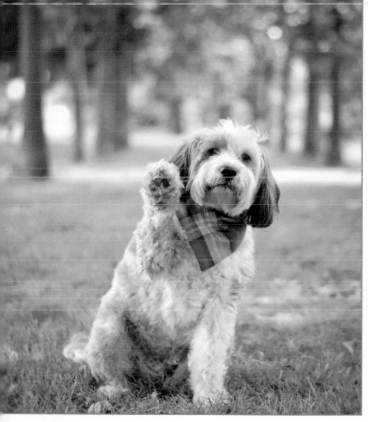

"AH, FUDGE!"

A handsome Tibetan Terrier with the sweet name FUDGE is eager to show us one of the hallmarks of his ancient breed: Large, flat "snowshoe" feet enabled these remarkable dogs to traverse the snowy terrain of their mountainous environment. Fudge lives far from Tibet in Runcorn, England, but his owner, Eleanor Williams, reports that he's an extremely adventurous soul who loves to explore beaches, woodlands, and, of course, mountains.

13·Thursday·April *2023*

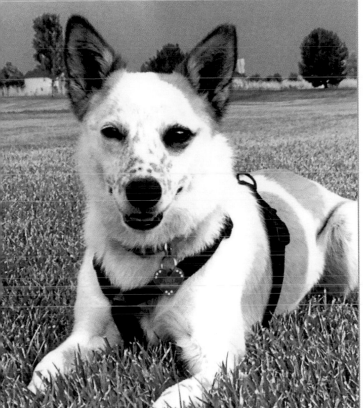

TO THE RESCUE

You never know when or where a rainbow is going to appear. Jen Moody of Firestone, CO, tells us that it took her five years to recover from the loss of her previous Australian Cattle Dog. Finally, after searching for the right dog for some time, she found JUSSY at the Longmont Humane Society. The Australian Cattle Dog/Whippet mix had been born in Mexico and shuffled through three shelters before she was a year old. Jen says Jussy's still working through some fear and anxiety issues, but she's made a commitment to look after her for the rest of her life. And by the way, Jen explains that the name *Jussy* is "Jesse" with an Australian accent.

14 · Friday · April *2023*

ROAD TRIP
JOCKO (Border Collie).—
Alex Todd, Rochester, MN

15·Saturday
April 2023

SCENIC HIGHWAY
JENNA & J. J. (Shelties).—
Deborah A. Jones, Boyertown, PA

16·Sunday
April 2023

ORTHODOX EASTER

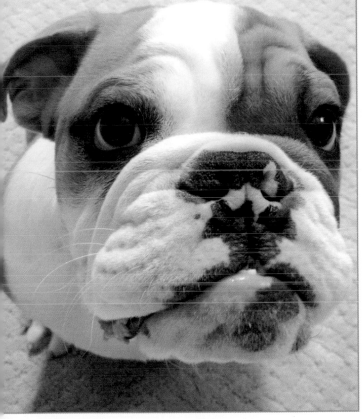

FINE WHINE

Almost all dogs whine. They whine to gain attention, when they are frightened or hurt, or when they are frustrated. For wild dogs, whining is limited to puppyhood; domestic dogs, however, whine throughout their adult lives. In other words, dogs have learned that whining is a very effective way to get something they want.

17·Monday·April *2023*

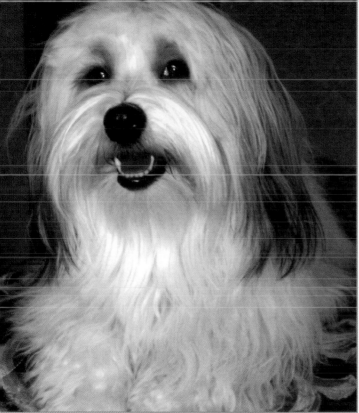

SOFT AND SILKY

The Havanese is the national dog of Cuba and the only breed native to that island country. At one time, this charming breed was also called the Silk Dog or the Spanish Silk Poodle, in reference to its soft coat. Although its popularity in the United States is a relatively new phenomenon, the Havanese has been in existence for hundreds of years. Queen Victoria of England and Charles Dickens both owned one.

18·Tuesday·April*2023*

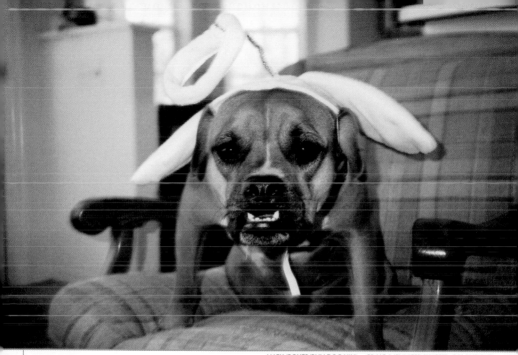

LUCY (BOXER/BULLDOG MIX).—CRAIG & JENNIFER SHAFFER, ORLANDO, FL

"**D**ogs are us, only innocent."

—Cynthia Heimel

19·Wednesday·April 2023

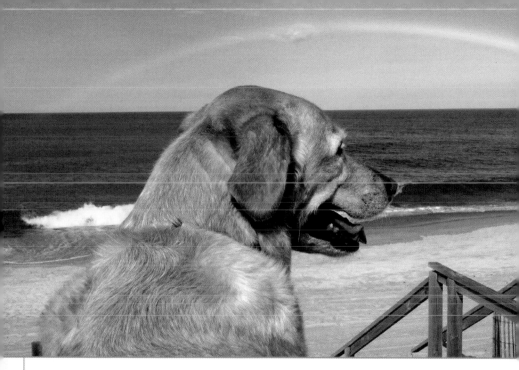

A RETRIEVER OVER THE RAINBOW Elizabeth and Bryan Compton of Mechanicsville, VA, got LUCY when she was eight weeks old. The Lab mix's mother had been rescued from a shelter just one day before she was to be euthanized, and Lucy and her siblings were born in a foster home. Lucy still loves the beach more than anyplace; she can sit watching the waves roll in for hours.

20·Thursday·April 2023

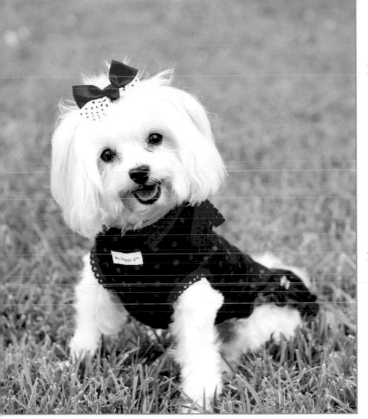

MINI-ME MUTTS?

If you consider your dog to be your perfect soul mate, you're not alone. According to a survey conducted by Natural Balance Canine Pet Foods, humans tend to choose dogs whose personalities are just like their own. Thus, people who are extroverted tend to own dogs with outgoing or "in-your-face" personalities, while introverted people usually have dogs who are more withdrawn and cautious.

21·Friday·April *2023*

EID AL-FITR BEGINS AT SUNDOWN

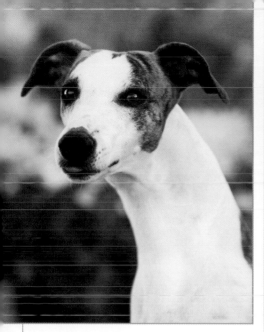

FROLICKING IN THE FIELD
WESLEY (Whippet).—
Melissa Durbin, Louisville, KY

22·Saturday
April *2023*

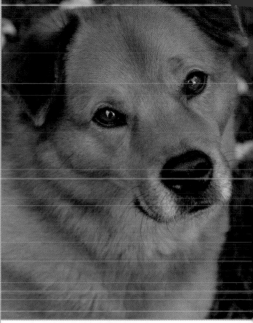

LAZING ON THE LAWN
KODIAK BEAR (Chow Chow mix).—
Halley Brown, Salem, OR

23·Sunday
April *2023*

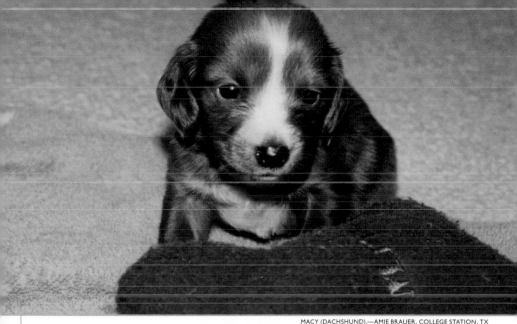

MACY (DACHSHUND).—AMIE BRAUER, COLLEGE STATION, TX

FRESH START There's nothing quite like puppy breath, and science even offers a detailed explanation as to why it smells so good. Puppy breath is a combination of pheromones, the odiferous and biologically important hormones that nature has designed to bond a pup with his mother, and the scent of lactose in his mom's milk. Unfortunately, puppy breath doesn't last long—usually from four weeks to eight weeks at most.

24 · Monday · April 2023

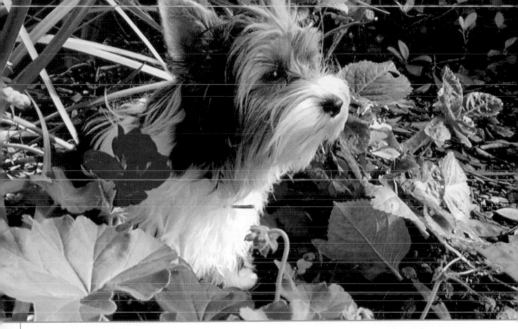

RARE OCCASIONS The Biewer Terrier, aka the Biewer Yorkshire Terrier a la Pom Pon, is a fairly new breed recognized by the American Rare Breed Association. Developed in the 1980s in Germany by Werner and Gertrud Biewer, the breed's foundation was a litter of Yorkshire Terrier pups who had a large proportion of white coloring in their coats, unusual for Yorkies. COLT, a Biewer pup, lives with Brian and Lindsay King in Auburndale, FL, where his favorite game is chasing lizards.

25·Tuesday·April 2023

ANZAC DAY
(AUSTRALIA & NEW ZEALAND)

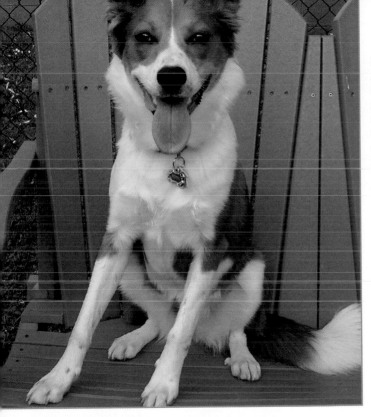

HAPPY ENDINGS

Abandoned at a shelter in Texas, suffering from a severe case of mange, and one day away from being euthanized, SOPHIE was rescued in the nick of time by a foster family, who nursed her back to health. After making the long trip from Texas to a shelter in New York, the Border Collie mix found a forever home with Mollie Gray of East Syracuse. Mollie was surprised to learn that this once homeless little pup was actually quite intelligent, curious, and affectionate. Mollie says Sophie loves going on nature hikes, especially when there's snow.

26 · Wednesday · April *2023*

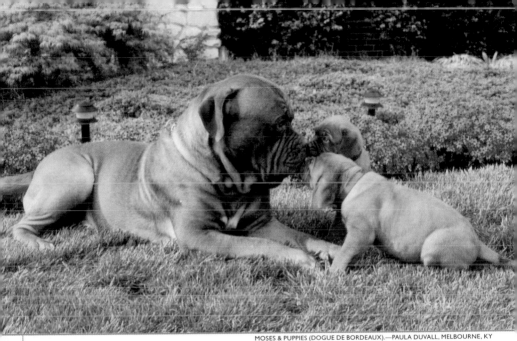

MOSES & PUPPIES (DOGUE DE BORDEAUX).—PAULA DUVALL, MELBOURNE, KY

PUPPY CATCH-22 It's important to socialize your pup at a very early age. But it's equally important to protect your pup from exposure to communicable canine diseases until she's fully vaccinated. To be safe, allow your puppy to socialize only if you are absolutely certain that her pals are current on their shots. In other words, a playdate with dogs owned by a known friend is okay, but hanging out at a dog park is not.

27·Thursday·April *2023*

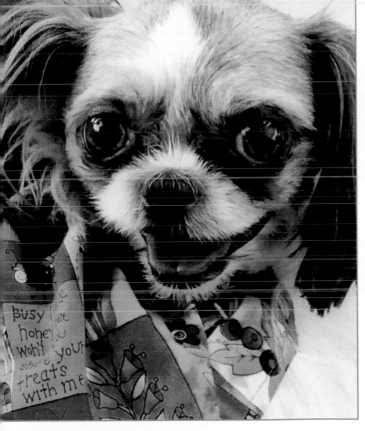

MADE IN MILWAUKEE

CINDERS is a Mi-Ki, a hybrid mix of Shih Tzu, Papillon, Maltese, and Japanese Chin that was developed in Milwaukee, WI, during the 1980s and officially recognized by the United Kennel Club in 2016. Fans report Mi-Kis to be smart gentle, quiet, and nonshedding. Sally Klupar, who lives with Cinders in Buffalo, Grove, IL, says that the breed makes "wonderful companions."

28·Friday·April 2023

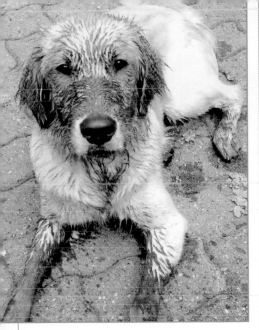

THERE'S MUD IN YOUR EYE
CHARLIE (Golden Retriever).—
Debra Stickney, Woodbury, MN

29·Saturday
April 2023

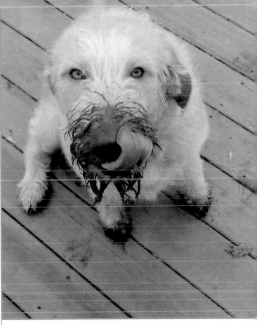

MUD IS THICKER THAN WATER
MAJOR (Labradoodle).—
Renee Matt, Rome, NY

30·Sunday
April 2023

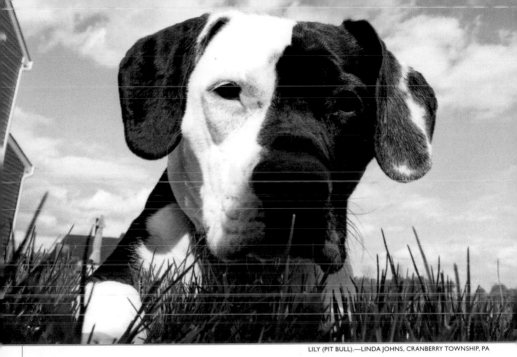

LILY (PIT BULL).—LINDA JOHNS, CRANBERRY TOWNSHIP, PA

COLOR CALLS Dog fanciers use innumerable names to describe their dogs' coats. Here are just a few: Wheaten is the color of ripening wheat, pale yellow to fawn; roan is a fine mixture of colored and white hairs; parti-color refers to a coat pattern consisting of at least two patches of different colors.

1·Monday·May 2023

BANK HOLIDAY (UNITED KINGDOM)
LABOUR DAY (QLD AUSTRALIA)

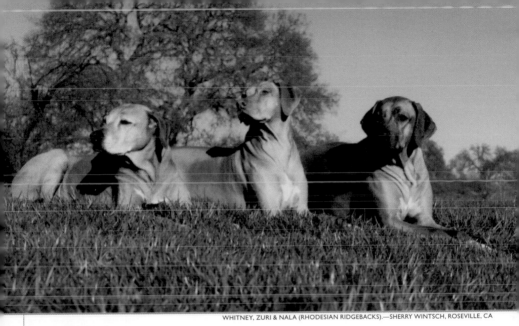

WHITNEY, ZURI & NALA (RHODESIAN RIDGEBACKS).—SHERRY WINTSCH, ROSEVILLE, CA

DOG LOVER'S CHALLENGE
Can you match the hardworking dog with his original job?

1. Dachshund
2. Newfoundland
3. Rottweiler
4. Rhodesian Ridgeback
5. Keeshond

A. Hunting lions
B. Pulling produce carts
C. Guarding barges
D. Hunting badgers
E. Hauling fish nets

ANSWERS:
1D, 2E, 3B, 4A, 5C

2·Tuesday·May *2023*

HAPPY ENDINGS Mark and Carmel Peppler of Mackinaw City, MI, remember that after the passing of one of their beloved dogs, their other pup, Junior, seemed just as despondent as they were. That was until a new dog, JERRY, entered their lives. Just looking at his bright and cheerful face, we're not surprised to hear that the tiny Pomeranian helped both the Pepplers and Junior overcome their sadness and move on.

3·Wednesday·May 2023

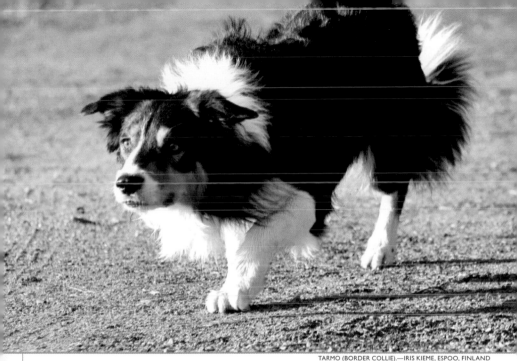

TARMO (BORDER COLLIE).—IRIS KIEME, ESPOO, FINLAND

TASTE TEST Compared to a human's, a dog's sense of taste is quite limited. This is a logical product of their evolution: The ancestors of man were vegetarian primates who took time to pick and choose from a wide range of stationary foods; dogs, on the other hand, were carnivores who spotted their prey at a distance and needed to eat what they caught.

4·Thursday·May 2023

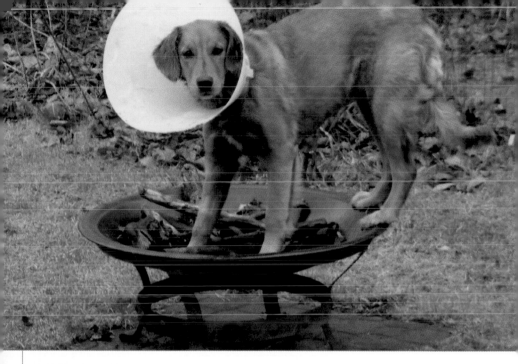

IN THE HOT SEAT Who else would retrieve sticks from the fire pit? EMMA is a genuine Golden goofball, and even the dreaded Elizabethan collar she had to wear after being spayed didn't interfere with her fun. The pup lives in Oshkosh, WI, with her family, James M. and Margaret A. Frey.

5·Friday·May 2023

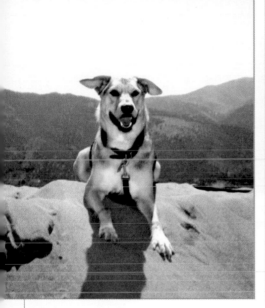

SITTING ON TOP . . .
ILOW (Beagle/Shepherd mix).—
Amelia & Peter Colarco, College Park, MD

6·Saturday
May *2023*

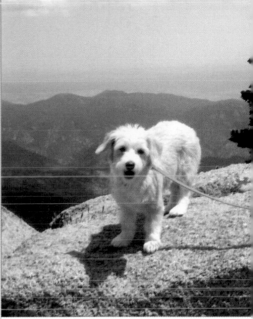

. . . OF THE WORLD
GEORGIE (Corgi/Bichon mix).—
Jean Talker, Geneva, IN

7·Sunday
May *2023*

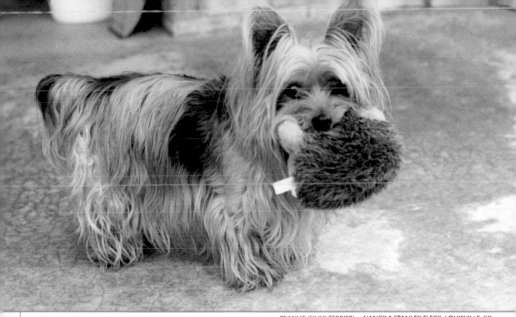

PEANUT (SILKY TERRIER).—NANCY & STANLEY FLECK, LOUISVILLE, KY

SILKY TERRIER • *Origin:* Australia, where the breed was developed at the turn of the 20th century by crossing native terriers with Yorkshire Terriers imported from England. She was originally known as the Sydney Silky Terrier.

• *Profile:* Sometimes confused with the Yorkie, the Silky Terrier is a larger dog whose soft, glossy coat comes in a broader range of colors, including black, cream, and fawn. The coat is long without touching the floor, and it is parted down the middle from her head to the root of her tail. The Silky's personality is pure terrier: confident, curious, and fun-loving.

8 · Monday · May *2023*

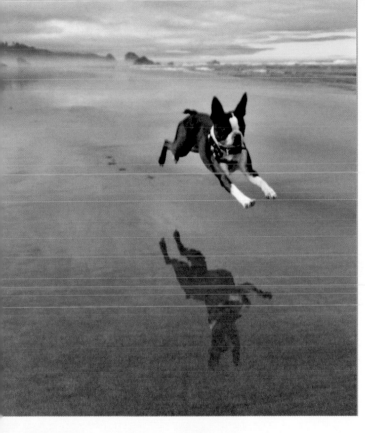

BOSTON BOUND

MIA is a Boston Terrier whose passion is long walks—and runs—on the beach. She lives with Emily Cheney on the West Coast in Redmond, WA, but hopes someday to travel to the East Coast and explore the city her breed was named for.

9·Tuesday·May *2023*

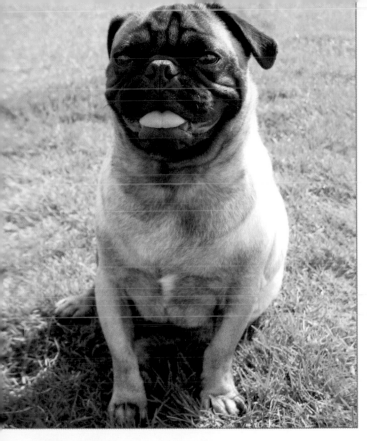

"**T**he pug is living proof that God has a sense of humor."

—Margo Kaufman

10·Wednesday·May 2023

30 Wednesday・May

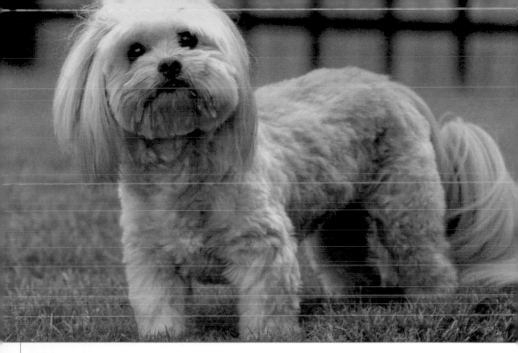

LHASA ON THE LOOKOUT Even though they're not very large, Lhasa Apsos once served as guards, responsible for alerting Himalayan monks to any strange goings-on in their monastic homes. According to Elizabeth Britt of Loganville, GA, her Lhasa BELLE shares her ancestors' diligent sense of watchfulness, so no one gets into her driveway or backyard without Elizabeth knowing about it. Lhasas come in 13 different colors; Belle's coat is the lovely red-gold variety.

11·Thursday·May*2023*

TRAINING TIP

Here's a tip with strings attached. To help develop a dog's ability to reason, the AKC suggests playing the following game. Tie a string or ribbon around a treat, then hide the treat under a pillow or a piece of furniture. Put the treat itself out of sight and reach of your dog's mouth or paw, but leave the string out in the open. While you encourage him with verbal praise, see how long it takes your dog to figure out that tugging the string results in scoring a treat. Next time, play the game the same way but use a different treat hidden in a different location.

12·Friday·May 2023

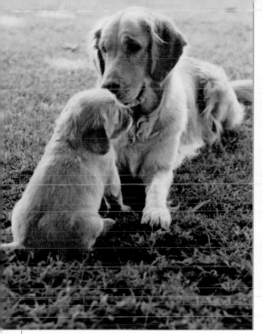

MAMA'S BOY
MOLLY (Golden Retriever) and her pup.—
Mrs. Paul Carr, Winchester, TN

13·Saturday
May 2023

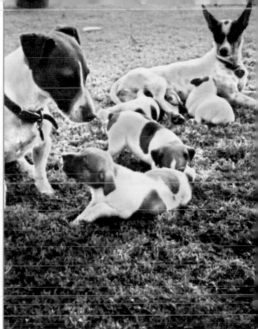

FAMILY OUTING
FIEST (Rat Terrier) & HARRY
(Jack Russell Terrier) and their pups.—
Ronnie Claire Edwards, Los Angeles, CA

14·Sunday
May 2023

MOTHER'S DAY

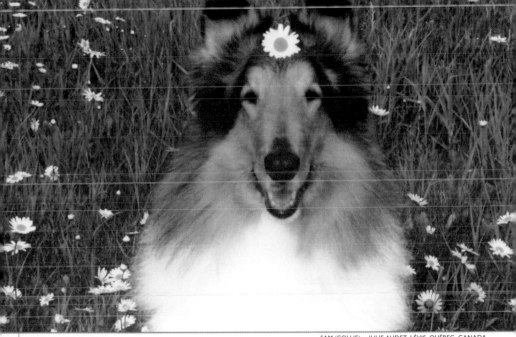

SAM (COLLIE).—JULIE AUDET, LÉVIS, QUÉBEC, CANADA

COLLIE CELEBS Achieving true star status during the middle of the 20th century, between the release of the 1942 film *Lassie Come Home* and the airing of the popular TV show *Lassie*, the Collie has had some high-profile support in its rise to fame. In the 1860s, English Queen Victoria fell in love with the breed in Scotland and created a "Collie Court" within her own kennels. Later, American captain of industry J. P. Morgan purchased an English champion Collie and opened the famous Cragston Kennels on the Hudson River in New York.

15 · Monday · May 2023

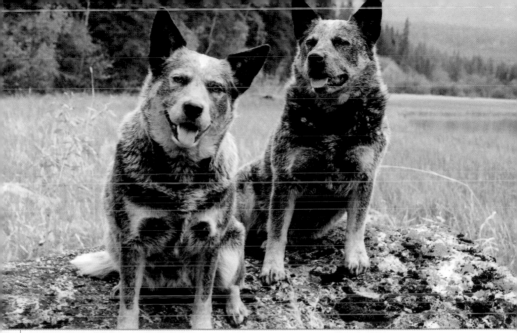

SINI & BUZZ (AUSTRALIAN CATTLE DOGS).—KIM KERR, CALGARY, ALBERTA, CANADA

COLORFUL CATTLE DOG The Australian Cattle Dog was developed with his ability to work, not his appearance, in mind. Yet the coloration of this hardworking dog also happens to be one of the handsomest of all breeds. A Cattle Dog's coat may be one of five colors: blue, blue speckled, blue mottled, red speckled, or red mottled, with black, tan, or red markings on the head and legs. The breed's unique coloration is due to the well-documented fact that the Dalmatian, with his spotted coat, figures prominently in his background.

16·Tuesday·May*2023*

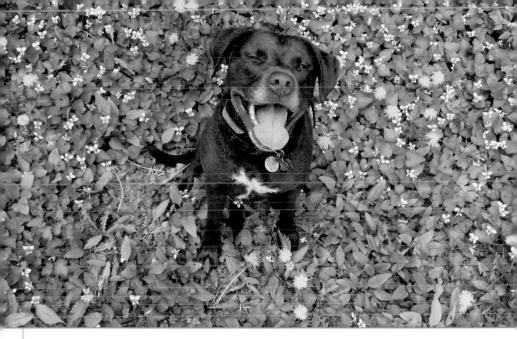

HAPPY ENDINGS BROWNIE was the runt of an unplanned litter. During her youth she suffered fearfulness and separation anxiety, and tended to avoid human contact, even with her original family. But when the shy American Staffordshire/Labrador mix met Brandi Kelley, she climbed right onto her lap and requested a belly rub. Since then Brownie and Brandi have been inseparable friends. They live in Madison, WI, work together as ambassadors for bully breeds, and support animal therapy for humans with mental disabilities.

17·Wednesday·May *2023*

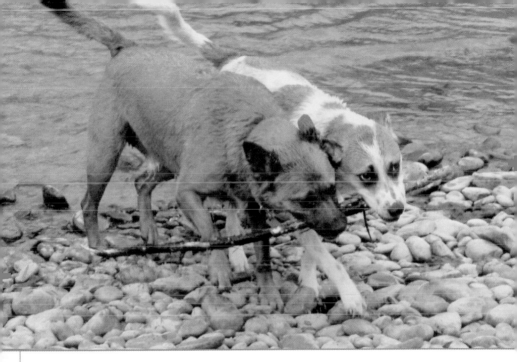

STICKING TOGETHER So little time, so many sticks to retrieve! At the river near their home in Tunkhannock, PA, RILEY, a Carolina mix, and KODA, a Terrier mix, learn that teamwork is the key to success. They're proudly bringing their prize stick to their caretakers, Robyn and Kristen Wiggins.

18·Thursday·May 2023

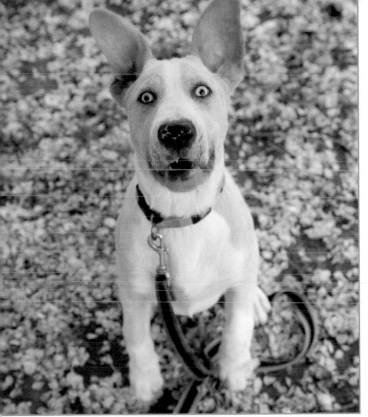

HOLD YOUR EARS!

Ear mites are tiny spiderlike creatures that invade the ear canal and feed on skin debris. Ear mites prefer cats as hosts, but dogs, especially pups, are also vulnerable. Signs include head shaking, ear scratching, and a dark discharge. After diagnosis under a microscope, a vet can prescribe mite-killing meds. Ear mites are contagious, so if one pet is infected, have other pets checked.

19·Friday·May 2023

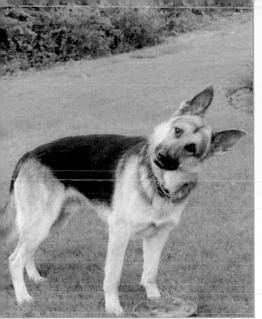

**"I COULD HAVE SWORN I LEFT
MY BALL HERE. . . ."**
CURTIS JAKE (German Shepherd Dog).—
Jeff & Ginger Clark, Helena, AL

20·Saturday
May*2023*

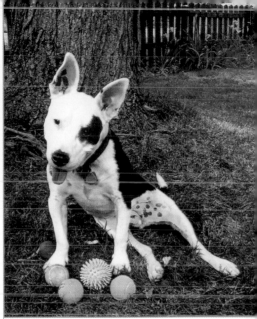

"FINDERS KEEPERS"
LIZZIE (Bull Terrier/Pit Bull mix).—
Jack & Cindy Bouer,
North Canton, OH

21·Sunday
May*2023*

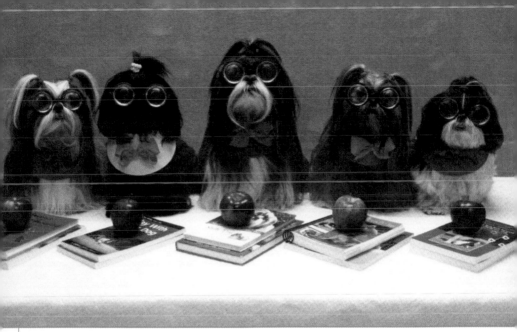

CORE CURRICULUM An advanced class of five bright Shih Tzus has been studying apples. They've learned that not only are apples a nice gift for the teacher, but also a healthy treat for canines, and most dogs love them. From left to right, these A students are SOPHIE, SADIE, CUTTER, CASSIE, and KIPPY, and their proud owner is Judi Gullickson of Peoria, IL.

22·Monday·May 2023

VICTORIA DAY (CANADA)

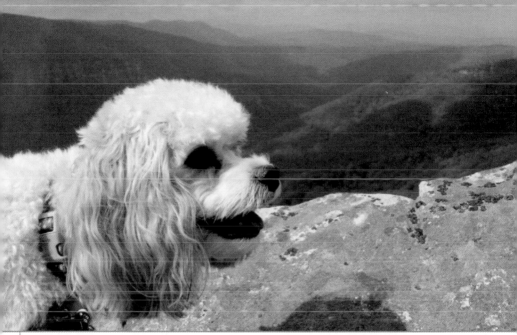

MAKING MOUNTAINS OUT OF MOLEHILLS The Ifugao people of the Philippine Islands assigned dogs an unusual role in their creation mythology. The god of the skyworld, Kabiat, came to Earth with his hunting dogs. But because the Earth was flat and featureless, he couldn't hear them bark at prey. So that the barking of his dogs might resound, Kabiat created mountains, hills, and valleys.

23·Tuesday·May 2023

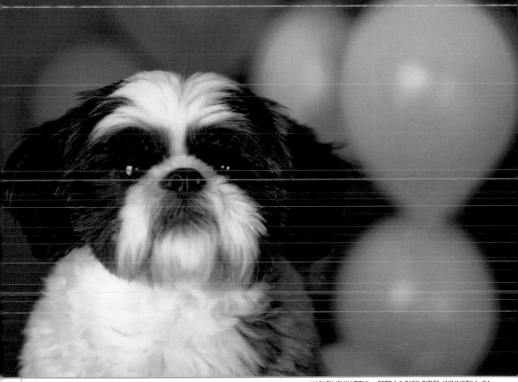

HARLEY (SHIH TZU).—PETRA & RICK BIDES, WINNETKA, CA

BIRTHDAY BOYCOTT? "Colored balloons and birthday songs are all very nice—but if that doggy ice-cream cake doesn't come out soon, I'm outta here."

24 · Wednesday · May *2023*

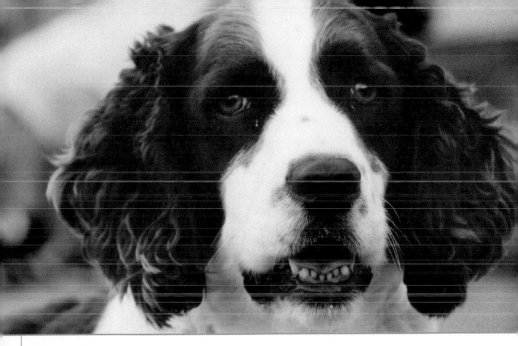

SUGAR IS SWEET The English Springer Spaniel's deep, soulful brown eyes and the beautiful white blaze between them make for one of the dog community's most appealing faces. Gordon and Nancy Fromwiller of Otisville, MI, tell us that SUGAR instantly goes into a pose whenever someone brings out a camera. That's not surprising, since she has one of the sweetest smiles we've ever seen.

25·Thursday·May 2023

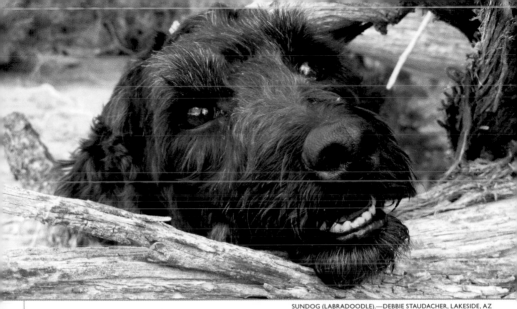

CANINES AROUND THE CAMPFIRE When you were a kid and went to summer camp, did you miss your dog more than you missed your family? If your answer is yes, we've got good news for you. A rapidly growing number of camp facilities around the country have introduced special programs where dogs and their owners can experience camping and the great outdoors *together*. At Dog Scouts of America in St. Helen, MI, canine campers can earn merit badges for swimming or agility. At Camp Dogwood in Lake Delton, WI, owners can attend workshops on pet massage and treat-making. And at Canine Camp Getaway in Lake George, NY, crafty canines can take a "barks and crafts" class, while mellow mutts can attend dog yoga.

26·Friday·May 2023

RETRIEVER
KAYCI MARIE (Labrador Retriever).—
John & Germaine Gilbert, Brooklyn, CT

27·Saturday
May 2023

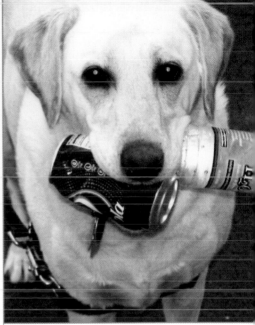

RECYCLER
KALI (Labrador Retriever).—
Phil & Bev Ewald, Webster, NY

28·Sunday
May 2023

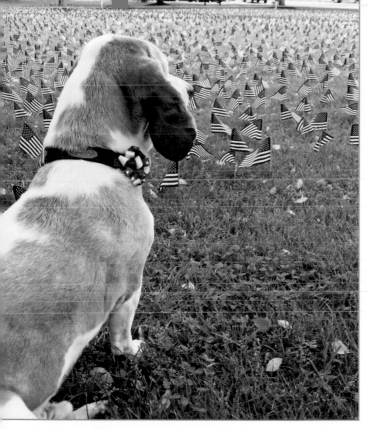

FAITHFUL WATCH

With a sense of intense loyalty so typical of our canine friends, this photo of KEEGAN reminds us to remember the sacrifices of so many who have served our country and the importance of supporting our troops at home and abroad. Keegan's a Basset Hound who lives with Holly Harris in Pepperell, MA.

29·Monday·May *2023*

MEMORIAL DAY OBSERVED
SPRING BANK HOLIDAY (UNITED KINGDOM)

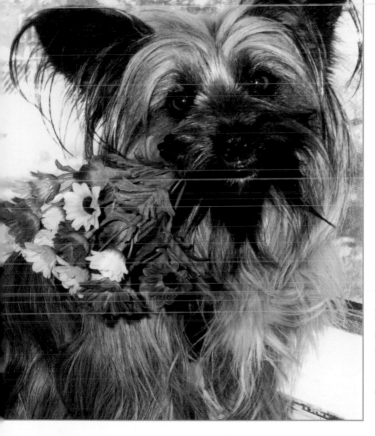

"Some dogs live for praise. They look at you as if to say 'Don't throw balls . . . just throw bouquets.'"

—HJORDIS ANDERSON

30·Tuesday·May *2023*

TRADITIONAL MEMORIAL DAY

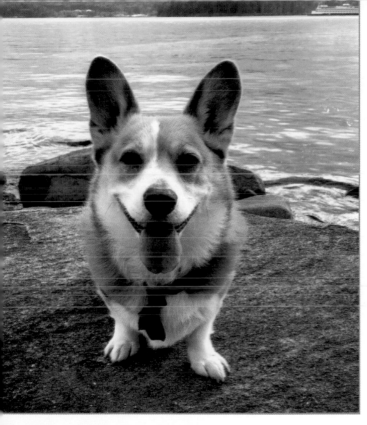

HAPPY ENDINGS

Sometimes even a pedigree dog can fall on hard times. REILLY was found as a stray, undernourished and half his current body weight. Luckily, his new loving owner, Stephanie Riler of Issaquah, WA, can report that the handsome Pembroke Welsh Corgi is healthy, strong, and even "outspoken." We wonder if Reilly would like to speak about how great it is to rescue a dog in need!

31·Wednesday·May₂₀₂₃

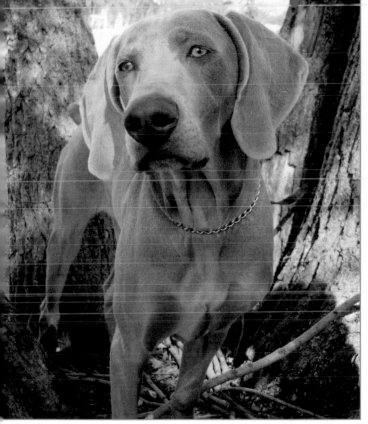

WEIMARANER

- *Origin:* The breed was designed for nobles of the 19th-century Weimar court, who sought a dog that combined all the best qualities of several German hunting breeds, including speed, a good nose, and courage. Because of the lack of big game in western Europe at the time, he was most often used as a bird dog.

- *Profile:* The gray color of his short, sleek coat has earned the Weimaraner the nickname the "silver ghost." The color is usually slightly lighter on the head and ears, which are long and soft. His long and lean torso is built, as his standard requires, for speed and endurance in the field.

1·Thursday·June 2023

2 Friday June

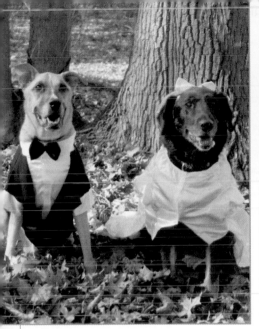

"I DO"
Caruso & Naia (Mixed breeds).—
Holly Gibbard, Emerson, NJ

3·Saturday
June₂₀₂₃

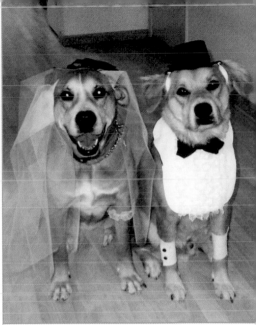

"ME TOO"
Trevor & Bradley (Mixed breeds).—
Kimberly Rivest, Peoria, AZ

4·Sunday
June₂₀₂₃

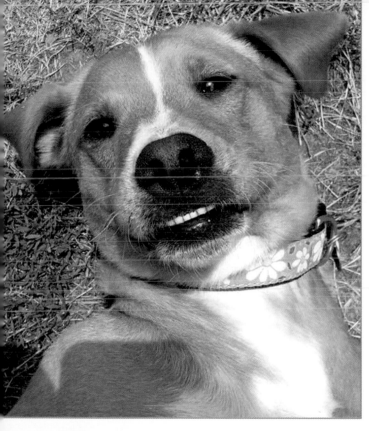

MUTT OF THE MONTH

Labrador Retrievers have been America's favorite breed for three decades, so it makes sense that we receive a lot of great photos of Labs and Lab mixes. We love them all. Introducing VIOLET, a Lab mix who was rescued in Louisiana and found a new home with Lori Vaudry of Cumberland, RI. Lori says Violet is smart, sweet, and goofy, and we all agree that her slight underbite makes her even cuter!

5 · Monday · June *2023*

QUEEN'S BIRTHDAY (NEW ZEALAND)

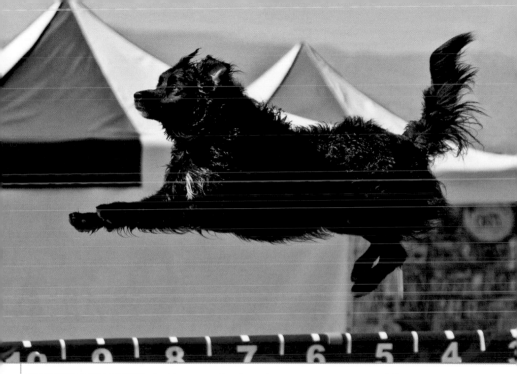

ROCKIN' THE DOCK A Chesapeake Bay Retriever mix named DAVY JONES is an avid dock jumping competitor. So far, his farthest jump is 18' 3". Davy lives in Pasadena, CA, with his best friend and trainer, Samantha Bonar.

6 · Tuesday · June *2023*

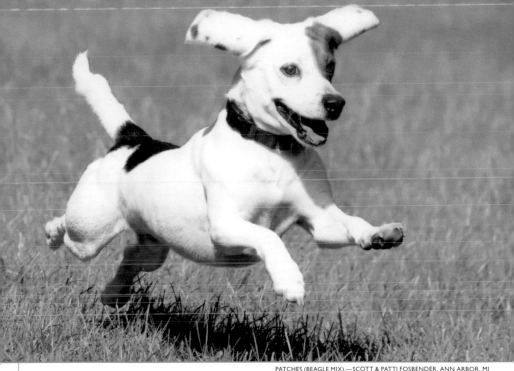

PATCHES (BEAGLE MIX).—SCOTT & PATTI FOSBENDER, ANN ARBOR, MI

"The dog lives for the day, the hour, even the moment."

—ROBERT F. SCOTT

7·Wednesday·June 2023

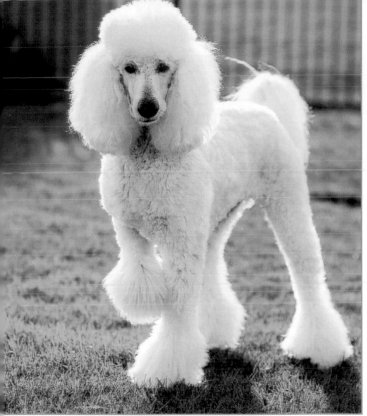

FORM, FUNCTION, AND FASHION

The unique trim and pom-poms that are classic hallmarks of a show Poodle were not created as decoration but rather as occupational necessity. The Poodle's work was hunting in and around water, and an unshorn poodle's thick coat might have weighed him down and inhibited his motion. With his bottom half shaved, a dog was more buoyant and could swim more easily. The mane and chest hair were kept long so that the Poodle's vital organs stayed warm in cold water. Eventually, Poodle owners got into the habit of tying colored ribbons on their dogs—but even this was done for identification not decoration.

8 · Thursday · June *2023*

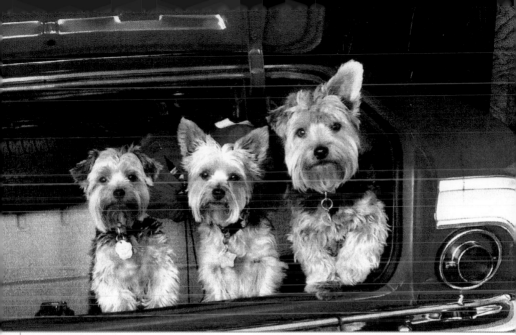

STONI, BELLA & BEN (YORKSHIRE TERRIERS).—PATTY SIKORSKI, BUFFALO, NY

THE BETTER TO HEAR YOU WITH The flap that forms the outer section of a dog's ear is called the pinna. The pinna initiates the hearing process by trapping sound waves. Some dogs have ears that stand erect all the time, some have floppy ears, and some have ears that are folded down but perk up when the dog is alert. Though all dogs hear well, those with erect ears hear most acutely.

9·Friday·June 2023

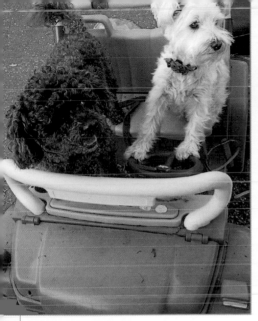

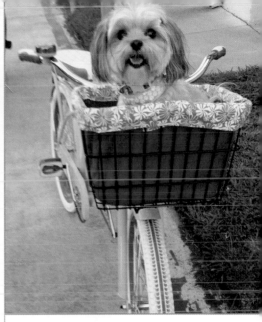

TWO FOR THE ROAD
GIDGET GRACE (Schnauzer mix) &
LILLY SUE (Poodle mix).—
Debora Cisneros, Lemon Grove, CA

10·Saturday
June 2023

HAPPY HITCHHIKER
LADYBUG (Yorkie/Shih Tzu mix).—
Sarah Gaines, Antioch, CA

11·Sunday
June 2023

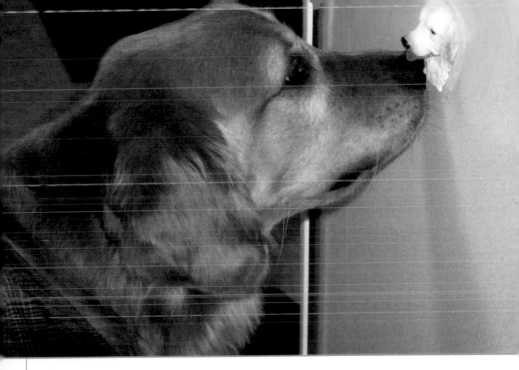

MINI-ME? Looks like Golden Retriever Nordo has a magnetic attraction to the refrigerator door at his Franklin, MA, home that he shares with the Purdy family.

12·Monday·June 2023

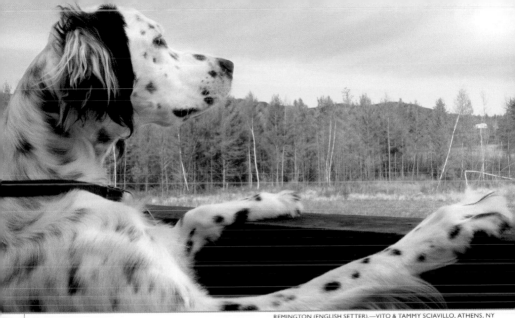

REMINGTON (ENGLISH SETTER).—VITO & TAMMY SCIAVILLO, ATHENS, NY

DOES YOUR DOG NEED GLASSES? Most dogs are nearsighted, at least to some degree, which means that their depth perception is poor. As a result, if you were standing in a crowd of people some distance away, your dog might not even be able to identify you. On the other hand, since dogs' eyes are positioned on the sides of their faces, they have good peripheral vision and are quite adept at seeing motion from side to side. A baseball analogy makes the difference easier to understand: A canine shortstop would have trouble judging the position of a line drive headed right for him, but a canine catcher would easily see a throw from third to first base.

13·Tuesday·June *2023*

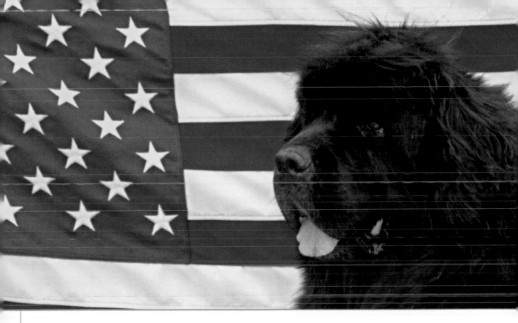

SERVICE WITH A SMILE ABBY, a Newfoundland, is a certified therapy dog who visits veterans at a VA hospital in Long Beach, CA. Fred and Jean Frueh of Garden Grove, CA, tell us that Abby has a new little sister, Kayce, and the Fruehs are hoping that Kayce will follow in her sister's paw prints and become a therapy dog, too. (And we're hoping we'll get to meet Kayce when her photo is submitted for a future 365 DOGS CALENDAR!)

14 · Wednesday · June 2023

FLAG DAY

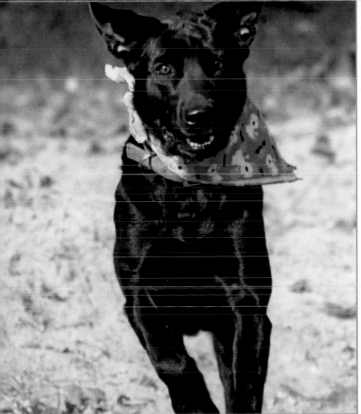

FOR THE LOVE OF LABS

The origin of the Labrador Retriever is not well documented. She may have been brought to Newfoundland by Basque or Portuguese fishermen, or she may even be a descendant of dogs that were brought there by Norse explorers during the Middle Ages. In either case, the hardworking water dog led a low-profile life in that remote region for hundreds of years—until the 1960s, when the popularity of the Labrador Retriever skyrocketed. For the last several decades, the Lab has held an unassailable position as the world's favorite breed.

15·Thursday·June *2023*

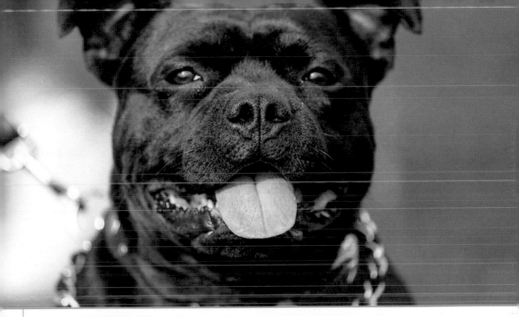

THE LONE RANGER Since he was the only puppy in his litter, that's the name he was given by his breeder. However, these days the friendly Staffordshire Bull Terrier RANGER is rarely alone, since he's got a great home with Noreen and Bill Maddox in San Diego, CA. Ranger's attended three obedience training programs and has a coursing ability certificate (coursing means hunting by sight rather than scent, and the AKC sponsors several events in that field). The Maddox family tells us that he loves veggies, ice cubes, and twice-daily walks in the neighborhood.

16·Friday·June *2023*

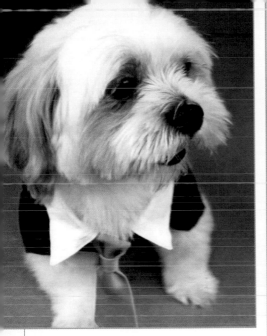

Q: "WHY ARE MEN RELUCTANT TO BE FATHERS?"
TOBY (Lhasa Apso).—
Samantha Murray, Mt. Prospect, IL

17·Saturday
June *2023*

A: "THEY AREN'T THROUGH BEING CHILDREN."*
HARRY (Terrier mix).—
Kathy & Chris Genova, Florham Park, NJ

18·Sunday
June *2023*

FATHER'S DAY

*Cindy Garner

RARE OCCASIONS

Although the Entlebucher Mountain Dog is the smallest of four breeds from the Swiss Alps (its better-known cousin is the Bernese Mountain Dog), it's surprisingly strong for its size. The breed is named for Entlebuch, a valley that runs between Lucerne and Bern, and there are two popular pronunciations: *ent-lee-boo-ker* and *entel-boo-ker*. Somewhat reserved around strangers, this hardworking, droving breed is at the same time devoted to and protective of its human family.

19 · Monday · June *2023*

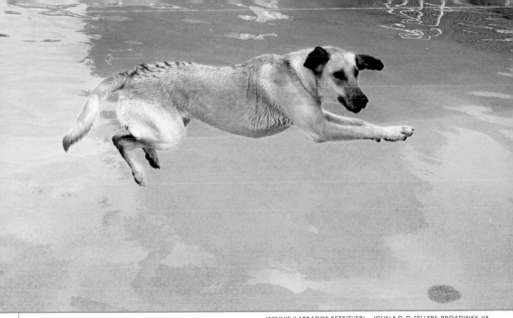
WINNIE (LABRADOR RETRIEVER).—JOHN & D. D. SELLERS, BROADWAY, VA

IN THE SWIM Some breeds, especially Labs, setters, and spaniels, take to the water naturally. Others, like Pugs or Bulldogs, don't, and there are good reasons for them to be a bit wary about it: Their heavy, short-legged bodies are not shaped well for swimming, and their compressed faces can make it hard for them to breathe. If your dog has not yet been exposed to water, it's necessary to make an honest assessment of how she feels about it and to respect that feeling. If she seems interested in swimming, encourage her but supervise her at the same time. If she projects a strong fear or dislike of it, though, don't force her, and never, ever, throw her in. Instead, choose a land-based activity to share.

20·Tuesday·June *2023*

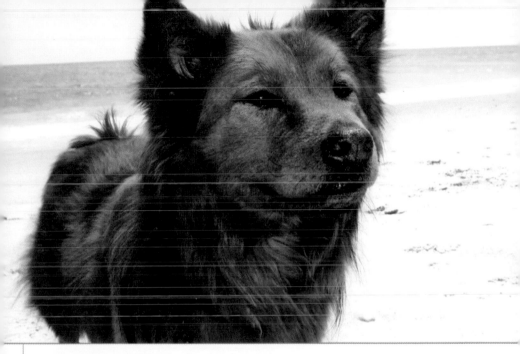

HAPPY ENDINGS Abandoned as a skinny, hairless stray on the side of a highway, GINGER found a new home with Diane Thomas of Durham, NC. Diane recalls that it didn't take too long for the sweet mix to get used to the good life—and for Ginger, the good life means the beach. Whether she's sitting on the sand watching waves or "chillin'" in a pair of shades on the deck, Ginger thinks that any time at the beach is a good time.

21·Wednesday·June 2023

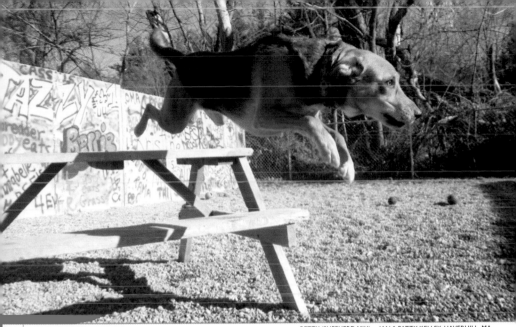

PARKS AND RECREATION At a recent conference sponsored by the Association of Pet Dog Trainers, an interesting observation about dog parks was discussed. Apparently, the number of visitors in a park has a direct effect on the behavior of dog owners: The fewer dogs and owners present, the less each owner pays attention to his own dog. In other words, owners get lax when a park is not crowded. Even if that's the case, dog park spokespeople remind visitors that it's always necessary for owners to monitor their dogs while at a park, crowded or not.

22·Thursday·June *2023*

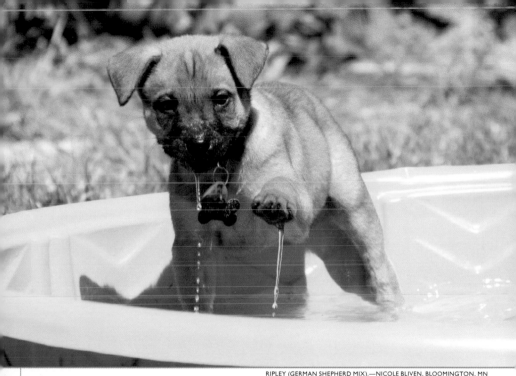

RIPLEY (GERMAN SHEPHERD MIX).—NICOLE BLIVEN, BLOOMINGTON, MN

"**E**very dog may have his day, but it's the puppies that have the *weak ends*."

—ANONYMOUS

23·Friday·June 2023

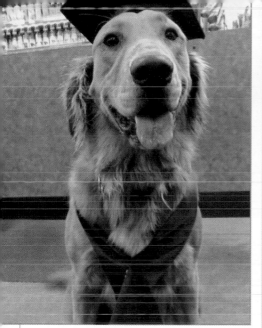

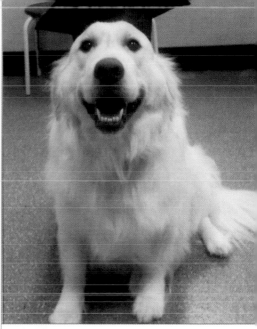

GOLDEN GRADUATE
MAVERICK (Golden Retriever).—
Donna Fennell, McKinney, TX

24·Saturday
June 2023

ST. JEAN BAPTISTE DAY
(CANADA)

DIPLOMA RETRIEVER
CHESTER (English Golden Retriever).—
Heather Bohmann, Bethlehem, GA

25·Sunday
June 2023

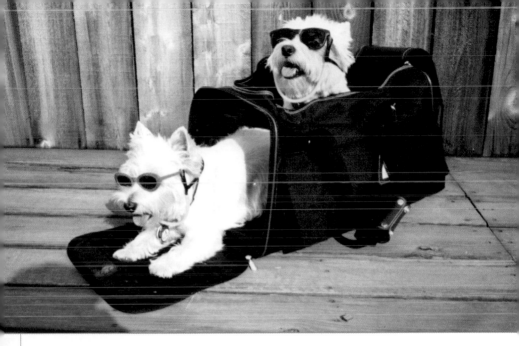

WAYWARD WESTIES Ever notice how our dogs just seem to know when we're planning a trip without them? NESSIE and KAYLEIGH, two particularly perceptive West Highland White Terriers, noticed that their companion, Merrily Shultz, was getting out the suitcases, and they decided to get proactive about it! The Westies live in Mission, KS, with Merrily, who doesn't stand a chance of going on vacation without them!

26·Monday·June 2023

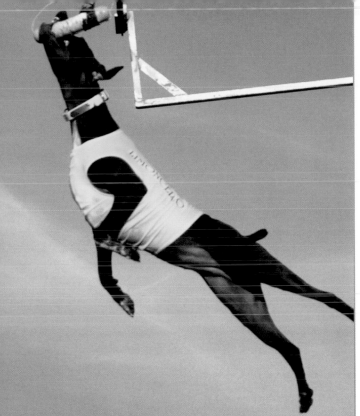

LIMONCELLO (GERMAN SHORTHAIRED POINTER)—JENNY BEADLING, MEDFORD LAKES, NJ

GO WITH THE FLOW

The format of a canine dock-jumping event varies according to the rules established by its sponsors. Some competitions include the classic "big-air" event, which tests horizontal distance; others add an "extreme vertical" event, which resembles the human high jump, or the "speed retrieve," in which dogs race against the clock as they leap into water to retrieve a floating object. Today, it's common for top canine competitors to clear horizontal distances of more than 25 feet.

27 · Tuesday · June 2023

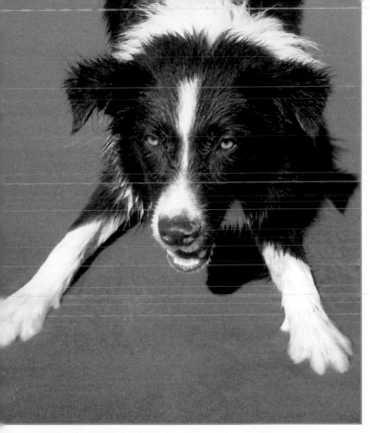

"**D**ogs don't trouble themselves with minutes or hours. Time is either 'now' or 'right now!'"

—Arthur Yorinks

28·Wednesday·June *2023*

EID AL-ADHA
BEGINS AT SUNDOWN

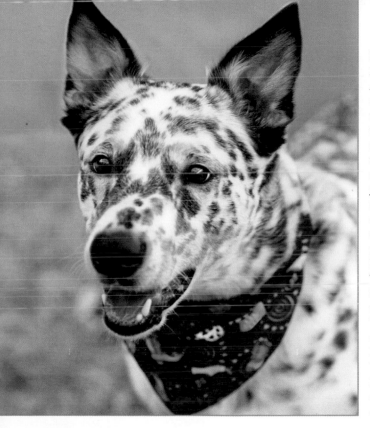

MIXED MESSAGE
ZOE's a mix of
Australian Cattle Dog
and Dalmatian, and
the unusual coloration
that resulted from that
mixture is among
the prettiest we've
ever seen. But it's not
just Zoe's coat that
makes for a wonderful
combination of
elements, it's also her
personality, which
her owner, Debi
Turner of Charleston,
SC, describes as
the perfect mix of
beauty, intelligence,
compassion, and
love. Debi claims that
behind those eyes,
Zoe's always problem-
solving and watching
over others.

29·Thursday·June *2023*

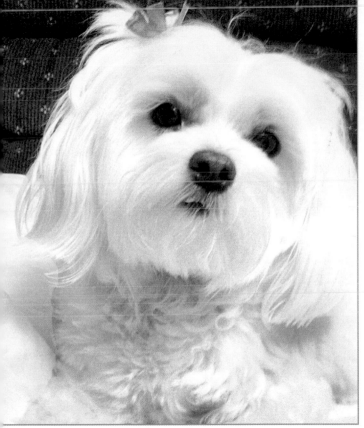

MANIA MALTIE

During the first century CE, Publius, Roman governor of Malta, commissioned a portrait of his beloved Maltese, Issa. The celebrated poet Martial wrote a poem about the precious pooch:

"Issa is more loving than any maiden. Issa is dearer than Indian gems. . . . That her last hour may not carry her off wholly, Publius has her limned in a picture, in which you will see an Issa so like, that not even herself is so like herself."

30 · Friday · June 2023

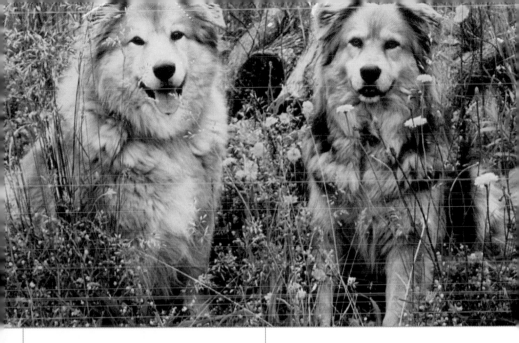

BIG BROTHER IS WATCHING
KODI (Chow/Shepherd mix).—
Patty Smith, Sykesville, MD

1·Saturday
July *2023*

CANADA DAY (CANADA)

OH, BROTHER!
BOOH (Chow/Shepherd mix).—
Patty Smith, Sykesville, MD

2·Sunday
July *2023*

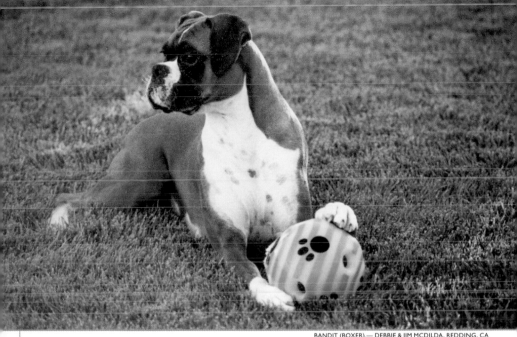

BANDIT (BOXER).— DEBBIE & JIM MCDILDA, REDDING, CA

BIG BANG THEORY Does your dog freak out when there are fireworks in town? Here are a few ways to help calm her down. 1) Seal the environment as much as possible: Draw drapes, close doors, shut windows, and turn on the A/C. 2) Play calm, soothing music, but not too loud. 3) Distract her with a new or favorite toy. 4) Try a thundershirt—the gentle compression of this tight-fitting pet T-shirt acts like swaddling clothes for a baby. 5) Introduce a DAP (dog-appeasing pheromones) product. DAPs claim to have natural stress-relieving properties—but ask your vet first.

3·Monday·July 2023

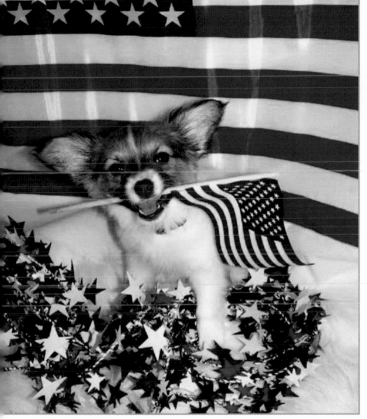

BEFORE THE PARADE PASSES BY

CHLOE and her mom, Sherry Heishman, won't miss a minute of the Fourth of July festivities in their hometown of Stephens City, VA. With those big Papillon ears, young Chloe can already hear the parade getting started all the way on the other side of town.

4·Tuesday·July 2023

INDEPENDENCE DAY

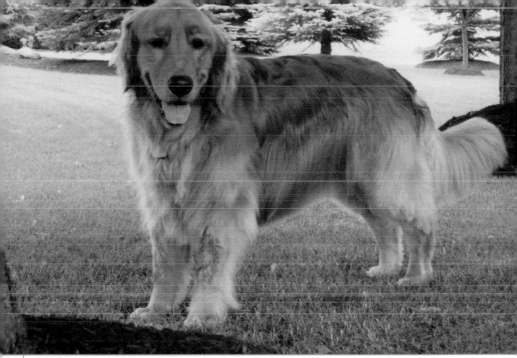

BAYLEY (GOLDEN RETRIEVER).—JANICE GLASS, SHARON, ONTARIO, CANADA

"**T**hat friendly smile isn't just for show—it seems that the Golden generally loves pretty much everyone."

—KRISTEN SEYMOUR

5·Wednesday·July 2023

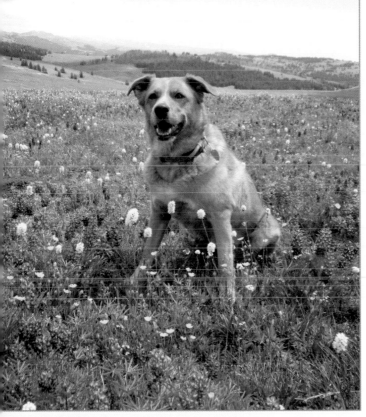

MUTT OF THE MONTH

For Sister Josetta Grant of Dayton, WY, Lab mix ANNIE is a blessing from above. Annie's easygoing disposition is totally in keeping with the Labrador component in her lineage—the breed's stability and gentleness have made it one of the most popular choices for assistance and therapy work. Sitting in a grassy meadow of flowers, Annie seems to be drawing her own spiritual inspiration from the distant Big Horn Mountains of Wyoming, where she and Sister Josetta live.

6·Thursday·July *2023*

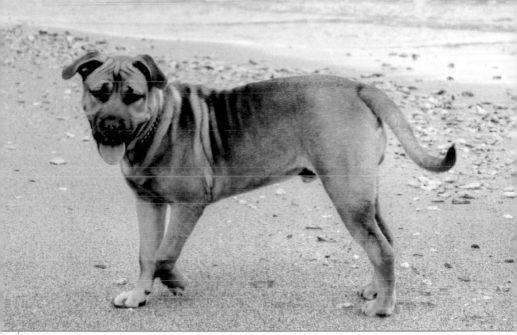

CHIEF (ROTTWEILER/CHOW MIX).—KAILI SEALES, KAUNAKAKAI, HI

DOG DAYS DELICIOUS If you're feeling the temperature skyrocket today, chances are your dog is, too. To help your best friend get through a sweltering summer day, try these delicious solutions. They're very easy to make, but he'll be convinced you're a world-class doggie chef.

• Fill an ice cube tray with low-fat, low-sodium chicken or beef broth to make frozen cube treats.

• Mix peanut butter with plain low-fat or nonfat yogurt; pour into paper cups and freeze.

7·Friday·July 2023

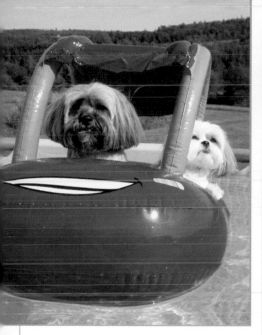

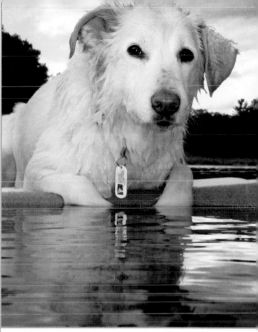

SHIH-TZU SLOOP Bob & Molly (Shih Tzu mixes).—Faith & Scott Hourihan, Riverbank, New Brunswick, Canada

8·Saturday
July *2023*

RETRIEVER RAFT
Daisy (Shepherd/Samoyed/Golden mix).—Deb & Rick Callahan, Storrs, CT

9·Sunday
July *2023*

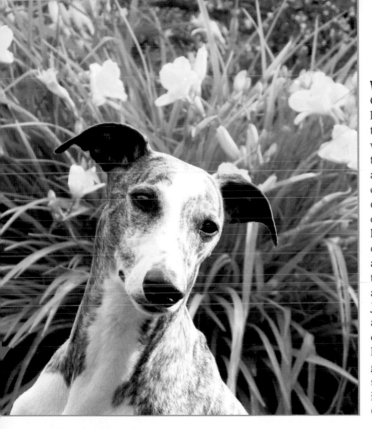

WHIPPET GOOD

Champion show dogs, like Olympic athletes, train for years. But when it's time for them to hang up their collars and call it quits, they can have as much difficulty leaving competition as their human counterparts do. Retired canine athletes can reignite their passion with new activities. Janet and Bo Juzkiw say that PERCY, a retired Whippet champ, has reinvented himself as their hiking guide on the trails that surround their home in Grand Forks, British Columbia, Canada.

10·Monday·July 2023

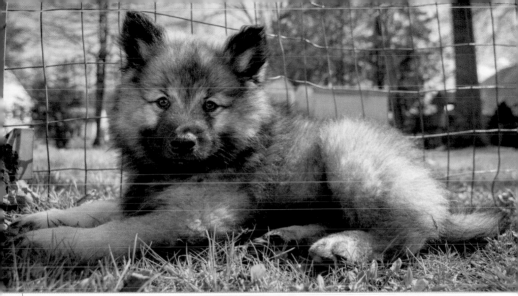

OZZIE (KEESHOND).—ANITA PULASKI, LAWRENCEVILLE, NJ

DOWNSIZING A puppy pen, located outdoors during warm weather or indoors when it's cold outside, can be a great tool for housebreaking a puppy. Since puppies instinctively dislike soiling their sleeping quarters, confining them to a smaller space encourages them to do their business elsewhere. Gradually, with some direction, they learn what spots are appropriate. Even if a pen is not available, confining a pup to one room, such as the kitchen, rather than giving him the run of the house, will also speed up his training.

11·Tuesday·July*2023*

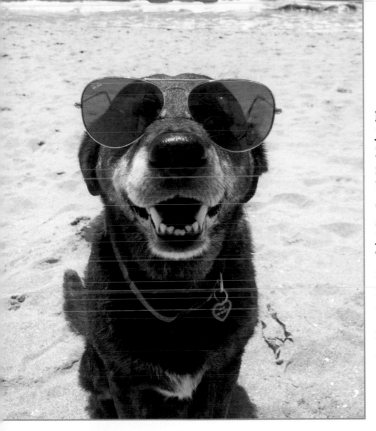

HAPPY ENDINGS

JoJo was born in Zambia and later moved to Kenya before she traveled overseas and found a forever home with Jill Meshekow in Torrance, CA. Jill reports that JoJo is crazy about the Cali life, especially going to the dog beach. And her new human family is equally happy that she's now a sunny California girl.

12·Wednesday·July 2023

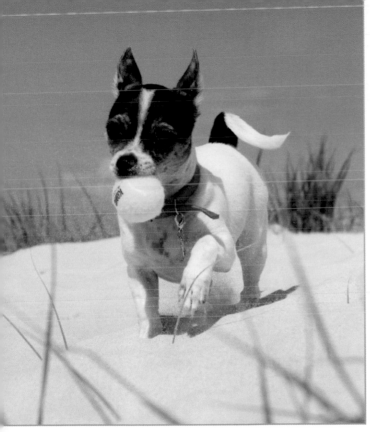

BEACH BALL

Most dogs love a day at the beach. But when it's over, getting the sand out of a dog's coat is essential. Thoroughly rinse the places where sand tends to collect: the ears, the tail, and the creases where the legs meet the torso. Make sure to rinse the belly and the paws, too. Even if you give your dog a shower at the beach, don't be surprised if she needs another bath when she gets home—even a small dog can accumulate a large amount of sand.

13·Thursday·July*2023*

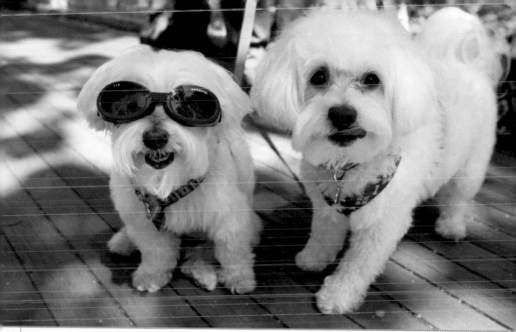

IF YOU CAN MAKE IT THERE Canine urbanites HARRY, a Maltese, and DANIEL, a Maltese mix, were rescued through Metropolitan Maltese Rescue and now live right next to Central Park in New York City. Their caretakers Jeff and Kathryn Janus tell us they're typical busy New Yorkers who even have jobs as "co-therapists" in their owner's psychotherapy practice. Harry, who's 14, has an eye condition called iris atrophy, which makes his eyes sensitive to bright sunlight, so when he's outside he wears shades.

14·Friday·July 2023

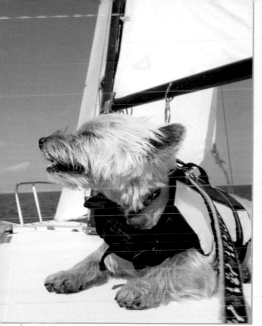

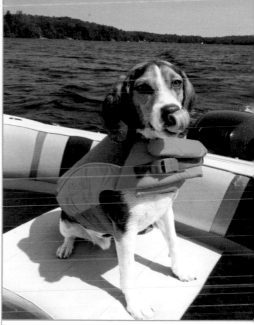

THE WIND IN YOUR EARS . . .
Benji (Cairn Terrier).—
Rosann & Doug Milius, Oshkosh, WI

15·Saturday
July 2023

. . . AND THE SALT IN YOUR SNOUT
Gibson (Beagle).—
Rachelle Pagé, Ottawa, Ontario, Canada

16·Sunday
July 2023

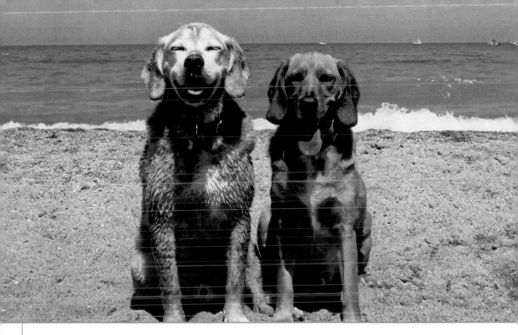

TO THE RESCUE Let the sun shine in! It's hard to imagine a sunnier pair of rescues than these guys. Both Golden Retriever/Basset Hound mixes, HOOCH was rescued in Wisconsin and TOBY was rescued in Kentucky. Stacy Borger of Villa Park, IL, tells us that their absolute favorite place to relax is Central Beach in the Indiana Dunes at Lake Michigan.

17 · Monday · July 2023

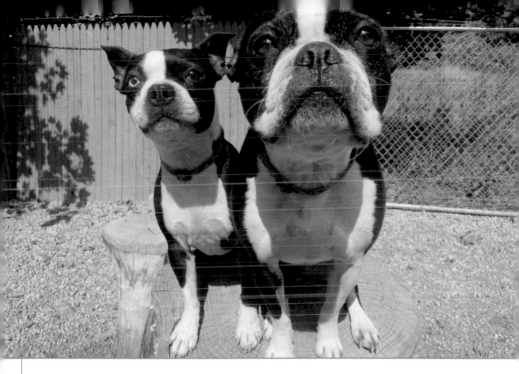

BOSTON BOUNCERS "And just where do you think you're going?" Boston Terriers PETIE and SOPHIE take their job as security guards of their backyard very seriously. Their owner is Sharon Schumaci of Atkinson, NH.

18 · Tuesday · July 2023

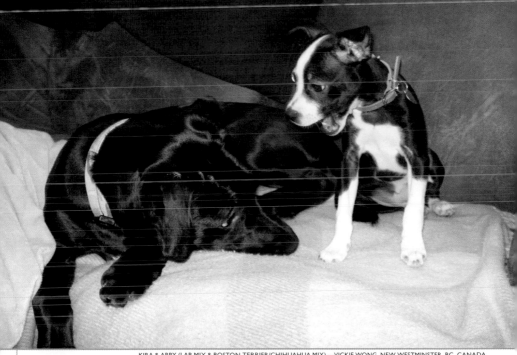

KIRA & ABBY (LAB MIX & BOSTON TERRIER/CHIHUAHUA MIX).—VICKIE WONG, NEW WESTMINSTER, BC, CANADA

"'I want to go out! I want something to eat! Pet me, scratch me, rub my ears now!' Dogs go in for exclamation points."

—ARTHUR YORINKS

19·Wednesday·July *2023*

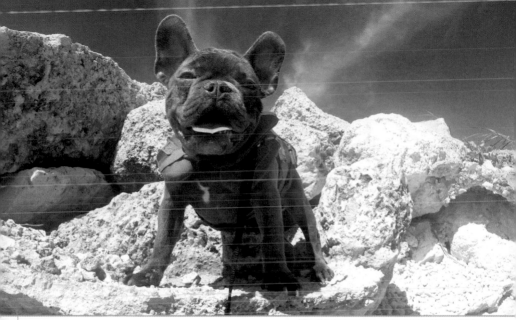

REMI (FRENCH BULLDOG).—SARAH WALLACE, PLAINFIELD, CT

VIVE LES CHIENS Parlez-vous français? If not, does your dog? Among the breeds registered by the American Kennel Club, several are native to France. How many of them can you name?

ANSWERS: Papillon, French Bulldog, Dogue de Bordeaux, Petit Basset Griffon Vendéen, Picardy Spaniel, Pyrenean Mountain Dog, Pyrenean Shepherd, Briard, Barbet, Brittany Spaniel, Berger Picard, Porcelaine

20 · Thursday · July 2023

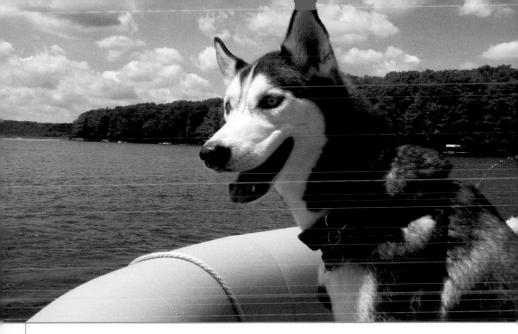

NO WAKE Who needs white water? There's no wind today and the lake is as flat as a mirror (well, *almost*). That's okay with SOPHIA because she's a dog that prefers being *on* the water rather than *in* it. The Siberian Husky goes rafting near her home in Baltimore, MD, with her best friend, Melissa Vandergriff.

21·Friday·July 2023

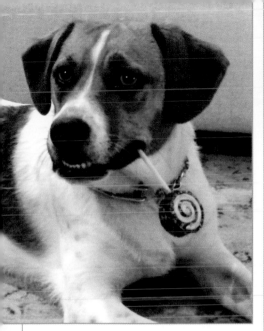

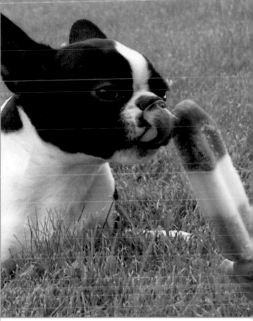

LOLLIPUP
REESE (Beagle mix).—
Megan Roth, Shaker Heights, OH

22·Saturday
July *2023*

ICEPUP
OLIVER (Boston Terrier).—
Paula Shupe, Chilhowie, VA

23·Sunday
July *2023*

GIA (SPINONE ITALIANO).—ALICE CHURCH, CHICAGO, IL

RARE OCCASIONS During the last three centuries, many European countries developed their own pointing dogs, each in accordance with the climate and terrain of their homelands. The Spinone Italiano, or Italian Coarsehaired Pointer, is a versatile gun dog with a soft mouth for retrieving and a coarse, wiry coat for negotiating Italy's dense woodlands. American fans began a Spinone club here during the 1980s, leading to the breed's recognition by the AKC in 2000. The Spinone is also renowned for its docile and quiet temperament.

24·Monday·July *2023*

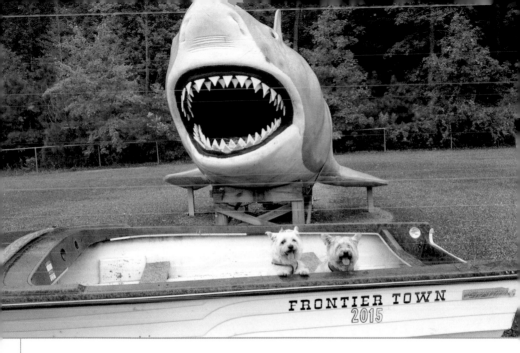

FRONTIER TOWN
2015

SWIMMING WITH THE SHARKS Louis Sauer recounts the summer when he and his two Cairn Terriers, ABBY and RUSTY, evacuated their home in Little River, SC, to escape Hurricane Matthew and ride out the storm safely in Ocean City, MD. Oh, well, the best-laid plans of Cairns and men . . .

25·Tuesday·July2023

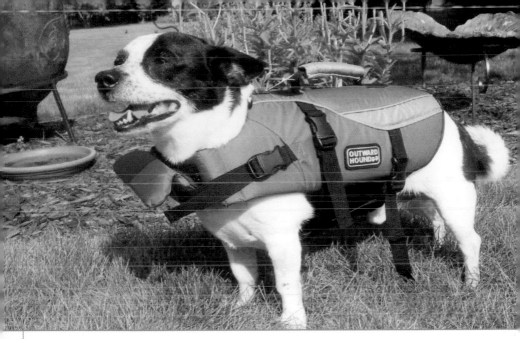

HAPPY ENDINGS Pat and Carol Moody of St. Joseph, MI, relate that CHUCK came to them through Animal Aid of Southwest Michigan. Skinny, dirty, and frightened, the terrier mix had been rescued from a terrible situation in which, among other abuses, he had been tossed from a second-story balcony. Incredibly, with the help of the Moodys, Chuck gradually healed, and the dog who couldn't even play fetch is now an energetic and engaged member of a loving family. He even has his own Facebook page in which he records his many adventures.

26·Wednesday·July 2023

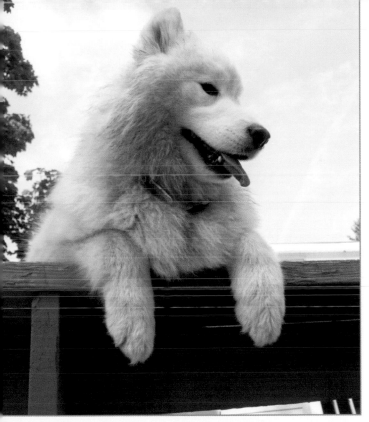

SUMMER BRUSH-OFF

Dogs with long, dense coats, like Samoyeds, Newfs, and many herding breeds, feel the summer heat more than others. Frequent brushing will remove dead hair and keep air moving through the coat, making your dog feel cooler. To take out as much extra undercoat as possible, use a slicker brush (the one with a curved pad holding multiple thin steel prongs) or a coat rake (there are several models, with rotating or rigid tines, flat or V-shaped).

27·Thursday·July 2023

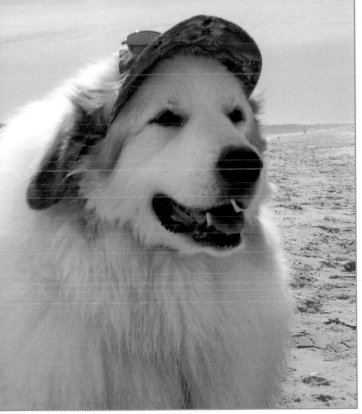

ON GUARD!

When choosing a dog for protection, consider the difference between guard dogs and watchdogs. A watchdog barks an alarm but does not necessarily engage an intruder. Most terriers, like Scotties or Jack Russells, are good watchdogs. On the other hand, guard dogs, like Dobies, are usually large enough to intimidate and capable of the aggression required to restrain an intruder. Herders, like the Great Pyrenees, may be called "guardian dogs" because they ward off threats to their flocks with a show of force until a shepherd arrives to intervene.

28·Friday·July *2023*

AT BAT
LOU (Mixed breed).—
Ashley Krueger, Franklin, WI

29·Saturday
July *2023*

ON THE MOUND
ROCKY (Poodle/Dachshund mix).—
Judith Ostrowski, Conway, AR

30·Sunday
July *2023*

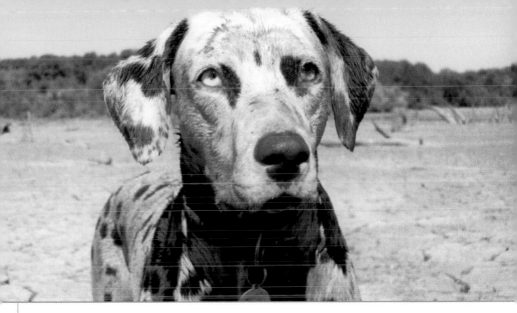

ON THE SPOT We're used to meeting Dalmatians whose coats have black spots on a white background. But some Dals have liver-colored spots rather than black ones, and, as we can see in this portrait of SYREN, they are no less striking. Whether black or liver color, the spots of a champion Dal's coat are likely to be round and distinct, rather than fuzzy or intermingled; they may vary in size, from the diameter of a dime to that of a half dollar, and the background coat on which the spots sit is often pure white. Syren lives with Kara Ann Sinclair in St. Charles, MO.

31·Monday·July 2023

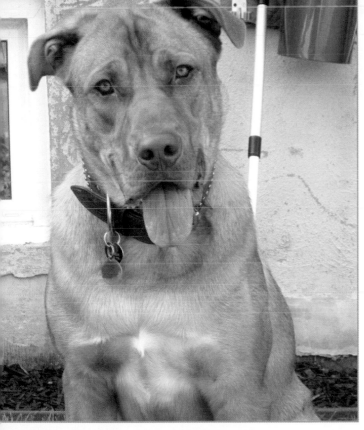

MUTT OF THE MONTH

There's always room for one more! Mastiff mix ZOR was abandoned with his littermates at three weeks old, then raised by a local rescue group until he was old enough for his new caretaker, Cynthia Biondi, to take him home. He's grown up to be a gentle giant of about 115 pounds. But as big as he is, he's still gracious enough to share his home with Cynthia's other dog, Sita, a Berger Picard, and six cats as well. They're from Sudbury, Ontario, Canada.

1·Tuesday·August 2023

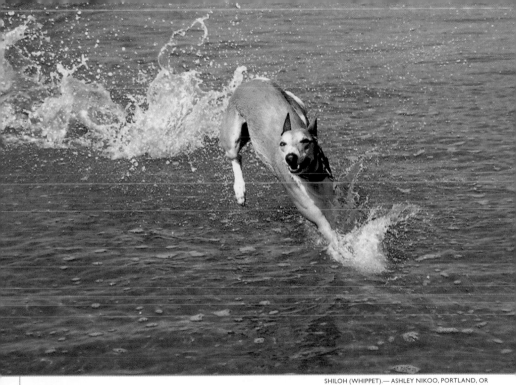

"**L**ife calls the tune, we dance."

—JOHN GALSWORTHY

2·Wednesday·August 2023

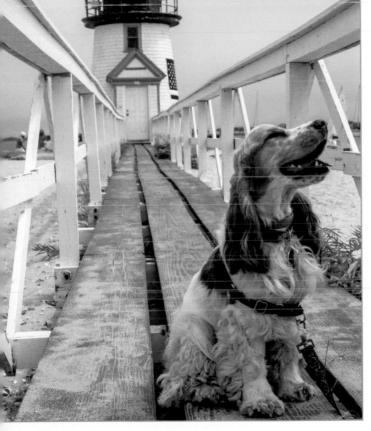

WHAT I DID ON SUMMER VACATION

The rolling surf, the soft sand, and the salty smells on the ocean breeze— TUCKER loved every minute of it! The lucky English Cocker Spaniel got to spend his first summer vacation on Nantucket in Massachusetts. Tucker is now back home in Chappaqua, NY, with his buddy Ashley Charleson, but he knows he'll be back to the beautiful island someday soon.

3·Thursday·August 2023

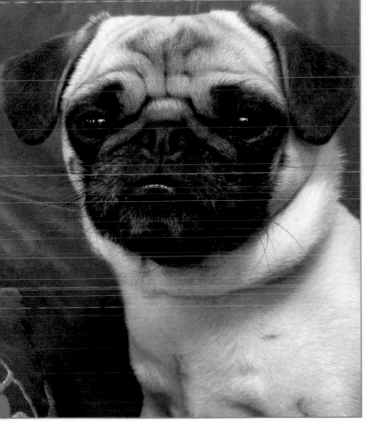

PUGS ON THE POOP DECK

Of ancient Chinese origin and most closely related to the Pekingese, the Pug was little known outside his native land until the British invasion of China in 1860, when several Pugs were brought home to England on returning sailing ships. The charming toy dog soon became a superstar in England, and even Queen Victoria herself took a strong fancy and got involved in breeding them. The queen owned a number of Pugs, whose names included Minka, Venus, Fatima, Olga, and Pedro.

4·Friday·August 2023

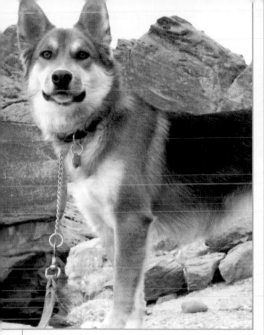

MESA MIX
Zoey (Shepherd mix).—
Jane Zalla, North Las Vegas, NV

5·Saturday
August *2023*

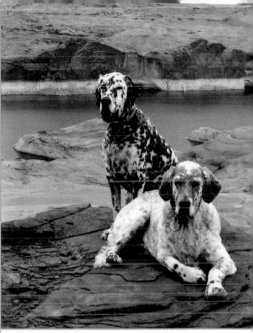

ROCK STARS
Toby & Pai (English Setters).—
Roger & Michelle Eastman, Sedona, AZ

6·Sunday
August *2023*

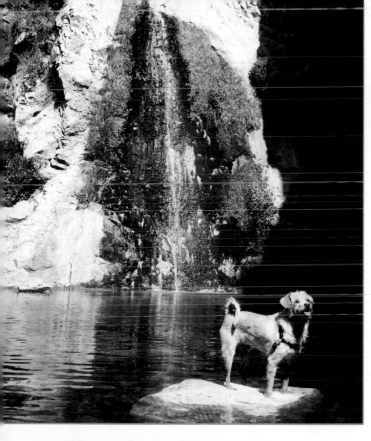

POOCH'S PARADISE

Ellie Jepperson of Los Angeles, CA, says that her Terrier/Poodle mix BERTIE always feels at home no matter where she is. But the day she discovered this secret pool and enchanting waterfall, she must have felt she had stumbled into a whole new world.

7·Monday·August 2023

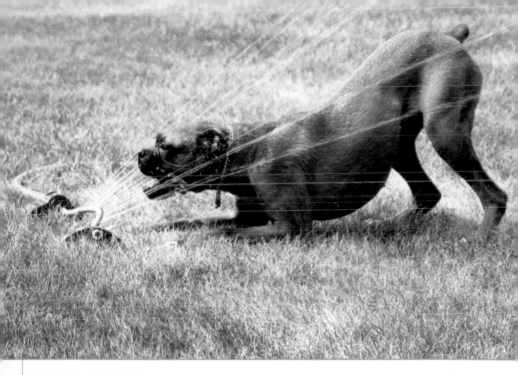

BOTTLED OR TAP? On a warm summer day, ROXY prefers her water gushing from a sprinkler. It looks like the beautiful Boxer has definitely figured out a way to beat the heat! Roxy lives with Theresa Coyle in Tappan, NY.

8·Tuesday·August*2023*

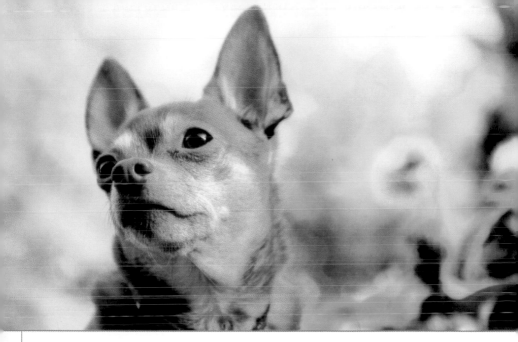

HAPPY ENDINGS Barb Nishimiya found CHIBI through a Chihuahua rescue organization after the death of her previous Chihuahua, Rocky. Though Barb will remain forever attached to Rocky, she's glad to report that these days Chibi has become the light of her life. Barb's story is yet another example of a dog lover and a dog rescuing each other. They're from Imlay City, MI.

9 · Wednesday · August *2023*

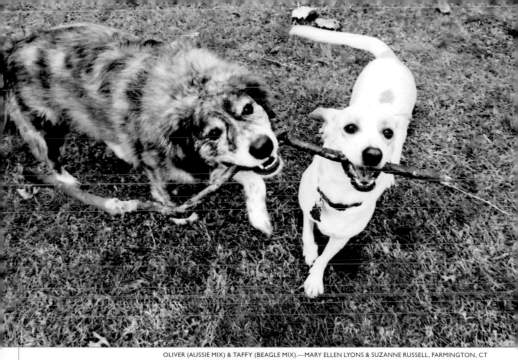

OLIVER (AUSSIE MIX) & TAFFY (BEAGLE MIX).—MARY ELLEN LYONS & SUZANNE RUSSELL, FARMINGTON, CT

LAND OF THE FREE, HOME OF THE PUPS The numbers prove that the United States has the biggest dog-loving population on the globe. More than 5 million puppies are born in America every year, and slightly more than one in every three American families has a dog. France has the world's second-highest number of dogs.

10·Thursday·August 2023

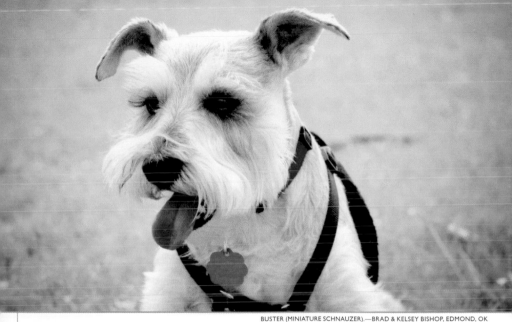

BUSTER (MINIATURE SCHNAUZER).—BRAD & KELSEY BISHOP, EDMOND, OK

MINIATURE SCHNAUZER • *Origin*: Germany, possibly as early as the 15th century. The Miniature Schnauzer was the result of mixing smaller Standard Schnauzers with Affenpinschers and Poodles. First exhibited as a separate breed in 1899, the Miniature is currently more popular than either the Standard or Giant Schnauzer.

• *Profile*: Once employed by farmers to keep the vermin population on their rural properties in check, the Miniature Schnauzer experienced a big career change, and for many years (since 1925 in the United States) the perky breed has served as a fun-loving family companion.

11·Friday·August 2023

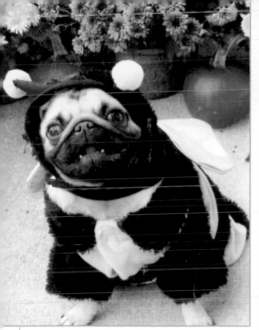

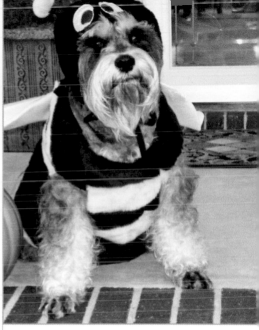

THE BEES' KNEES
MAGGIE (Pug).—
Tracey & Shaun Correia, Methuen, MA

12·Saturday
August *2023*

LET IT BEE
RUDY (Miniature Schnauzer).—
Darryl & Monica Cloninger, Belmont, NC

13·Sunday
August *2023*

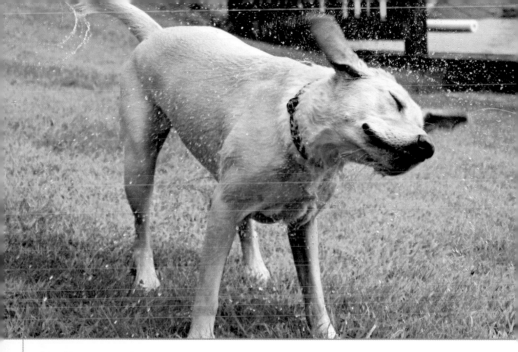

NO GREAT SHAKES RYLEE's ready to dry off—better take cover. The soggy Labrador's owner, Paula Nedock, was glad her camera had a zoom lens so she didn't get soaked, too! The Lab loves swimming and catching balls at their home in Patton, PA.

14·Monday·August 2023

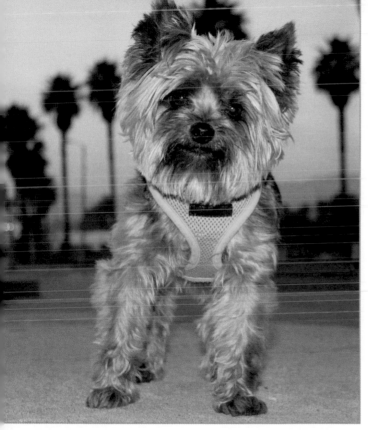

RILEY (YORKSHIRE TERRIER).—DEBBIE PERRY, SANTA MONICA, CA

SHEDDING LIGHT

Though shedding may be an annoyance to us, it's actually a vital part of a dog's physical well-being. A dog's coat protects his skin from cuts, scrapes, and sunburn, and insulates him from heat or cold. But hair can be damaged by sun, air pollution, dryness, and the wear and tear of being lain on or scratched. Shedding enables a dog to maintain balance by replacing old hairs with new.

15 · Tuesday · August 2023

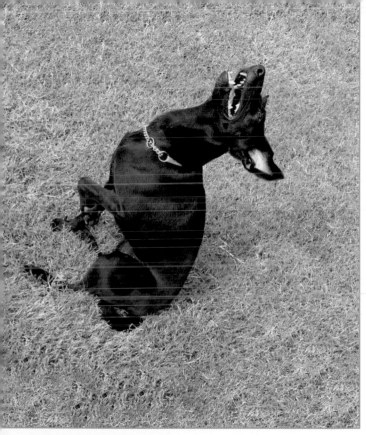

"**I** am joy in a wooly coat, come to dance into your life, to make you laugh."

—Julie Church

16 · Wednesday · August *2023*

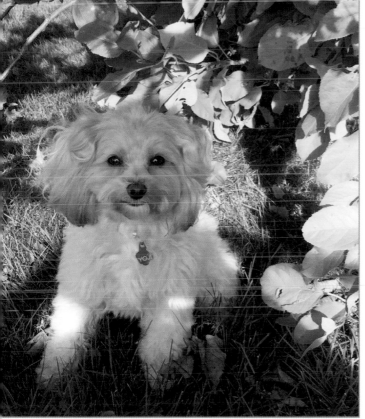

APPLES TO ORANGES

Is fruit good for dogs? The answer is both yes and no. A number of fruits are very nutritious for them: Apples have healthy antioxidants; bananas are a good source of dietary fiber as well as vitamins A, B, and C; berries have anthocyanins, plant-based pigments with strong antioxidant and anti-inflammatory benefits; and cantaloupe, pears, and pineapple are also nutritious. On the other hand, a number of fruits are not good for dogs at all: Grapes and raisins can cause acute kidney failure; fruit pits and seeds in cherries, mangos, peaches, plums, and apples may contain cyanide that, in large quantities, can be toxic.

17·Thursday·August 2023

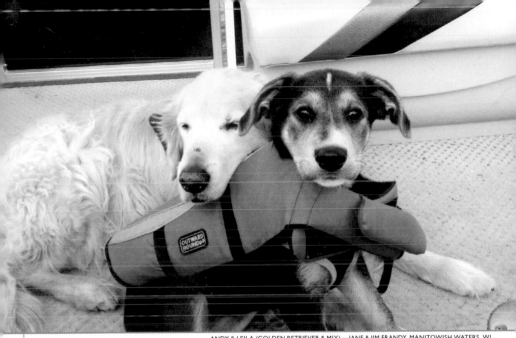

ANDY & LEILA (GOLDEN RETRIEVER & MIX).—JANE & JIM FRANDY, MANITOWISH WATERS, WI

SAVING GRACE Nearly half of the citizens of New Orleans who refused to evacuate the city during Hurricane Katrina did so because of their pets. In the aftermath of this disaster, Congress passed the Pets Evacuation and Transportation Standards Act, which compels rescue agencies to save pets as well as people. To date, more than 30 states have passed versions of the act.

18·Friday·August 2023

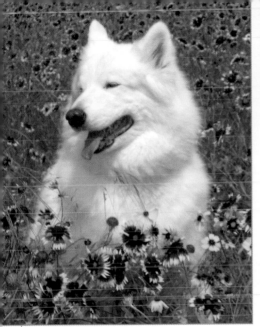

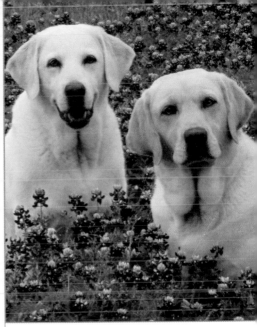

SAMOYED SERENITY
KOBIE (Samoyed).—
Karen Reynolds, New Braunfels, TX

19·Saturday
August₂₀₂₃

RETRIEVERS' REPOSE
MACY & KATIE (Labrador Retrievers).—
Sue Beaver, Corpus Christi, TX

20·Sunday
August₂₀₂₃

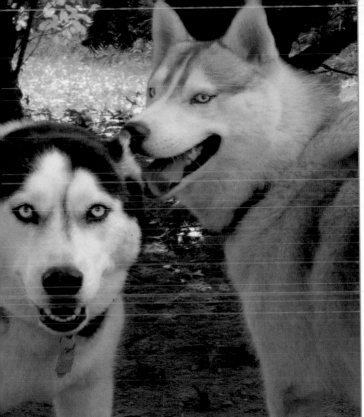

HUSKY HIERARCHY

Throughout the long history of their breed, Siberian Huskies have been called upon to live and work in packs. So it's not surprising that Huskies are especially skilled at forming hierarchies that make it easier for multiple strong-willed dogs to coexist peacefully. NANNA and SADIE are a pack of two who live with Susan Meier and her family in Southwick, MA. Susan explains that they worked out a highly functional relationship long ago: Nanna is bossy all the time, while Sadie always wants to play.

21·Monday·August 2023

REMEDY FOR RELIEF

Unfortunately, many canine seniors suffer to a large or small degree from arthritis. For an at-home temporary relief treament for hip pain, warm a damp (not wet) towel in the dryer for 10 to 11 minutes, then place it on your dog's hips while he's resting. The moisture in the towel retains heat. If you choose to use an electric heating pad, be careful not to set the temperature too high.

22·Tuesday·August *2023*

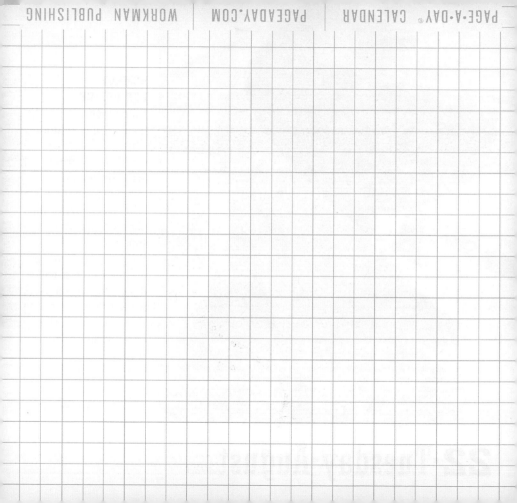

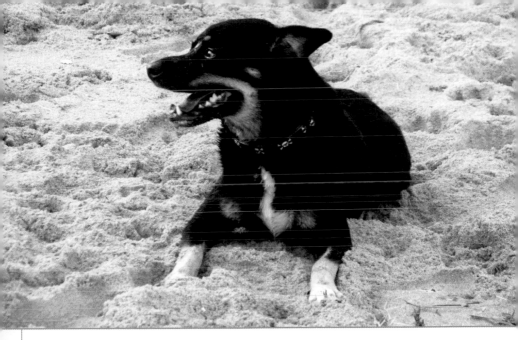

HAPPY ENDINGS CAESAR was just five or six weeks old when he was picked up on the streets of a bad neighborhood. He had severe burns on his back that had become badly infected. Thank goodness, the pup found his way to Jill Banaszak of Fort Lauderdale, FL, who was fostering for the county shelter. Impressed by his tremendous will to survive, Jill decided to adopt Caesar, a mixed breed, permanently. Although the physical scars are permanent, with Jill's help over the years, the brave dog has succeeded at moving beyond the emotional ones.

23·Wednesday·August₂₀₂₃

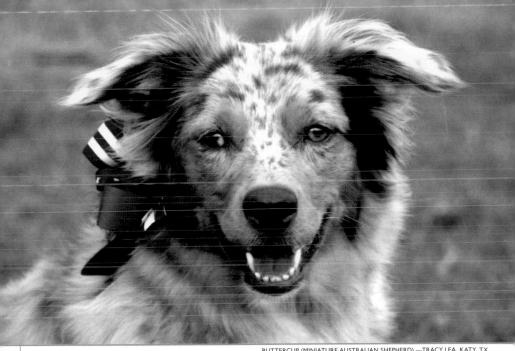

BUTTERCUP (MINIATURE AUSTRALIAN SHEPHERD).—TRACY LEA, KATY, TX

WHAT'S IN A NAME? Recognized world over as one of dogdom's greatest herders of both sheep and cattle, the Australian Shepherd is nevertheless misnamed. The talented Aussie is not, in fact, from Down Under, but rather from California, where the breed was created by ranchers during the mid-19th century.

24·Thursday·August *2023*

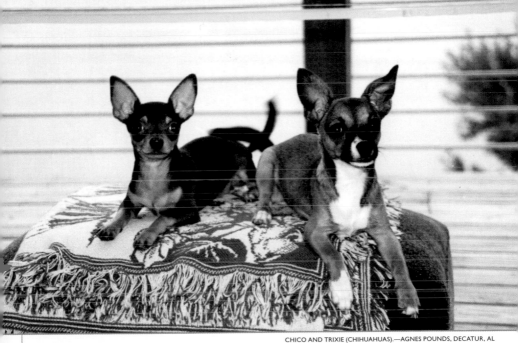

CHICO AND TRIXIE (CHIHUAHUAS).—AGNES POUNDS, DECATUR, AL

DOG EXPERT QUIZ

1. What is the tallest dog breed?
2. What is the tiniest dog breed?
3. What is the fastest dog breed?

ANSWERS:
1. Irish Wolfhound
2. Chihuahua
3. Greyhound

25·Friday·August 2023

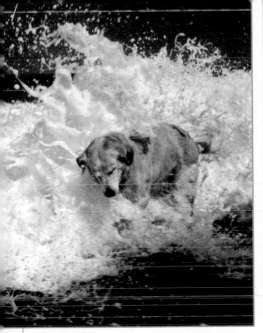

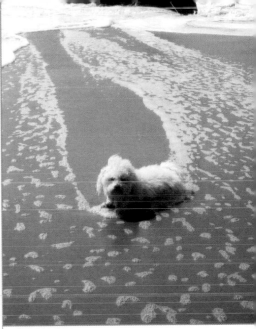

BIG SPLASH
Princess (Retriever).—
Laurence Mountcastle, Kailua-Kona, HI

26·Saturday
August *2023*

HIGH TIDE
Lily (Bichon Frise).—
Paula Church, West Tisbury, MA

27·Sunday
August *2023*

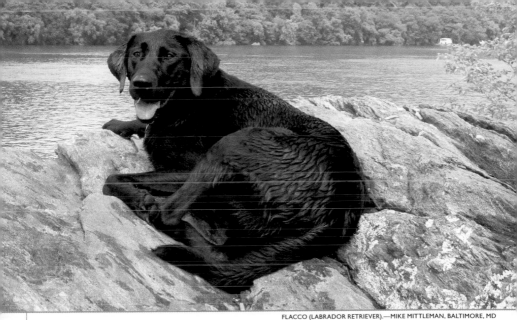

DOG DAYS OF SUMMER Lazy days and sleepy dogs are both familiar features of a long, hot summer. But pooped-out pooches were not the inspiration for the "dog days of summer," a popular phrase used to describe the steamy days of July and August. The expression originated in ancient Rome, where the *dies caniculares* or "dog days" were associated with the star Sirius, called the "Dog Star" because it was the brightest star in the constellation Canis Major (Large Dog). Romans wrongly believed that the star was the source of their hot weather, when "wine turned sour, the sea boiled, and dogs grew mad."

28·Monday·August 2023

SUMMER BANK HOLIDAY
(ENG., WALES, N. IRE.)

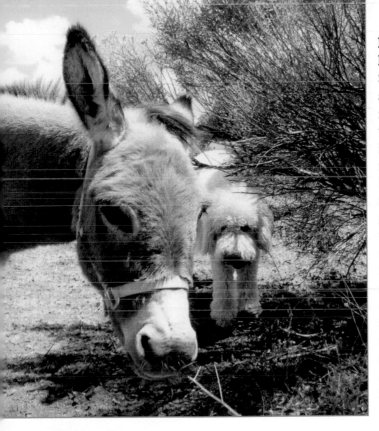

EVERYBODY'S BEST FRIEND

SPANKY gets along with all the many animals in the Neale family, including their miniature donkey, Louie. He even tried his paw at grazing, after watching Louie enjoying a meal, but the Goldendoodle decided that eating dried straw wasn't all that tasty. Susan and John Neale, as well as Spanky and the rest of the family, are from Farmington, NM.

29 · Tuesday · August 2023

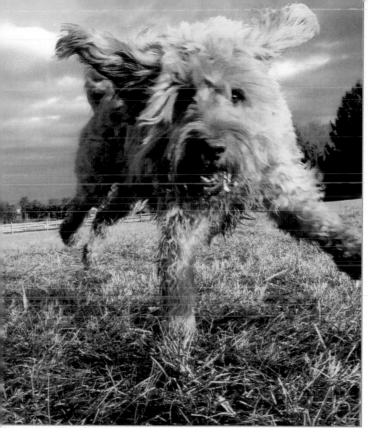

"**I**f every time you saw me, you gave me a back rub, I would run to greet you, too."

—ROBERT BRAULT

30·Wednesday·August *2023*

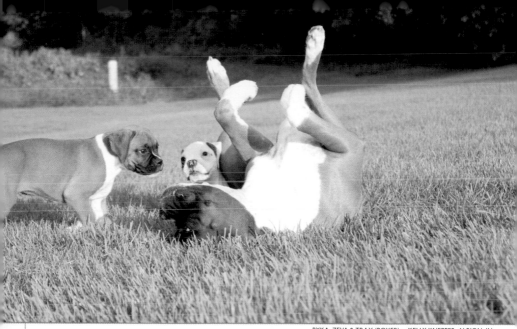

RYKA, ZEVA & TRAX (BOXER).—KELLY KNEPPER, ALBION, IN

TRAINING TIPS Although puppies socialize with their littermates soon after birth, once a pup is removed from the litter it's up to her human family to carry on with the time-sensitive task of socialization. Ideally, owners should allow their puppies to accompany them everywhere that is safe. That means to parks, to the library, to stores that welcome dogs, and to the homes of friends and relatives. The more a puppy interacts with other people and animals, the more social she will be as an adult.

31·Thursday·August *2023*

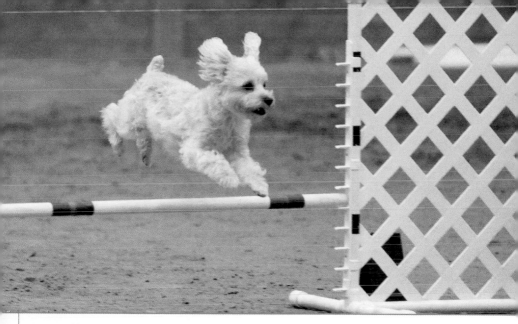

OVER THE TOP WENDY's a Morkie, a hybrid cross between a Maltese and a Yorkie, and according to her best friend, Mallory Shirley of Bradenton, FL, she's always been special. At puppy school she finished at the top of her class. She also competes in AKC agility events and has won 12 ribbons. And when she's at home, she's usually up to something that we've learned so many dogs from the Sunshine State really enjoy: hunting lizards.

1·Friday·September *2023*

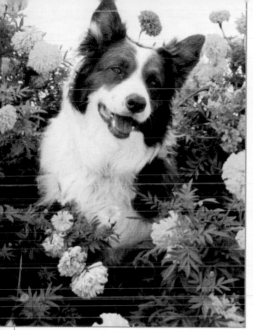

FLORAL BORDER COLLIE
Roxy (Border Collie).—
Darlene Maasz, Fort Atkinson, WI

2·Saturday
September *2023*

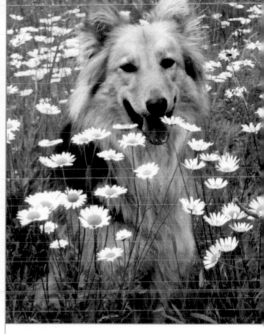

DAISY DOG
Becka (Shepherd mix).—
Kathy Harvey, Glasgow, KY

3·Sunday
September *2023*

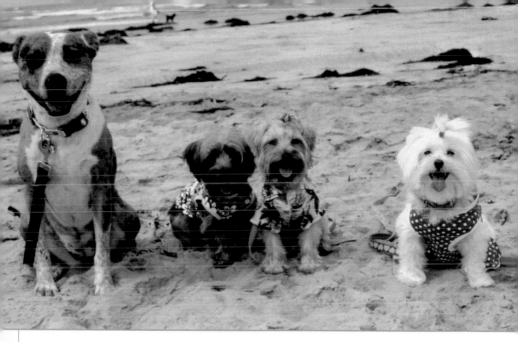

WAG IF YOU LOVE LONG WEEKENDS! What could be better than an extra day at the beach? These smiley buddies are, from left to right: JENNIE (Catahoula), THEO and NORMAN (Yorkies), and ANNABELLE (Maltese). All four of them were rescued by Heather and Todd Gabaldon of Glendale, AZ, and every year they get to accompany the family to the Del Mar Dog Beach in California. Heather let us know that Theo will be taking dog surfing lessons, while his furry siblings cheer him on from the beach.

4·Monday·September *2023*

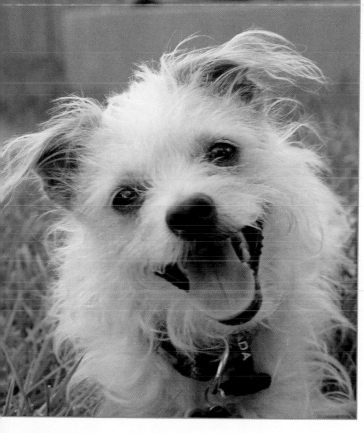

MUTT OF THE MONTH

Have you ever been invited to a terrier Tupperware party? Terrier mix LADY joined Holly Massey's family at age seven, after her previous owner could no longer take care of her. Holly explains that, although she is technically a senior, Lady has a high energy level and runs a mile with her and her husband every day. Apparently Lady isn't too old for mischief, either: She's convinced that any food left out on the kitchen counter is fair game and has even broken into Tupperware containers and sealed cookie jars. They live in Orange, CA.

5·Tuesday·September 2023

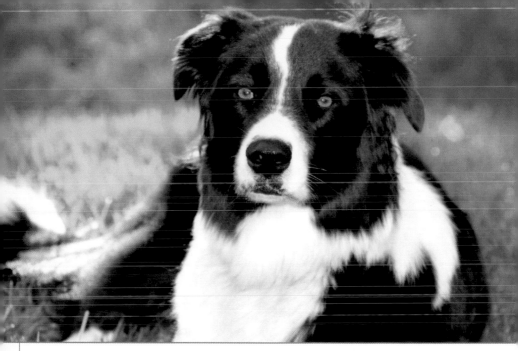

HAPPY ENDINGS Beautiful LIBBY was rescued from an animal shelter at four months old. Her new owner, Rozanne Leystra, recalls that the Border Collie's loving nature was evident from the get-go, and when she reached maturity, Libby became part of the provincial pet therapy program. Rozanne thinks that if more people had Libby's outgoing and positive attitude, what a wonderful world this would be. They live in Sarnia, Ontario, Canada.

6·Wednesday·September *2023*

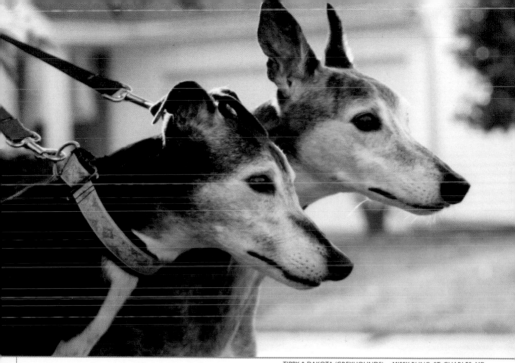

TIPPY & DAKOTA (GREYHOUNDS).—MISSY RUNG, ST. CHARLES, MD

NO SHADES OF GREY Capable of reaching speeds up to 43 mph, the Greyhound is the fleetest of all breeds. Curiously, though, fans of the Greyhound often report that she is a dog of extreme contrasts: Outdoors, she loves nothing better than tearing around a field like a lightning bolt; indoors, on the other paw, she is perfectly content with an extended snooze on the couch.

7·Thursday·September *2023*

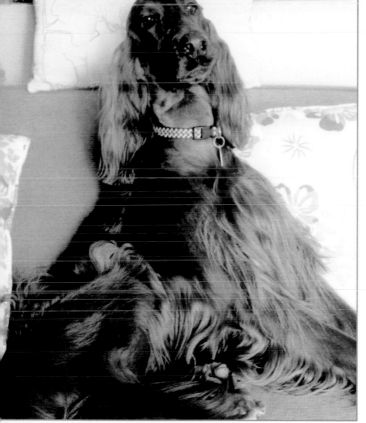

IRISH SETTER

• *Origin:* Eighteenth-century Ireland, where her ancestors include the Gordon Setter and the English Setter.

• *Profile:* As handsome as she is, the Irish Setter was developed for her prowess at hunting, rather than for her good looks. Her coat is moderately long, flat, and shiny, with longer feathering on the ears, tail, and belly, and it is a deep, rich color that's properly described as chestnut red or mahogany. The Irish's focused performance in the field is counterbalanced by her temperament at home, where she is known to be rollicking and sometimes downright goofy.

8·Friday·September*2023*

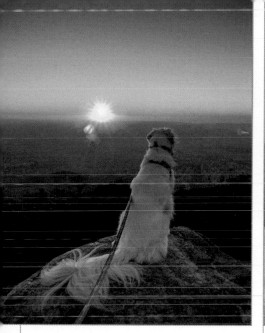

EARLY TO BED . . .
Sota (Brittany Spaniel mix).—
Adam Crane, San Diego, CA

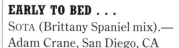

9 · Saturday
September *2023*

. . . EARLY TO RISE.
Lulu (Beagle mix).—
Jeff Weibel, Williams, AZ

10 · Sunday
September *2023*

*GRANDPARENTS
DAY*

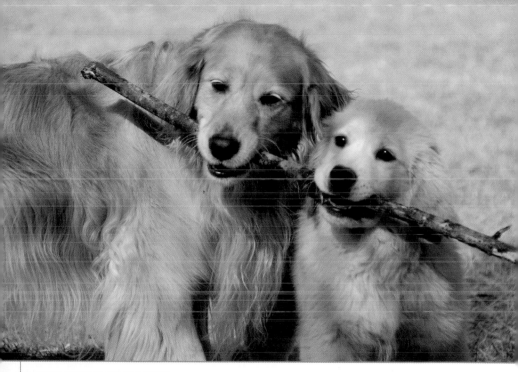

LET'S STICK TOGETHER Margaret Wagner of Bedford, VA, writes that her Goldens, JULIE and BELLA, do everything together—that includes eating, traveling, and even fetching.

11·Monday·September *2023*

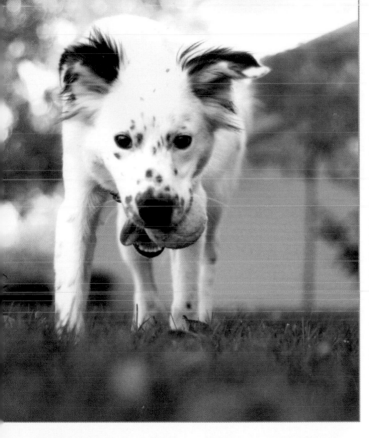

WORTH WAITING FOR

KERMIT's pal, Heidi Tyner, remembers that she had begged her parents to allow her to get a dog for five years before they finally said "yes." But the moment she saw the Dalmatian/Aussie mix at the shelter, Heidi knew he was for her and that she had found a friend well worth waiting for. They're from Cedar Rapids, IA.

12·Tuesday·September *2023*

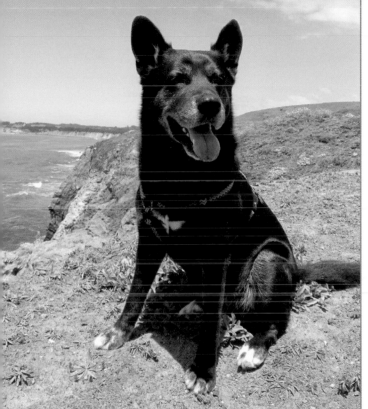

"**O**f course what he most intensely dreams of is being taken out on walks, and the more you are able so to indulge him, the more he will adore you and the more all the latent beauty of his nature will come out."

—HENRY JAMES

13·Wednesday·September₂₀₂₃

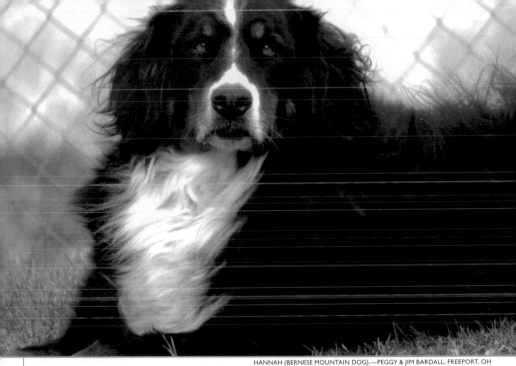

HANNAH (BERNESE MOUNTAIN DOG).—PEGGY & JIM BARDALL, FREEPORT, OH

A HAIR OF THE DOG Hair, itself a dead structure, is produced by living cells beneath the epidermis called hair follicles. Dogs have compound hair follicles that produce bundles of 7 to 15 hairs each, determined by their breed. Generally each follicle contains a single large, long, stiff guard hair along with a number of softer and finer underhairs.

14·Thursday·September *2023*

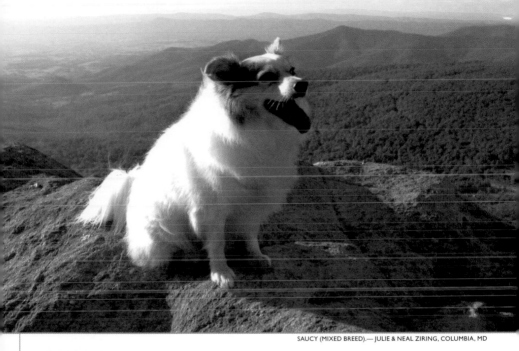

SAUCY (MIXED BREED).— JULIE & NEAL ZIRING, COLUMBIA, MD

ELEVATED RISK At elevations above 8,000 feet, dogs can get altitude sickness just as humans can. Outdoor lovers who take their dogs hiking or skiing should take precautions because altitude sickness can be dangerous and even result in pulmonary edema. A slow ascent to a high elevation is safer than a fast ascent. Exercise at unfamiliar heights should be limited. A vet may treat a dog affected by altitude sickness with acetazolamide or dexamethasone.

15·Friday·September *2023*

ROSH HASHANAH
BEGINS AT SUNDOWN

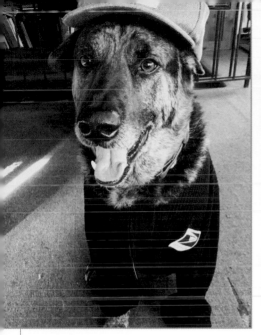

SPECIAL DELIVERY
LUCAS (German Shepherd).—
Lew, East Northport, NY

16 · Saturday
September *2023*

BREAKING NEWS
PUTTER (Golden Retriever).—
Chuck Gallina, Auburn, AL

17 · Sunday
September *2023*

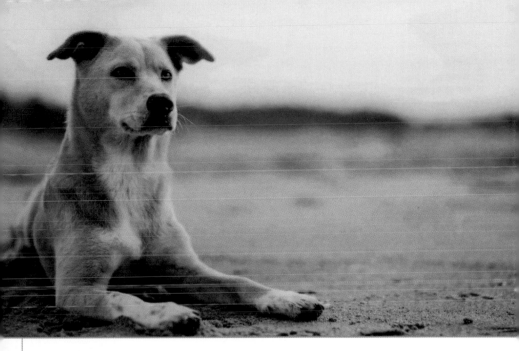

TO THE RESCUE Just say "cheese." Lindsay and Keith Hammond of Wilmington, DE, say that their Labrador/Beagle mix JUNO is an energetic dog who loves any activity that takes her outdoors. As a rescue dog, she's still a little shy around new people—that is, until someone offers her a piece of cheese, her favorite treat.

18·Monday·September 2023

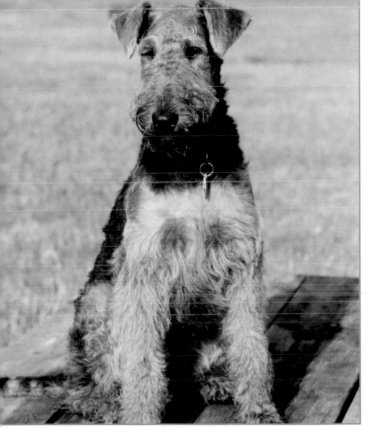

AIREDALE TERRIER

- *Origin:* The breed is named for the Aire River valley in northern England, where he hunted vermin that lived in the banks of the river. Later, during World War I, the courageous Airedale served as guard and messenger for the British military.

- *Profile:* The largest of all terriers—indeed, his nickname is "King of Terriers"—the Airedale has long legs, and males stand 23 inches at the withers. Devotees know that while he is both extremely intelligent and highly trainable, this remarkable dog has at the same time an undeniably goofy side and a wry sense of humor. More often than not, an Airedale harbors a strong conviction that he is the star of his family.

19·Tuesday·September ₂₀₂₃

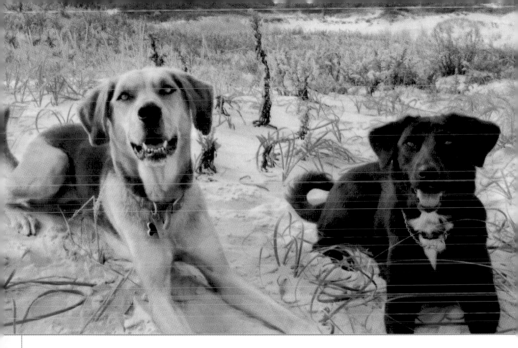

HAPPY ENDINGS Meet a pair of inseparable sun worshippers. When Christine Lincoln adopted MOLLY, the black Labrador mix was timid and depressed. But her other dog PAGE, a hound mix, immediately took Molly under her wing and gently encouraged her to come out of her shell in a way, Christine says, "that only another dog can do." Here, Molly and Page relax for some serious sunbathing near their home in Rockaway, NJ.

20·Wednesday·September*2023*

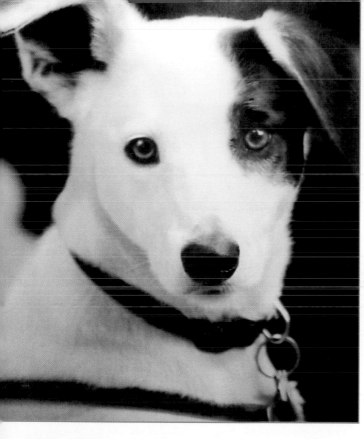

ABOUT FACE
Sweet-faced EMMA JAYNE is a Heeler/Collie mix who lives with Anita and Wayne Taylor of Owen Sound, Ontario, Canada. She loves to run, either on her own or alongside her dad's bike. Wayne writes that even as a senior dog, Emma never forgets a face. And who could ever forget hers?

21·Thursday·September *2023*

INTERNATIONAL DAY OF PEACE

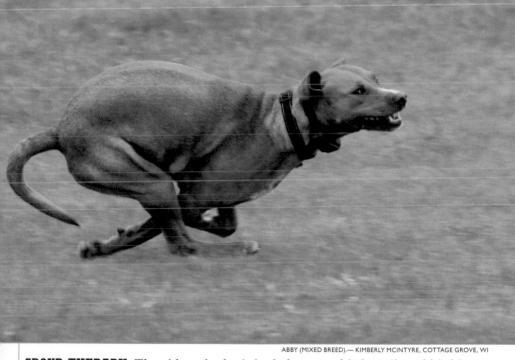

ABBY (MIXED BREED).— KIMBERLY MCINTYRE, COTTAGE GROVE, WI

CROUP THERAPY The sides of a dog's body between his last rib and his hip are the flanks; the area of the back above the hips, extending to the root of the tail, is the croup; the region directly above the hips is the haunch; the highest point of a dog's torso, basically his shoulders, is known as his withers.

22·Friday·September *2023*

RETRIEVER RECEIVER
SADIE (Goldendoodle).—
Leanne Meinema, Allendale, MI

23·Saturday
September *2023*

DOODLE DEFENSE
OAKLEY (Goldendoodle).—
Kayli Hoehn, Fort Myers, FL

24·Sunday
September *2023*

*YOM KIPPUR
BEGINS AT
SUNDOWN*

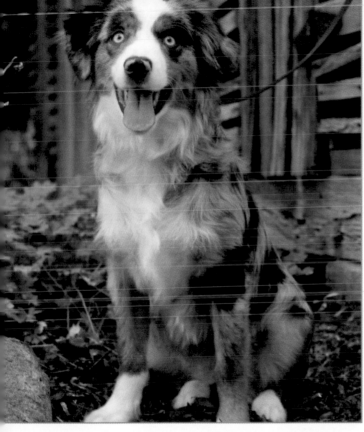

FUNNY BONES

Q: What do you call a dog who designs buildings?

A: A bark-itect.

25 · Monday · September 2023

*QUEEN'S BIRTHDAY
(WA AUSTRALIA)*

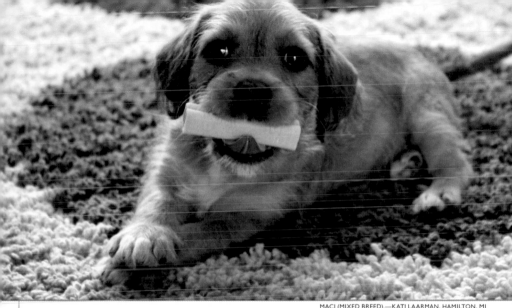

BONING UP Dogs have been eating bones for thousands of years. Today, however, there is controversy about the benefits and hazards of dog bones, and even veterinarians hold opposing views. Some vets warn that cooked bones are brittle and can splinter, while others believe raw bones can carry harmful bacteria. Some experts tell us to withhold all bones and replace them with hard rubber chew toys. Feeding your dog bones is a subject to discuss with your vet, but one word of advice can be agreed on by everyone: If you decide to give your dog a bone, make sure to *supervise* her when you do.

26·Tuesday·September 2023

*MAWLID AN-NABI
BEGINS AT SUNDOWN*

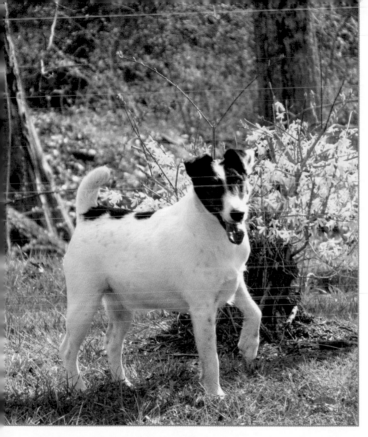

"**F**ox terriers are born with about four times as much original sin in them as other dogs are. . . ."

—Jerome K. Jerome

27·Wednesday·September 2023

227 Wednesday September 23

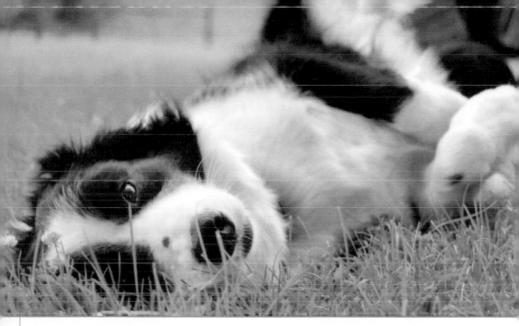

LYING DOWN ON THE JOB It's a rare moment when a Border Collie, one of the smartest, most talented, and hardest-working breeds of all, takes a break. But the late-summer sun was so warm and the grass so soft and comfortable that MOLLY just couldn't help it! Jeff and Bethanne Fowler know that Molly will be back on her feet soon and, as usual, herding other animals and her family or visiting her loyal fan base at several businesses in her small hometown of Mount Vernon, OH.

28·Thursday·September 2023

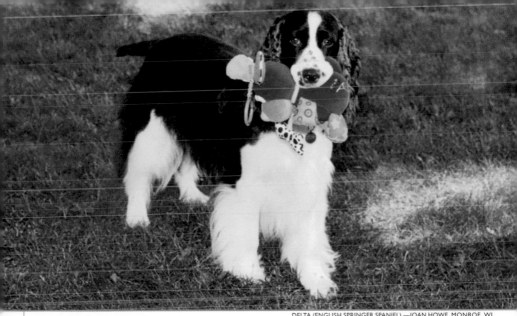

DELTA (ENGLISH SPRINGER SPANIEL).—JOAN HOWE, MONROE, WI

POOCH'S PLAY LIST No single dog breed has a monopoly on play, and any dog, no matter her breed, size, or age, probably enjoys playing. But according to the popular canine website Dogster.com, these are the breeds that like to play the most: English Springer Spaniel, West Highland White Terrier, Labrador Retriever, Papillon, Bearded Collie, Brittany, Portuguese Water Dog, Flat-Coated Retriever, Beagle, and Standard Schnauzer.

29·Friday·September 2023

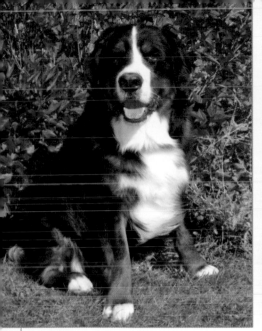

FALL GUY
Uno (Bernese Mountain Dog).—
Julie Daul, De Pere, WI

30·Saturday
September *2023*

FALLING FOR YOU
Teddy (Goldendoodle).—
Jacki Lawrence, Elmhurst, IL

1·Sunday
October *2023*

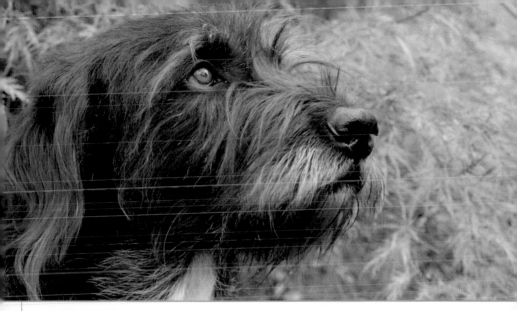

MUTT OF THE MONTH They say that the eyes are windows to the soul, and the story of BAILEY just might prove that to be true. After the pup was surrendered to a shelter in Tennessee when he was one year old, it was his eyes that saved him: The caring foster mom who decided to rescue him explains that "if they make eye contact with me, I pull them out." Soon, the Irish Wolfhound mix was on his way to Groton, MA, and a permanent home with Barbara Kozenko. Barbara tells us that after reading about pet therapy in the 365 DOGS CALENDAR, she had always dreamed about participating in it. Bailey enabled Barbara to fulfill that dream, and the pair visits a local hospital every week, where Bailey charms everyone he meets with those deep "cognac" eyes.

2·Monday·October *2023*

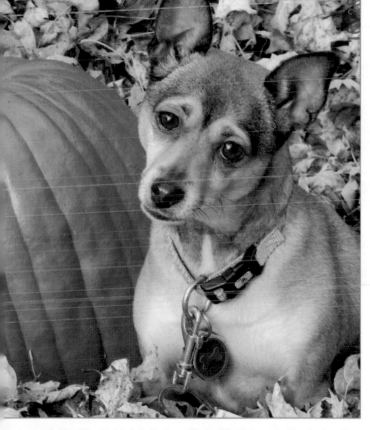

PUZZLING PUMPKIN

You'd be confused, too, if your family brought home a pumpkin that was bigger than you! HEIDI's a tiny cross of Chihuahua and Miniature Pinscher. Her owner, Vicki Radtke, explains how, perhaps in an effort to make up for her short stature, she often stands straight up on her hind legs like a meerkat surveying the landscape, all the while doing a 360-degree pirouette so she doesn't miss a thing. They're from Stoddard, WI.

3·Tuesday·October *2023*

It's time! Order your *365 Dogs Calendar* for 2024.

Visit **pageaday.com** to browse all of our unique, fun, and creative calendars. If you like this calendar, you may find these just your style, too:

The right calendar can bring a smile, a laugh, a challenge, or a new piece of information every day of the year. Discover which calendar is perfect for you, and then think about giving the gift of daily delight to someone you care about.

Get surprised and delighted by our cat and dog contests, new lines of stationery and puzzles—plus more! Sign up for our newsletter at **pageaday.com/news**.

Attention, Pet Parents!

Do you have an adorable cat or dog that wants to be a star?
Submit photos of your pet for a chance to be featured
in one of our beloved and bestselling pet calendars.

For instructions on how to submit photos, learn about
prizes, and for complete contest rules, go to:

pageaday.com/contests

HAPPY ENDINGS

When the going gets tough, the tough get going! English Bulldog MICKEY has spina bifida, an illness that renders him incontinent. In addition to that, he was born with his rear legs fused, and uses a rolling cart to get around outdoors. Sandi and Selina Kenitzer, of Hughson, CA, report that Mickey is strong, determined, loving, and funny—in other words, a true inspiration to everyone around him.

4·Wednesday·October *2023*

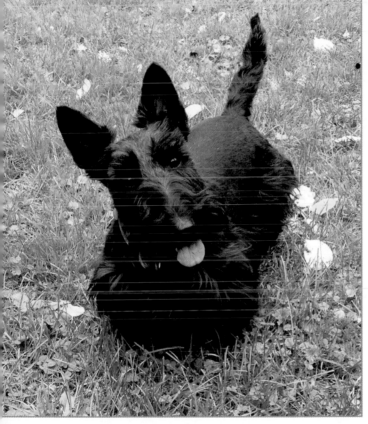

RAINED OUT

Several cultures have produced myths that link black dogs with evil or disaster. On a brighter side, the ancient Scots believed that if a stray dog followed you home, you would be granted good luck—and even more so if the dog was black. The Scots also held that if the dog actually entered your house, it portended a new friendship to come, one that would be faithful, sincere, and caring. Unless, that is, the dog entered your house on a rainy day, in which case you could expect nothing but bad luck to come of it.

5·Thursday·October *2023*

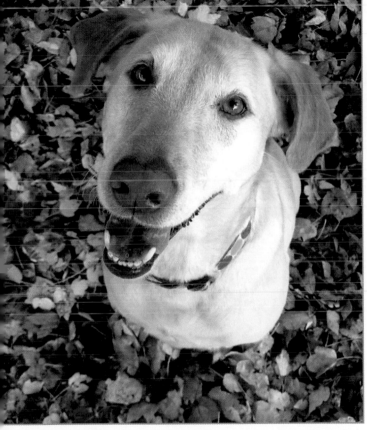

FALL FEAST FOR FIDO

This easy recipe for veggie pup chip treats from Samantha Meyers of *Dogster* magazine captures the colors and flavors of the season.

Ingredients: Sweet potatoes, beets, turnips, and/or carrots, and coconut oil

- Preheat oven to 250 degrees Fahrenheit.
- Wash and dry the vegetables.
- Slice each vegetable very thinly and coat in coconut oil.
- Bake for two hours, keeping a close eye on the veggies during the last half hour.

Note: You might add salt to the chips that you want to eat yourself, but your dog will probably love them even without salt.

6·Friday·October 2023

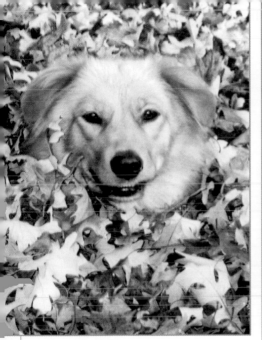

UP TO MY NECK
MAGGIE (Golden Retriever mix).—
Vicki Erdmann, Minneapolis, MN

7·Saturday
October *2023*

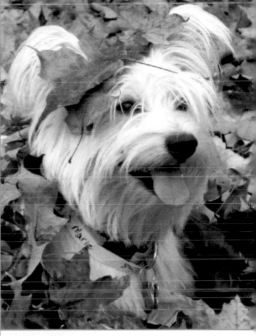

PILE IT ON
AGNES (West Highland White Terrier).—
Cathi & David Combs, Jackson, TN

8·Sunday
October *2023*

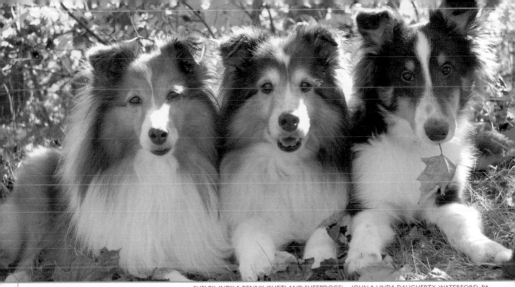

SHETLAND SHEEPDOG •*Origin:* Known by the nickname "Sheltie," the Shetland Sheepdog hails from the archipelago of Shetland, an area of roughly 500 square miles, off the northeastern coast of Scotland. Both the Sheltie and his larger cousin the Collie are thought to have derived from Scotland's older Border Collies.

• *Profile:* The Sheltie's beautiful double coat consists of a soft undercoat so dense and furry as to give the long, straight, and harsh outer coat a quality that aficionados call "standoff." Essentially a working Collie in miniature, the Sheltie is extremely intelligent and athletic, excelling in several canine sports. At home the breed is eager to be involved with his human family, though, like many herding dogs, he's cautious of new people and other animals.

9·Monday·October 2023

INDIGENOUS PEOPLES' DAY
COLUMBUS DAY OBSERVED
THANKSGIVING (CANADA)

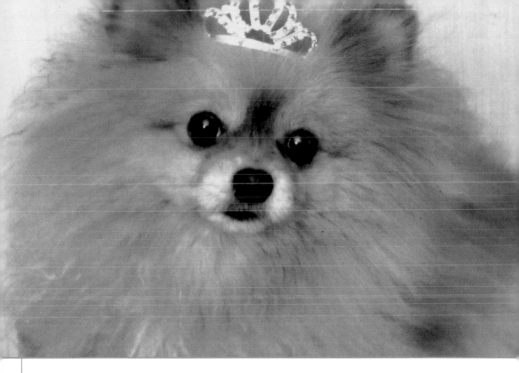

POM QUEEN Howard and Elizabeth Crutchfield admit that when they first met her at the breeder's, Pomeranian GRACIE was already a diva. Now, there's no question who wears the crown around their home in Youngsville, NC.

10 · Tuesday · October 2023

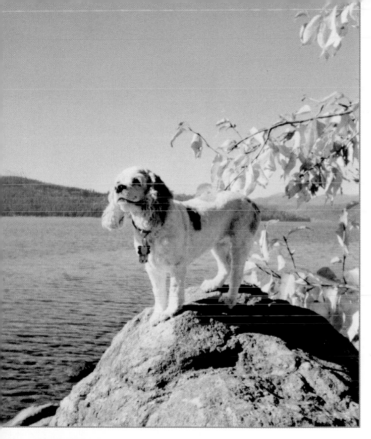

"**D**ogs' lives are too short. Their only fault, really."

—AGNES SLIGH TURNBULL

11·Wednesday·October *2023*

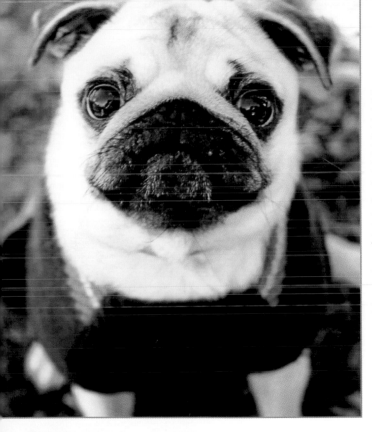

ITSY-BITSY
Her family, Kevin, Kirsten, and Kenna Kalka of Florissant, MO, tell us that when this photo was taken, their Pug, Bitsy, was just about to take off with a squeaky toy or a stolen sock. She paused for a brief moment, as if to deliver a message they've heard often since Itsy joined the family: "Catch me if you can."

12·Thursday·October *2023*

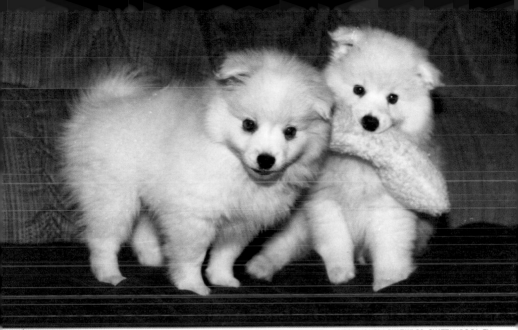

SHAY & DILLY (AMERICAN ESKIMO DOGS).— ANDREA JONES & FAY TAYLOR, CHATTANOOGA, TN

TRAINING TIPS Traditionally, the period between a puppy's third and twelfth week of life is known as the "socialization period." During this time, safe exposure to as many other animals, people, and experiences as possible can help him grow up into a secure and well-behaved adult. Don't forget, though, that exposure to new stimuli continues to benefit a dog long after the official socialization period has passed.

13·Friday·October *2023*

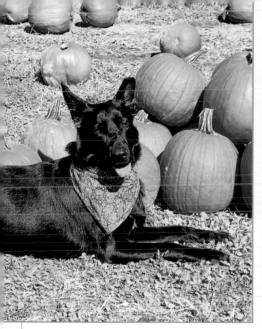

POOCH IN THE PATCH
DAPHNE (German Shepherd).—
Marie Guide, Woburn, MA

14·Saturday
October 2023

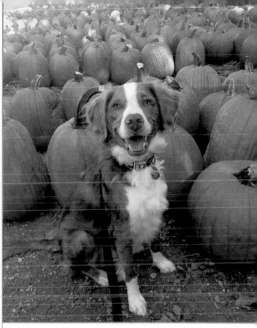

EASY PICKIN'S
BOOMER (Brittany Spaniel/
Australian Shepherd mix).—
Kelsi Wrigley, Macon, IL

15·Sunday
October 2023

October

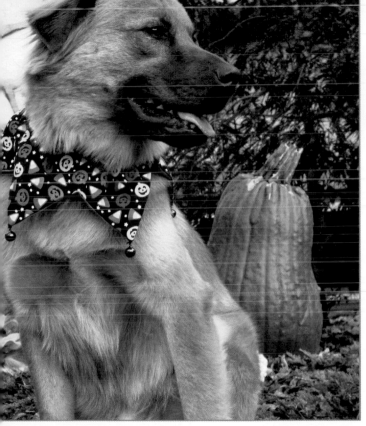

IN FOR A TREAT

Mixed breed ACE keeps an eye out for neighborhood tricksters. But according to Marion and Baron Yeager of Mercerville, NJ, who rescued him, Ace himself has been a really good boy—and Halloween's going to be all treats. The Yeagers note that this doesn't mean candy because they're aware that sweets are not good for dogs. Instead, Ace will get bits of fresh apples and carrots and gourmet dog treats baked and decorated especially for Halloween.

16·Monday·October 2023

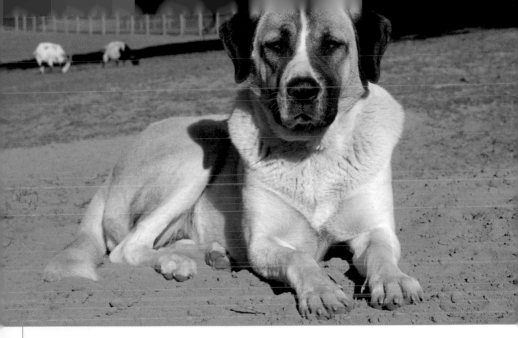

RARE OCCASIONS Contrary to her breed name, the Anatolian Shepherd was developed as a guard dog rather than a herding dog. Originating in Turkey as far back as 6,000 years ago, she is large in size and faithfully protective of livestock under her charge, as well as her human family. Her coat may be either smooth or rough, up to four inches long, and any color or pattern, including fawn and brindle. NOEL is an Anatolian who lives and works on a small ranch in Salinas, CA. Her pal, Carol White, reports that, true to her hardworking roots, Noel takes her job very seriously.

17·Tuesday·October 2023

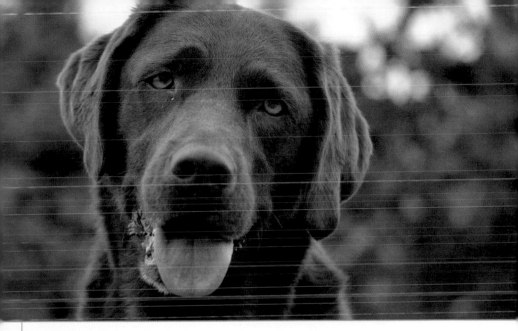

HAPPY ENDINGS In 2014, REESE was diagnosed with a grade II mast cell tumor. She underwent two surgeries to remove the tumor and eight chemotherapy treatments to prevent the spread of cancer to her liver and spleen. Her owner, Elizabeth Czenczek of Kitchener, Ontario, Canada, is so happy to report that recently an ultrasound test has shown that Reese is now in remission, and the chocolate Lab is back to her old self: happy, adventurous, and snuggly.

18 · Wednesday · October *2023*

TRAINING TIPS

Since when does dog training involve a great deal of catnapping?

A young puppy cannot reasonably be expected to refrain from relieving himself for more than three hours. Thus, caretakers who want to do the best by their puppies must learn how to cope with long nights consisting of short periods of sleep interrupted by quick trips outside. Sleepy owners can take comfort in one reliable fact: The more often a pup is taken out, the sooner the housebreaking period will be over.

19·Thursday·October *2023*

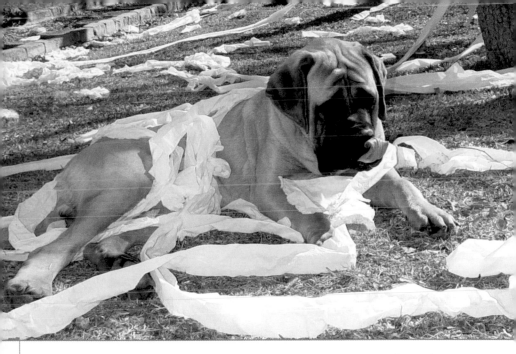

LET THE GOOD TIMES ROLL! As guilty as he may appear, BUSTER was actually not the one who made this mess, says Shannon Ross of Fort Worth, TX. Instead, the English Mastiff (a breed renowned for its skill as a guard dog) was actually snoozing while a group of kids plastered the yard's trees with toilet paper. Shannon and her family woke up to the strange sight of Buster munching on the rolls that had fallen from the trees during the night.

20·Friday·October 2023

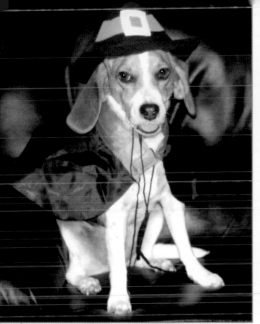

DOUBLE, DOUBLE . . .
GABRIELLA (Beagle).—
Eugenia Anton, Miami, FL

21·Saturday
October *2023*

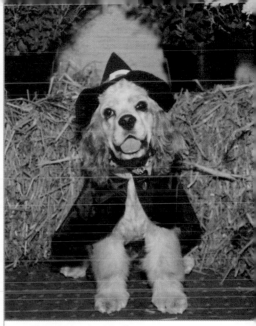

. . . DOGGIE TROUBLE
MAGGI MAY (Cocker Spaniel).—
Shelli McManus, Knox, TN

22·Sunday
October *2023*

REFLECTIVE ROTTIE

In this pensive shot, JADE takes in the vibrant autumn gold from the deck of her home in Severn, MD. Her caretaker and best friend is Michelle Melotti. As the Rottweiler enters her golden years, Michelle also finds herself feeling a bit reflective. Reminiscing about her first encounter with the pup, she remembers Jade came into her life just when she needed her most.

23·Monday·October *2023*

LABOUR DAY (NEW ZEALAND)

STREET SMART

Homeless dogs in urban centers are collectively known as "street dogs." We look forward to a time when no dog has to live on the streets, but in the meantime it's amazing to realize just how strong and resilient street dogs can be. On the resort island of Phuket in Thailand, for instance, almost the entire population of street dogs was wiped out after the disastrous tsunami in 2004. In a span of only one year, the street dog population had almost replenished itself.

24·Tuesday·October 2023

BANDIT (BORDER COLLIE).—CATHERINE & GARY PAQUETTE, RIVERSIDE, RI

"**I**f he didn't have other outlets I swear he would herd the toilet and the bathtub."

—Roger Caras, on his Border Collie Duncan

25·Wednesday·October *2023*

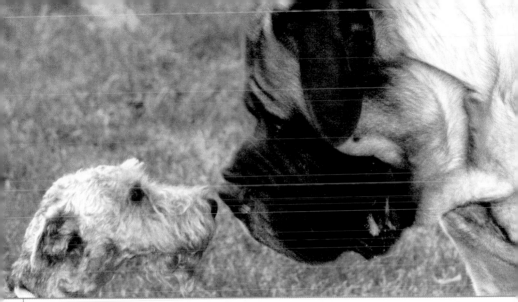

GETTING TO KNOW YOU For young dogs working on their socialization skills, as well as older rescued or re-homed dogs who were denied the chance to develop their skills properly, dog trainer Abbie Mood offers a low-stress method of socialization she calls the "three-second rule." When meeting new people or other animals, relax the leash and allow the dog to sniff "hello" for three seconds before moving along. Mood thinks that's enough time for a dog to assess the presence of another creature, but not enough time for a potential problem, such as aggression, to get out of control.

26·Thursday·October 2023

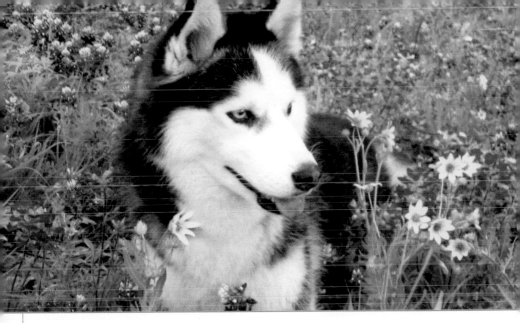

TO THE RESCUE Lovely SASHA was rescued through an organization called Husky Haven. Her companions, Cyndi and Frank Whitley of Houston, TX, note that this photo was taken during an annual trip to photograph their dogs rambling in the wildflowers. The blue flowers here are, of course, bluebonnets, the state flower of Texas, and we think they coordinate beautifully with Sasha's ice-blue eyes.

27·Friday·October *2023*

THE DEVIL FINDS WORK . . .
Zoe (Cockapoo).—
Jack & Paula Kotowski, Santa Barbara, CA

28·Saturday
October 2023

. . . FOR IDLE PAWS
Dorrie (Shih Tzu).—
Linda Prichard, Taylorsville, UT

29·Sunday
October 2023

EVERYBODY'S BEST FRIEND Does it tickle between the toes? A meticulous cat named Meeko puts the finishing touch on a bath and manicure for Yorkie MARLIE. These buddies live with Michelle Graff in Groton, SD.

30 · Monday · October *2023*

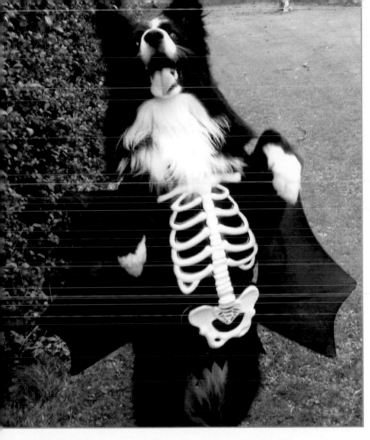

CREEPY COLLIE

Everybody knows that Border Collies are one of the smartest breeds of all—some of them can understand hundreds of words. But we didn't know that one of those words is *boo*! This spooky pooch is ASHA, who lives with Connie Kells in Newtownards, County Down, Northern Ireland.

31·Tuesday·October *2023*

HALLOWEEN

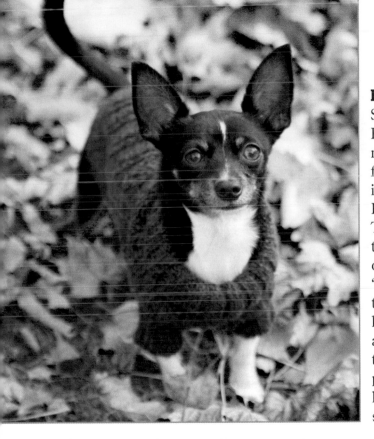

HAPPY ENDINGS

SCOOBY is a Toy Fox Terrier mix rescued from a shelter in Philadelphia. Kristie Natalini of Trooper, PA, says that he's smart, observant, and "interactive." In the fall, when the leaves turn color and the nights turn cooler, five-pound Scooby knows that it's sweater weather.

1·Wednesday·November 2023

2 Thursday November 2023

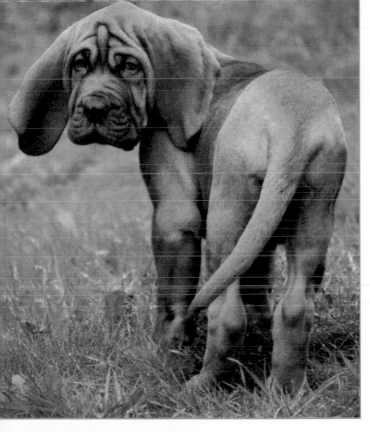

MASTIFF MOMENT

Most of the time DEMPSEY is just like all puppies—he's growing by leaps and bounds, he plays all the time, and he's undeniably goofy. But every once in a while, there's a moment when this little tough guy gives a look that lets you know that he'll grow up to be everything a Mastiff was born to be—strong, serious-minded, and 100 percent protective of his friends. He lives with Stacie Ballweg in Duvall, WA.

3·Friday·November 2023

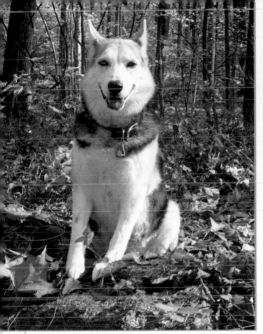

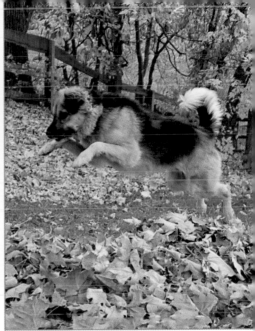

FALLING FOR YOU
 (Siberian Husky mix).—
Patricia & Jerry Harlowe, Catonsville, MD

4·Saturday
November *2023*

JUMPING OVER A NEW LEAF
SHELBY (Chow/Shepherd mix).—
Guy & Lori Wagner, Union, KY

5·Sunday
November *2023*

DAYLIGHT SAVING TIME
ENDS AT 2:00 A.M.
(US & CANADA)

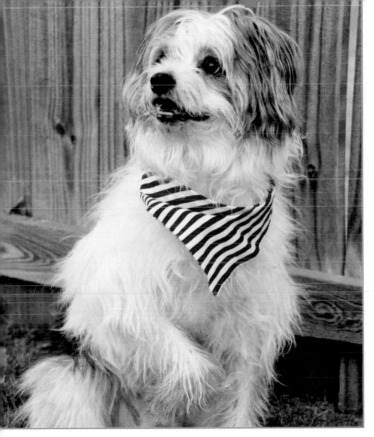

"**C**hildren and dogs are as necessary to the welfare of the country as Wall Street and the railroads."

—HARRY S. TRUMAN

6·Monday·November 2023

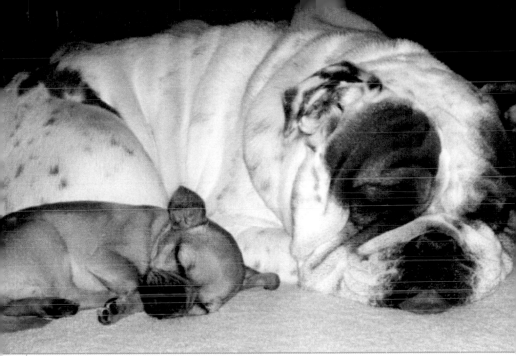

WEEZY (BULLDOG) & ABBY (CHUG).—NICK BISTODEAU, CAMBRIDGE, MN

"**L**ife is something to do if you can't get to sleep."

—FRAN LEBOWITZ

8·Wednesday·November 2023

It's time! Order your *365 Dogs Calendar* for 2024.

Visit **pageaday.com** to browse all of our unique, fun, and creative calendars. If you like this calendar, you may find these just your style, too:

The right calendar can bring a smile, a laugh, a challenge, or a new piece of information every day of the year. Discover which calendar is perfect for you, and then think about giving the gift of daily delight to someone you care about.

Get surprised and delighted by our cat and dog contests, new lines of stationery and puzzles—plus more! Sign up for our newsletter at **pageaday.com/news**.

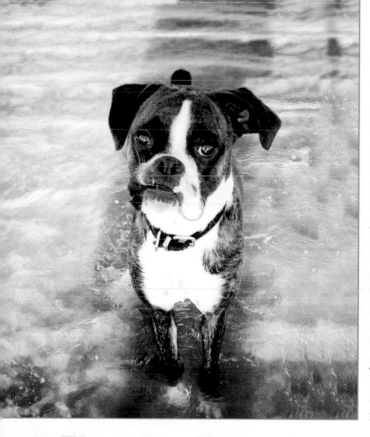

TO THE RESCUE

Rescued through Florida Boxer Rescue when she was a year old, BRANDY is a Florida native. She enjoys her new home near the beach in Jacksonville, FL, but her companion, Kayla Barker, explains that she has a love-hate relationship with the water: She loves running and jumping in the surf, but mention a bath, and she'll take off for parts unknown.

9·Thursday·November *2023*

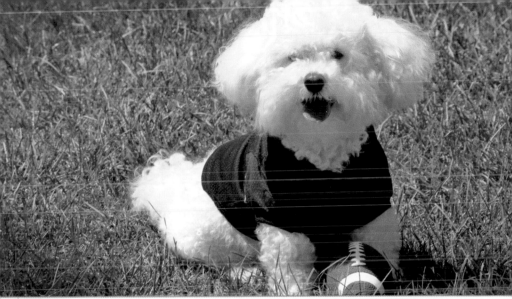

PRO PAWS POINT SPREAD

Matt Ufford, sportswriter for SB Nation, suggests this offensive lineup for a canine pro-football dream team:

QB Golden Retriever
RB Siberian Husky
FB Bull Terrier
WR1 Whippet
WR2 Aussie
TE Bullmastiff
OL Mountain dogs
(Bernese, Saint Bernard, Great Pyrenees)

And for defense:

DT Mastiff
DE Rottweiler
LB Pit Bull
CB Jack Russell
SS Boxer
FS German Shepherd

10·Friday·November 2023

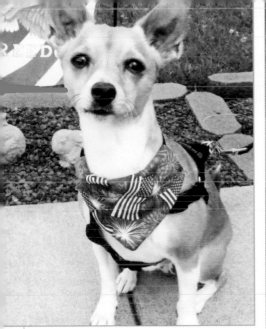

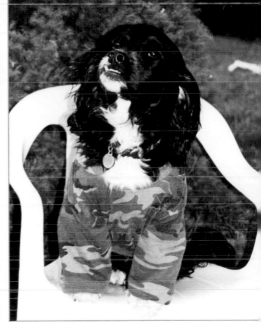

AT ATTENTION
CHLOE (Terrier mix).—
Paul & Michele Ruane, Middleburg, PA

11·Saturday
November 2023

VETERANS DAY
REMEMBRANCE DAY
(CANADA)

ON A MISSION
LOUIS (Miniature Dachshund/Cocker Spaniel mix).— Evelyn & Bill Thrift, Bowie, MD

12·Sunday
November 2023

DIWALI BEGINS

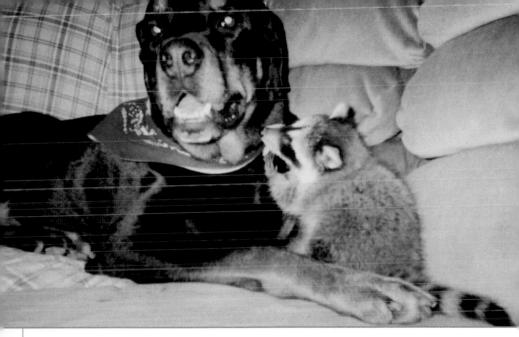

EVERYBODY'S BEST FRIEND Nobody can cook up trouble as quickly as a raccoon can, and it looks like Coonley is at it again. GAGE listens politely, but he wants no part of the raccoon's latest plan for mischief. Colleen Condon of Walworth, WI, tells us that Gage, a Rottie, is the most patient creature she's ever known, and he keeps his cool with all her orphaned animals.

13·Monday·November 2023

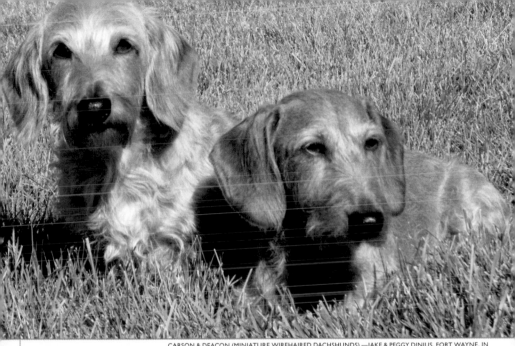

CARSON & DEACON (MINIATURE WIREHAIRED DACHSHUNDS).—JAKE & PEGGY DINIUS, FORT WAYNE, IN

SMALL DOGS WITH BIG DREAMS Small dogs are growing—not in size, but in popularity. While most of the top ten breeds registered by the AKC are big, like the Lab (who's been top dog for more than two decades), as of this writing, the Yorkshire Terrier is seventh on the AKC's list of registrations. Another little guy with big aspirations is the Dachshund, who holds tenth place. Standard Doxies weigh up to 32 pounds, but the miniature variety is 11 pounds or less.

14·Tuesday·November *2023*

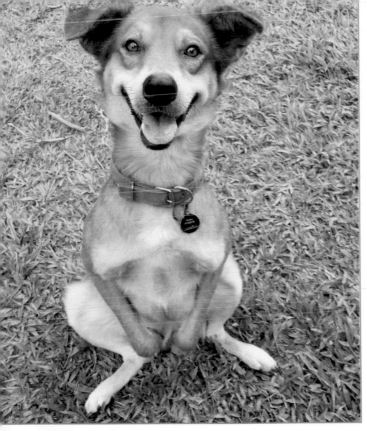

HAPPY ENDINGS

TIMMY was rescued from a life on the streets of Malaysia, and now he's safe and secure in a new home with Siew Hui Ming of Selangor. Siew thinks that the difficulty and danger of the mixed breed's former street life may be the reason why Timmy's favorite hobby these days is simply sleeping. After all, he's earned his rest!

15·Wednesday·November *2023*

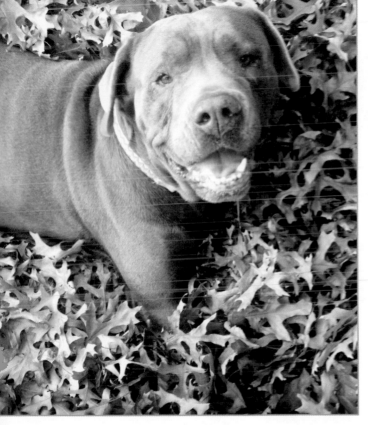

RARE OCCASIONS

The Cane Corso is a fascinating breed found mostly in southern Italy, and especially the regions of Puglia, Lucania, and Sannio. It is believed to be a descendant of the giant Mastiff-type dogs bred by the ancient Romans. The breed name derives from the Latin word *cohors*, meaning guardian or protector, and challenging such a formidable friend would seem like a very bad idea indeed! At the same time, the Cane Corso, if trained properly, can be a wonderful family dog. Bo, who lives with Maggie Leep in Oklahoma City, OK, is described by her family as sweet, funny, and very loyal.

16·Thursday·November 2023

ELSA (CHIHUAHUA)—GAIL SWINGLE, EUCLID, OH

DOG EXPERT QUIZ

Toy dogs have been popular all over the world for centuries. Can you match the breed with its country of origin?

1. Entlebucher
2. Affenpinscher
3. Papillon
4. Shih Tzu
5. Silky Terrier
6. Chihuahua

A. France
B. Australia
C. China
D. Switzerland
E. Germany
F. Mexico

17 · Friday · November *2023*

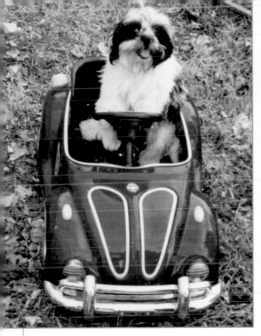

THE ROAD LESS TAKEN
KIANA (Shih Tzu).—
Ruben & Suzanne Santana, Brooklyn, NY

18·Saturday
November *2023*

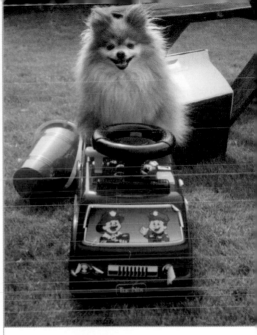

BUSMAN'S HOLIDAY
PEANUT (Pomeranian).—
Ed Gervasoni, Castro Valley, CA

19·Sunday
November *2023*

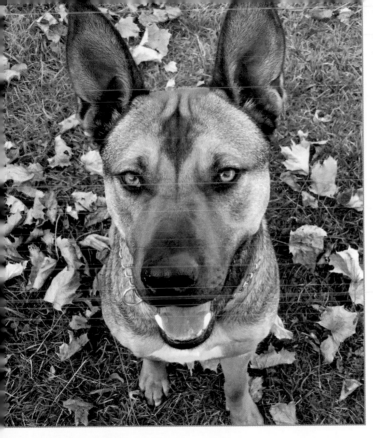

REBEL WITH A CAUSE

Adopted but soon returned to the shelter because of his high energy level and his talent as an escape artist, REBEL's cause was clear: Find a permanent home. Luckily, the Malinois/Pit Bull mix was rescued by Rebecca Naragon of Bremen, IN, who, after many hours of training, brought him to a place where he felt secure enough to calm down and behave well. Rebecca tells us that when she walks Rebel through town, everyone takes a double look because of his unique face.

20 · Monday · November 2023

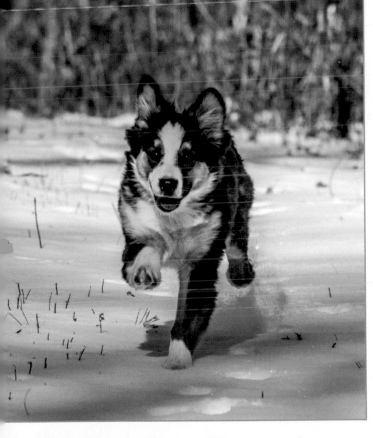

FIRST SNOW
The white stuff came early in Missouri, but not too early for CELLA. There's nothing that makes the athletic Australian Shepherd happier than bounding through the woods on the morning after a storm. She lives in Waverly, MO, with Lisa Hostetter, who will try to catch up with the Aussie as soon as she puts on her snow boots.

21·Tuesday·November *2023*

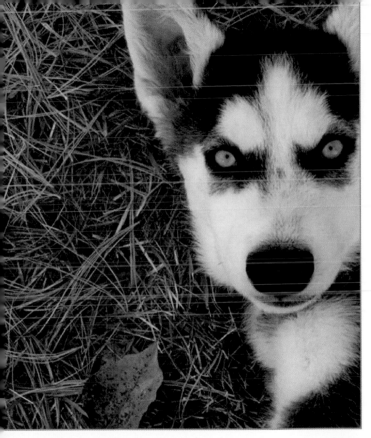

"**H**e seemed neither old nor young. His strength lay in his eyes. They looked as old as the hills, and as young and as wild."

—JOHN MUIR

22·Wednesday·November *2023*

BIRD WATCHER When the host said, "Say cheese!" for a holiday dinner photo, HUNTER looked right into the camera as he always does. TOPAZ, on the other hand, had eyes only for that turkey. Happily, the patient Golden Retrievers got to share a delicious Thanksgiving dinner with their best friend, Brian Stringall of Hillsborough, NC.

23·Thursday·November *2023*

THANKSGIVING

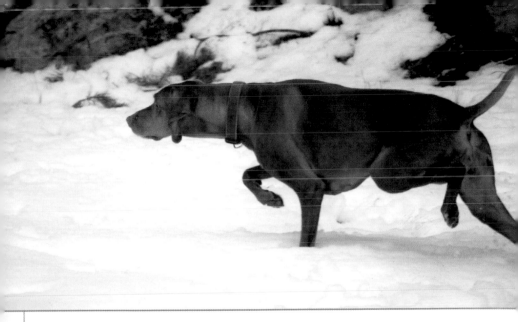

A POINT WELL TAKEN Although any dog at all might be trained to point, some breeds, such as the Vizsla, have an instinctual knack for it. Here, EMMA, a Vizsla who lives with Lorraine Jorqlewich in Marietta, GA, displays a classic point: She stands motionless as if frozen in time, her snout thrust forward toward the scent; one front foot is held up off the ground, her tail is pointed to the sky as she maintains an intense focus on her work.

24·Friday·November *2023*

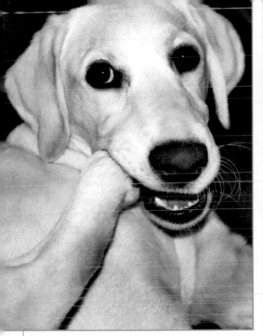

JUST A NIBBLE
BRIE (Labrador Retriever).—
Sarah & Paul Pontynen, Stuart, FL

25·Saturday
November*2023*

CHOMP!
LAURELAI (Lab/Golden/Terrier mix).—
The LeCorre Family, Shoreham, NY

26·Sunday
November*2023*

MARCUS (FRENCH BULLDOG).—CHANTAL FERRINI, MENLO PARK, CA

TRAINING TIP Many dogs have an instinctual dislike of having their paws touched. But in case of an emergency, it's important to get your dog accustomed to it.

Place a towel on your lap (or on the floor if he's large). Put your dog's front paws on the towel, and then hold a treat in the air above him. When he tries to reach the treat, say "yes" and reward him with the treat. After repeating several times, gently fold the towel over his paws before giving him the treat. If he removes his paws from the folded towel, withhold the treat until the next session.

Finally, with gradually increasing pressure over time, rub your dog's paws with the towel. By this time, he should be comfortable with your touch.

27·Monday·November 2023

TALLIE (ALASKAN MALAMUTE).— LINDSEY & PAUL RIGGS, PISCATAWAY, NJ

SERIOUS FUN According to a report from the AKC, recent research shows that dogs who frequently play with people and other dogs are less fearful, less destructive, and have far fewer behavioral problems than dogs that don't play.

28·Tuesday·November *2023*

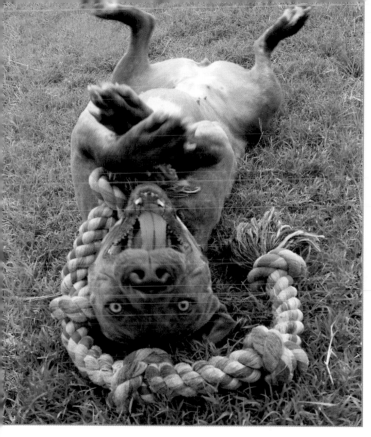

HAPPY ENDINGS

BELLE is an endearingly goofy American Staffordshire rescued by Viki Dunn of Aubrey, TX. Viki recalls that Belle was rejected from three homes in only three days, and she was unsocialized and insecure. With a great deal of TLC from Viki, as well as from the other two rescued dogs and two rescued cats who live in Viki's home, Belle has come a long way, and she can finally believe that she is home for good.

29·Wednesday·November *2023*

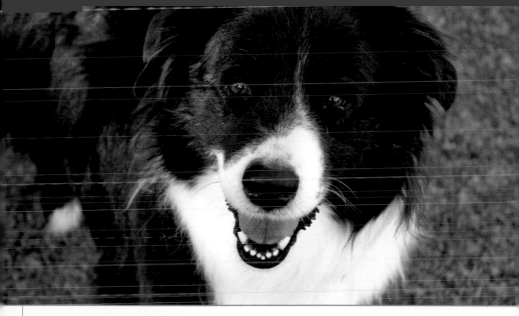

MUTT OF THE MONTH When Katie O'Meara of Rancho Santa Fe, CA, rescued her from a puppy mill, she was told that LUCY was a Border Collie. But as Lucy grew and grew, beginning to look more like a bear than a Border Collie, Katie's curious family decided to have a DNA test done. The O'Mearas learned that their adopted daughter has many breeds in her genetic makeup but that it would be most accurate to call her a Great Pyrenees mix.

1·Friday·December *2023*

KEEP YOUR EYES . . .
KODA (Golden Retriever/Collie mix).—
Jennifer Kertz, Fort Myers, FL

2·Saturday
December 2023

. . . ON THE PRIZE
BENNIE (English Cream Golden Retriever).—
Billy & Kerri McKellar, Franklin, TN

3·Sunday
December 2023

BRUSSELS GRIFFON • *Origin:* The development of the Brussels Griffon is credited to coachmen of 19th-century Belgium who bred dogs to keep their stables free of vermin.
• *Profile:* A beard, mustache, and a facial expression often described as "almost human" are hallmarks of this distinctive breed. Although typically his coat is harsh and wiry, the breed also includes a variety of smooth-coated dogs known as the Brabançon. Due to his small size, the Brussels Griffon makes a wonderful companion in urban settings. That said, however, he is in no way content to lead the life of a pampered lapdog. Instead, his intelligence and high energy demand regular physical activity and mental stimulation as well.

4·Monday·December 2023

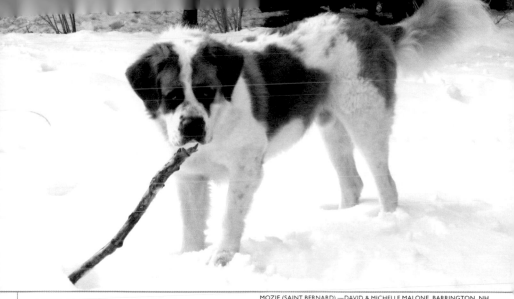

MOZIE (SAINT BERNARD).—DAVID & MICHELLE MALONE, BARRINGTON, NH

WINTRY WISDOM A dog's skin is just as sensitive as a human's or even more so, and dry, cold, or windy winter air can be damaging. Here are some simple tips to avoid skin problems through the season:

- Provide plenty (at least one ounce per pound daily) of fresh water.
- If the air in your house is especially dry, invest in a humidifier.
- Bathe your dog less during the winter.
- Brush your dog daily—brushing removes dead skin cells and stimulates natural oils.
- Ask your vet about adding a fatty acid supplement, such as fish oil, to your dog's diet.

5·Tuesday·December *2023*

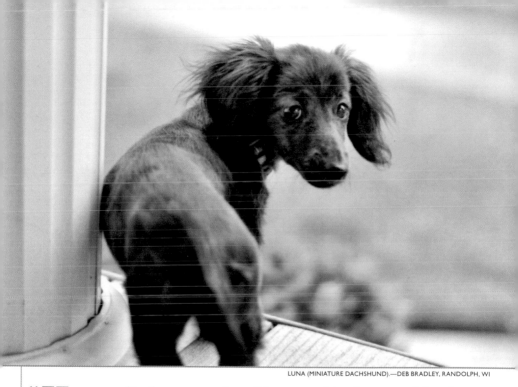

LUNA (MINIATURE DACHSHUND).—DEB BRADLEY, RANDOLPH, WI

"**H**e even disobeys me when I instruct him in something he wants to do."

—E. B. WHITE, about his Dachshund FRED

6·Wednesday·December *2023*

X Thursday December

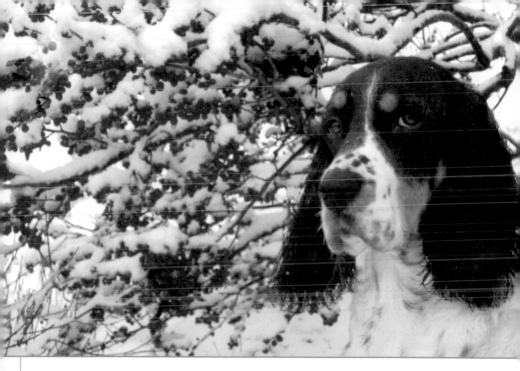

THE SNOWBALL EFFECT Ken and Becky Downey of Mt. Crawford, VA, admit that their English Springer Spaniel, KIRBY, loves the snow so much that it took more than an hour of playing before she would calm down enough to have her picture taken. It was worth it, though, and in this photo we love the way the red winter berries contrast with the freckles on Kirby's muzzle.

8·Friday·December *2023*

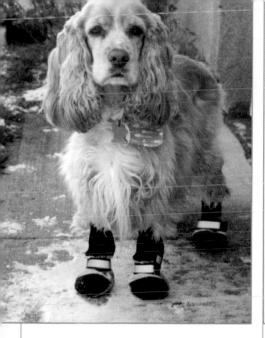

BOOT CAMP
PRINCESS (Cocker Spaniel).—
Heather Masch, Carlstadt, NJ

9·Saturday
December *2023*

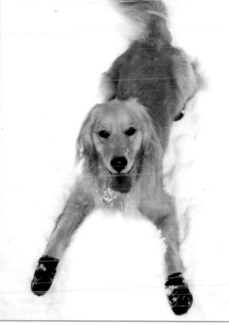

SLIPPERY SLOPE
HEIDI (Golden Retriever).—
Anne & Alan Rosenfeld, West Linn, OR

10·Sunday
December *2023*

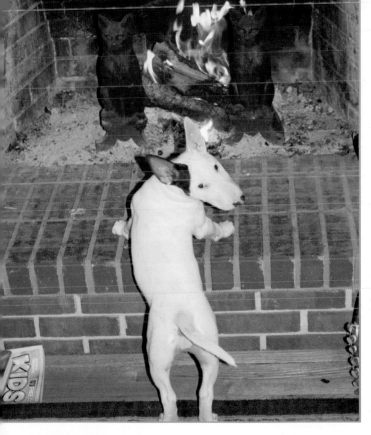

"WHERE'S THE FIRE?"

It's time to add another log to the fireplace, but JOSIE has been too busy playing to get to it. Lucky for Josie, her family, Bethany and Jonathan Owen, will keep the fire going and keep the Bull Terrier pup warm on even the chilliest winter night. They're from Winter Haven, FL.

11·Monday·December 2023

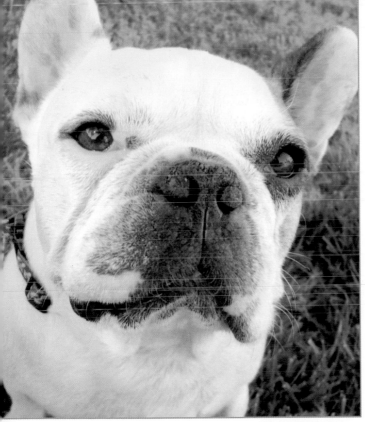

JOB SEARCH

The French Bulldog descended from English Bulldogs owned by British lace workers who emigrated to the continent in search of work. Mixed with local breeds, the Frenchie soon became a favorite both in France and in the United Kingdom. This amiable companion dog then extended its popularity across the Atlantic and is now a favorite of American urbanites.

12·Tuesday·December *2023*

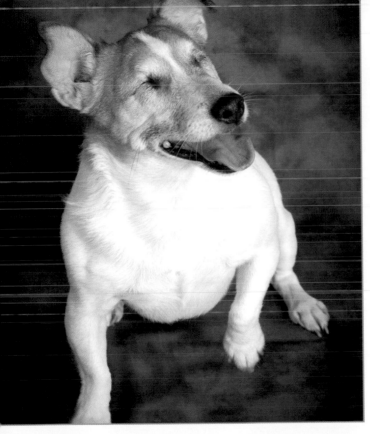

HAPPY ENDINGS

Lens luxation is a genetic condition in which the eye lens detaches from its normal position, ultimately resulting in blindness. This disease is especially common to terriers and terrier-type dogs. ABBY, a terrier mix, lost her sight to lens luxation, yet her owner, Laura Fogel, writes that she hasn't let her impairment slow her down one bit. She still enjoys a very full and happy life. Abby even has her own Facebook page called Abby Dabby Do! They're from Litchfield, MI.

13·Wednesday·December *2023*

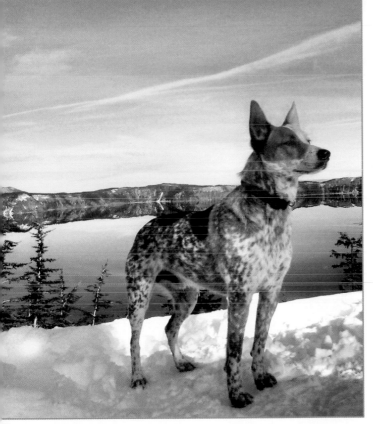

PEAK PERFORMANCE

YOGI's owner tells us that the Australian Cattle Dog is an ace when it comes to fetching and that he's also a big hit with all the lady dogs. Athletic and outdoorsy like most Cattle Dogs, if Yogi's not at the park, you might find him on the top of any given mountain. Yogi and Joey Verdian live in Berkeley, CA.

14·Thursday·December *2023*

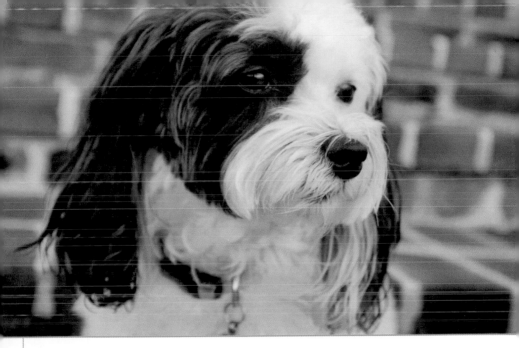

SIDE BY SIDE SAKI is a Bichon/Poodle mix from Forest Hill, CA, and his mom, Marcia Young, admits that he's a little bit on the wild side. He's highly social and spends most of his days in a whirlwind of activity, especially searching for squirrels in the yard. But when December comes and the nights start getting colder, Marcia knows that the only place Saki wants to be is by her side.

15·Friday·December *2023*

TINY HOUSES
BUBBA (Saint Bernard).—
Mike Anderson, St. Paul, MN

16 · Saturday
December 2023

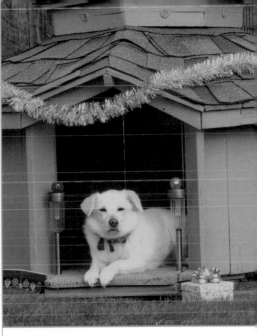

MUTT MANSIONS
LILY (American Eskimo/Jack Russell mix).—
Birgit Isaacs, Port Alberni, British Columbia,
Canada

17 · Sunday
December 2023

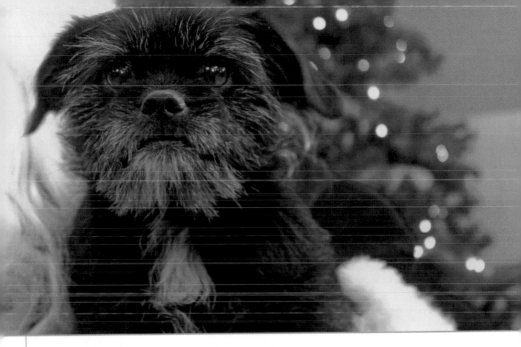

TO THE RESCUE This holiday season, it looks like everything's coming up Rosie. ROSIE's a rescue who was removed from a hoarder's house in Missouri, along with 29 other dogs. Her new owners, Lois and Albert Buteau of Raynham, MA, admit that it didn't take the Terrier mix long to adapt to her new life of luxury. She especially likes the holidays, knowing that there will be plenty of presents under the tree for her.

18·Monday·December *2023*

19 Tuesday December

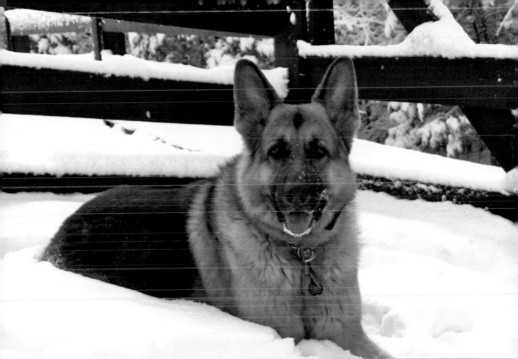

TAZ (GERMAN SHEPHERD).—GRACE PIASECKI, PRINCETON, NJ

"**B**y and large my major impulse, when I see a dog, is to stop whatever I'm doing and say hello."

—STEVEN BAUER

20·Wednesday·December 2023

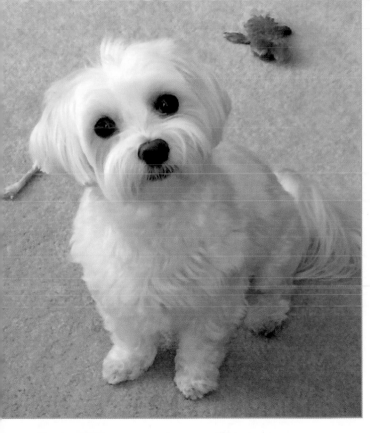

SNOW BLIND
Like all Maltese, JACKSON has a pure-white fluffy coat. He loves to play in the snow, but his caretaker, Amy Kessler of Alexandria, VA, admits that when he does, he has to wear his coat—otherwise you won't see him, except for his black nose and eyes.

21·Thursday·December₂₀₂₃

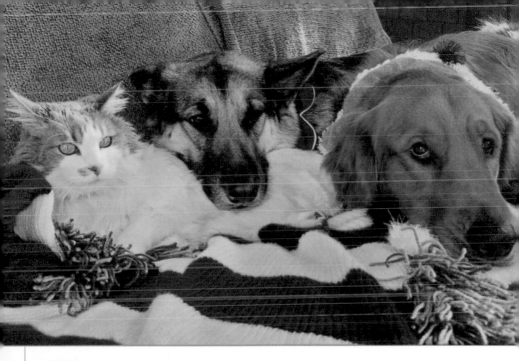

EVERYBODY'S BEST FRIEND Time for a Christmas catnap! They've been making toys and wrapping presents for days, and now these elves are shelved. The sleepy pals are SYDNEY, a German Shepherd; SUMMIT, a Golden Retriever; and their feline friend, Homey. They live in Peoria, AZ, with Robyn Jaynes.

22·Friday·December *2023*

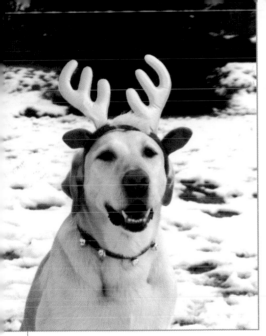

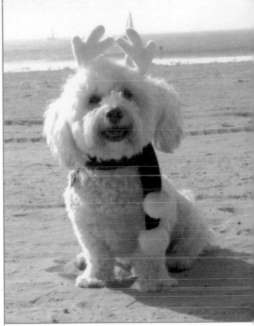

SNOWBOUND REINDOG
HONEY BEAR (Labrador Retriever).—
Clarence Mason, Greendale, WI

23·Saturday
December*2023*

SURFSIDE REINDOG
RODGER (Bichon mix).—
Catherine & Scott Bigbee, Los Angeles, CA

24·Sunday
December*2023*

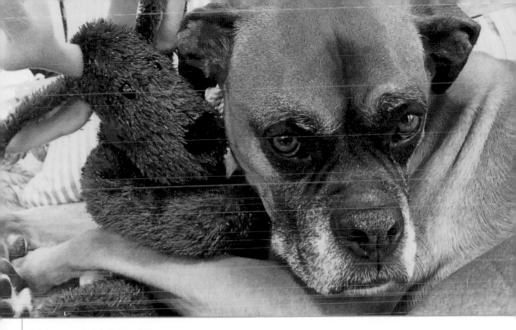

THEN HOW THE REINDEER LOVED HER And it looks like the feeling is mutual. GINGER got plenty of presents Christmas morning, but it became perfectly clear which one was her favorite when she and a plush reindeer formed an instant bond. The Boxer is spending the holiday at home with Brenda Newman in Yorktown, VA.

25·Monday·December 2023

CHRISTMAS

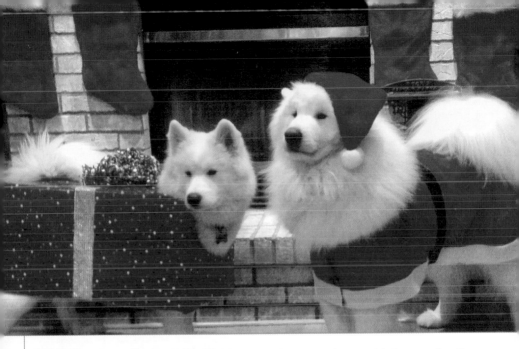

DREAMING OF A WHITE CHRISTMAS If you share your home with Samoyeds, all your Christmases are white! MAYA and GUNNER, a pair of beautiful Samoyeds who live with Barbara Gage in Webster, MN, smile for their elaborately staged fireside holiday photo. When not posing, they're busy with a great number of activities, including sledding, carting, hiking, herding, agility, therapy, and dog shows.

26·Tuesday·December 2023

KWANZAA BEGINS
BOXING DAY

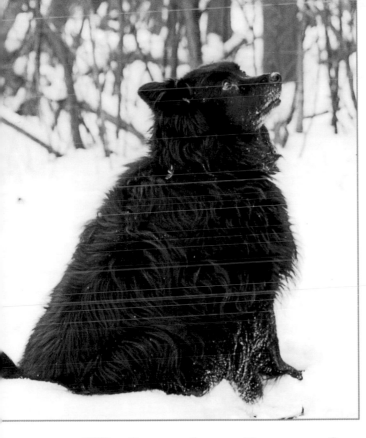

HAPPY ENDINGS

MAGGIE MAY was rescued by the Detroit Animal Cops during an animal cruelty case. At that time she was not housebroken, un-socialized, hyperactive, and extremely "mouthy." After being returned by two adoptive families due to her behavioral problems, she found a new home with Mary V. Dorsey of Beverly Hills, MI. With patience and lots of TLC, the Border Collie mix was finally able to resolve her problems, and Mary says she's the most loyal and protective dog ever. Her passions? Herding Mary's grandchildren and making dog angels in the Michigan snow.

27·Wednesday·December 2023

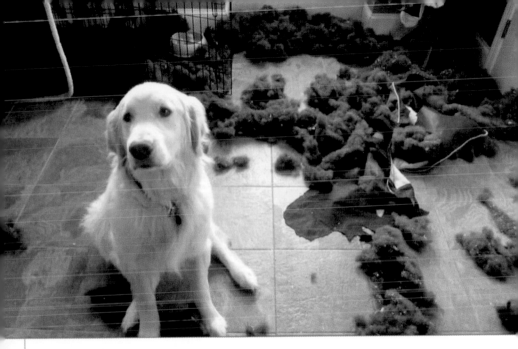

YOU MADE YOUR BED, NOW LIE IN IT! SLIPPERS received a nice new bed as a Christmas present just a couple of days ago. But then he decided to rearrange the stuffing! The Golden pup tried to pin the crime on his older Golden brother, Cody, but the shredded pieces of cloth on his nose made it pretty clear who the culprit was. Slippers and his family, Carly, Brianna, and Danielle Faltraco, are from Wantage, NJ.

28·Thursday·December 2023

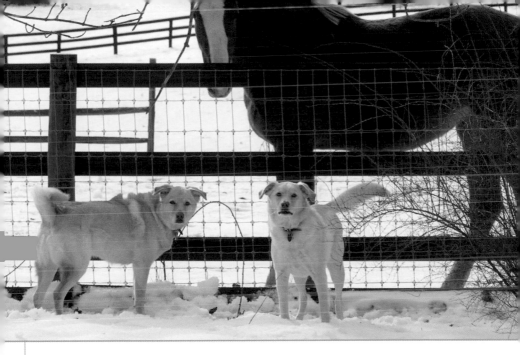

EVERYBODY'S BEST FRIEND Meet a couple of dogs who like horseplay. Asa and Parley are Labrador mixes who were adopted through a rescue group by Kurt Schroeder and Lynn Webster. At their new home in Lovettsville, VA, they soon befriended Kurt and Lynn's horse Nova, and nowadays the Lab brothers can spend hours running up and down the fence at Nova's paddock. And sometimes, Lynn adds, the three friends seem happy just to hang out together.

29·Friday·December *2023*

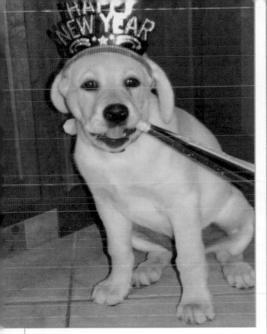

NEW YEAR BABY
SABRINA (Labrador Retriever).—
Kristin Kabis, Kenvil, NJ

30·Saturday
December *2023*

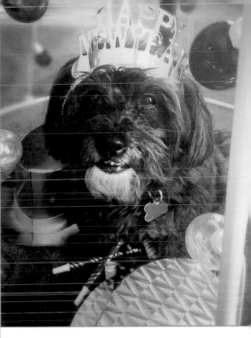

COUNTDOWN TO 2024
SHILOH (Havanese).—
Claudia Johnson, Cazenovia, NY

31·Sunday
December *2023*

Attention, Pet Parents!

Do you have an adorable cat or dog that wants to be a star? Submit photos of your pet for a chance to be featured in one of our beloved and bestselling pet calendars.

For instructions on how to submit photos, learn about prizes, and for complete contest rules, go to:

pageaday.com/contests

Written by Wayne Harry Kirn
Compiled by Analucia Zepeda
Photo research by John Blum
Cover photo: Cobberdog
Cover photo credit: Nynke van Holten/Shutterstock

ISBN 978-1-5235-1579-0

Printed in Thailand on responsibly sourced paper.

Workman Publishing Co., Inc.
225 Varick Street
New York, NY 10014-4381

pageaday.com

workman

ACKNOWLEDGMENT

Text vetted by
Kristin Kutscher, V.M.D.

BUSTER (DACHSHUND MIX)—CAROLYN SAMPRON, MORRISON, CO

STAY CONNECTED AT
PAGEADAY.COM!

Shop for calendars, puzzles, and books. Enter our world-famous cat and dog contests. And sign up for the newsletter at **pageaday.com/news** for exclusive offers on sales, sweepstakes, and more.

2024

JANUARY
S	M	T	W	T	F	S
	1	2	3	4	5	6
7	8	9	10	11	12	13
14	15	16	17	18	19	20
21	22	23	24	25	26	27
28	29	30	31			

FEBRUARY
S	M	T	W	T	F	S
				1	2	3
4	5	6	7	8	9	10
11	12	13	14	15	16	17
18	19	20	21	22	23	24
25	26	27	28	29		

MARCH
S	M	T	W	T	F	S
					1	2
3	4	5	6	7	8	9
10	11	12	13	14	15	16
17	18	19	20	21	22	23
$^{24}/_{31}$	25	26	27	28	29	30

APRIL
S	M	T	W	T	F	S
	1	2	3	4	5	6
7	8	9	10	11	12	13
14	15	16	17	18	19	20
21	22	23	24	25	26	27
28	29	30				

MAY
S	M	T	W	T	F	S
			1	2	3	4
5	6	7	8	9	10	11
12	13	14	15	16	17	18
19	20	21	22	23	24	25
26	27	28	29	30	31	

JUNE
S	M	T	W	T	F	S
						1
2	3	4	5	6	7	8
9	10	11	12	13	14	15
16	17	18	19	20	21	22
$^{23}/_{30}$	24	25	26	27	28	29

JULY
S	M	T	W	T	F	S
	1	2	3	4	5	6
7	8	9	10	11	12	13
14	15	16	17	18	19	20
21	22	23	24	25	26	27
28	29	30	31			

AUGUST
S	M	T	W	T	F	S
				1	2	3
4	5	6	7	8	9	10
11	12	13	14	15	16	17
18	19	20	21	22	23	24
25	26	27	28	29	30	31

SEPTEMBER
S	M	T	W	T	F	S
1	2	3	4	5	6	7
8	9	10	11	12	13	14
15	16	17	18	19	20	21
22	23	24	25	26	27	28
29	30					

OCTOBER
S	M	T	W	T	F	S
		1	2	3	4	5
6	7	8	9	10	11	12
13	14	15	16	17	18	19
20	21	22	23	24	25	26
27	28	29	30	31		

NOVEMBER
S	M	T	W	T	F	S
					1	2
3	4	5	6	7	8	9
10	11	12	13	14	15	16
17	18	19	20	21	22	23
24	25	26	27	28	29	30

DECEMBER
S	M	T	W	T	F	S
1	2	3	4	5	6	7
8	9	10	11	12	13	14
15	16	17	18	19	20	21
22	23	24	25	26	27	28
29	30	31				